UNHINGED

On Jitterbugs, Melancholics and Mad-Doctors

Dr. Guislain
Museum
Ghent

HANNIBAL

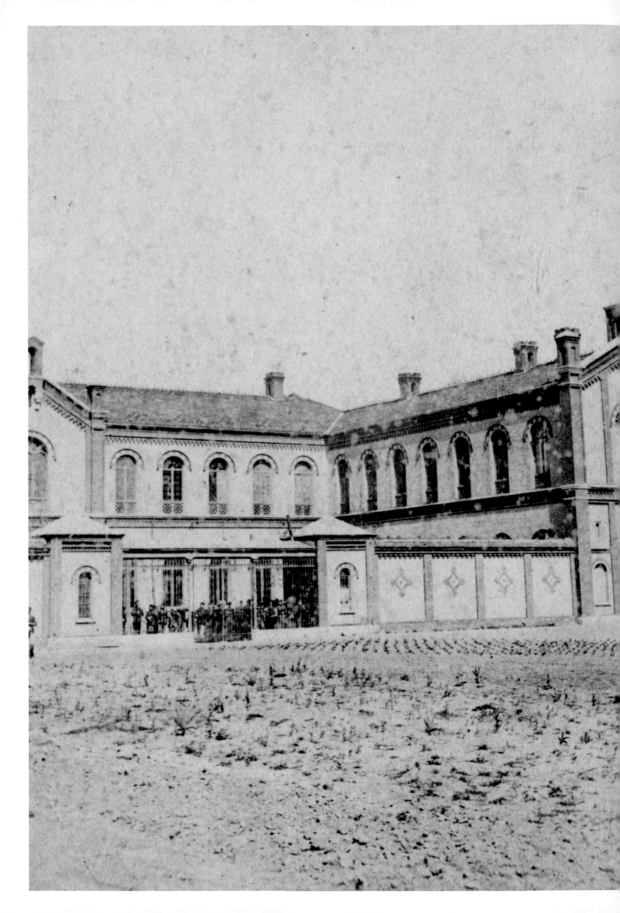

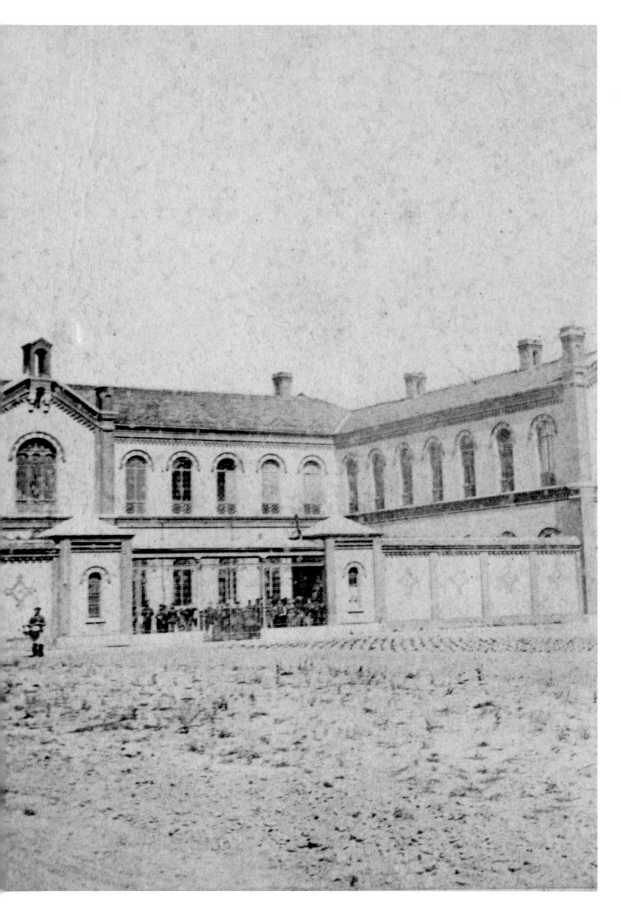

(previous pages)
Stereographic card of the Hospice Guislain (detail), c. 1860. Dr. Guislain Museum, Ghent

Andrew Scull

THE DR. GUISLAIN MUSEUM: AN APPRECIATION

Foreword

The asylum once seemed to be one of the most enduring symbols of civilisation's determination to isolate and hide away the mentally ill. Though it proclaimed itself a therapeutic institution, its public image was more as the Bluebeard's cupboard of the neighbourhood, a Gothic castle behind whose high walls and barred windows, a nameless horror lurked. Its inmates were shut up in every sense of the term, lost from public view, their utterances dismissed as the ravings of Unreason, their lives at the mercy of those who presumed to act in their name. Stigma, shame and scandal have persistently shadowed madness, and our struggles to understand alienation, to deal compassionately with those who suffer from it, and to conjure up effective responses to its ravages and depredations, continue unabated in the present. We now live in the twilight of the asylum age. The once-familiar 'museums' of madness that haunted the imagination of our forebears are fast-fading from our collective consciousness. A few have been repurposed, albeit with strenuous efforts to mask their past history — as housing for the nouveaux riches, for example, London's Colney Hatch Asylum transformed into the Princess Park Manor development; or as vacation spots for the moneyed classes, doubtless blissfully unaware that they are occupying what was once Venice's madhouse for women now repurposed as a luxury hotel on San Clemente Island, whose owners boast with no sense of irony that it is 'the perfect destination to unwind in total relaxation'. Most mental hospitals, however, have fallen into disrepair, a sad collection of neglected hulks slowly suffering the fate that awaits us all: 'dust thou art, and unto dust thou shall return', as the Book of Genesis would have it.

It is thus singularly appropriate that what I regard as the world's leading psychiatry museum, the Dr. Guislain Museum, should be housed in the walls of a nineteenth-century asylum. Museums of psychiatry, rather like medical museums, are a rare species these days. Medical museums were once very common.

They existed in the first instance, not so much to entertain and educate hoi polloi, but rather as collections of clinical curiosities that illustrated the prominence and success of their owners, and that were useful in instructing neophyte physicians. They were a fundamental part of the nineteenth-century medical student's education, allowing the comparison of healthy and diseased anatomical specimens. Medicine moved on from the anatomical-pathological era, and only a handful of such establishments now survive, such as the Mutter Museum in Philadelphia and the Hunterian Museum housed by the Royal College of Surgeons in London.

By contrast, remarkably few museums of psychiatry have ever existed. And oddly, one of the most famous such establishments is an *anti*-psychiatry museum, set up in Hollywood by the cult of Scientology, its message captured in its very name: Psychiatry — An Industry of Death Museum. Colonial Williamsburg in Virginia, that Disneyfied recreation of early American history, contains a recreation of the Bedlam that opened its doors there in 1773, and the original Bedlam, Bethlem Hospital in London, recently opened a small museum curating artefacts from its long history. The Freud Museums in London and Vienna are, as their name implies, primarily of interest to those focused on the history of psychoanalysis. In another more specialised vein, the Prinzhorn Collection in Heidelberg, Germany, houses a remarkable collection of artwork created by the mentally ill and assembled by Hans Prinzhorn (a collection that was somehow preserved from the Nazis who sought to destroy it); and Jean Dubuffet's later compendium of *art brut* (a term he coined) is now on exhibit in Lausanne, Switzerland. None of these establishments compare, however, in ambition, in size, in range, or in importance to the Dr. Guislain Museum, the most comprehensive establishment of its type known to me.

The museum is housed in Belgium's oldest asylum, planned as early as 1824, but not opening its doors until 1857. Those who built the nineteenth-century asylum system initially conceived of these institutions as curative spaces, a new social geography of madness quite literally providing asylum or respite from the bewildering pressures of the world outside. On entering the museum, one is therefore at once made aware of how, even a few generations ago, Western societies opted to respond to mental disturbance. To enter the grounds and the wards of one of these establishments is to walk into a now-forgotten world. To imagine oneself confined in

such a place is likely to conjure up nightmares, yet can we be so sure that our own 'solutions' to the problems posed by the gravest forms of mental disturbance are so manifestly superior to these? The spectre of chronic homelessness and the wholesale neglect that often masquerades as community care might give us all pause.

In any event, the museum you are now about to enter explores not just the world of the asylum, but the broader history of mental illness in the Western world. It is a rich and complex subject. Madness has not always been interpreted through a medical lens. Religious and supernatural accounts of mental illness long had a strong hold over the popular imagination, and co-existed alongside attempts to provide a naturalistic account of profound disturbances of reason and the emotions. The shattering emotional turmoil, the alienation of some of our fellow human beings from the common-sense reality the rest of us think we share, has a long history of fascinating and frightening us. Few are immune to its terrors, for to enter such a world, even in the imagination, is to be reminded how tenuous our own hold on reality may sometimes seem to be. If madness challenges our sense of the very limits of what it means to be human, it can come as no surprise that it has been a central topic of concern for artists and writers, for scientists, physicians and divines.

Here lie some of the most profound forms of human suffering — sadness, isolation, alienation, misery, and the death of reason and consciousness. Nor is the pain and misery that losing one's mind entails confined to its most obvious and immediate victims, for its consequences extend, not just to their loved ones, but also to society at large. No society is immune to the problems it creates, and a museum that examines this subject over time has a rich and complex set of stories to tell. And to tell them, and to rescue the mentally ill themselves from the silencing that has so often been their lot, requires a willingness to tell those stories from a variety of perspectives, and utilizing a broad array of materials, something the Dr. Guislain Museum does with surpassing skill.

Museums are first and foremost places designed to collect and preserve, as well as to interpret and display, all manner of items and objects that can help us recapture worlds that we have lost, even worlds that were hidden and often misunderstood in their own time. The moral architecture that was the asylum is one artefact that the Dr. Guislain Museum brings to our attention, as I have already indicated. But that larger container envelops all sorts of

other artefacts that can broaden our understanding, and, one hopes, begin to break down some of the prejudices, the stereotypes, and the ritual exclusions that have so often been the mental patients' lot. There are documents that illustrate how our society has grappled with madness and sought to comprehend its ravages, even surviving fragments of patients' own accounts of their travails. Some of these record the emergence of psychiatry as a distinctive form of knowledge, and the at times torturous pathways its attempts to remedy mental illness have taken. Here, too, one is in the presence of striking examples of the treatment technologies that have been mobilised to confront the demons of madness, and these will bring many people up short. The preservation and display of these objects, and the discussion of their place in the therapeutics of mental disorder, constitutes one of the many important contributions the museum's collection makes.

Paintings and sculptures from past centuries give us useful perspectives on the place of mental illness in past centuries. The museum has a valuable collection of works of art that capture various aspects of mental illness, of interest in all eras, but particularly in eras where many were illiterate and visual materials can give us important insights into attitudes and understandings of madness in those distant times. Beyond what images by recognized artists can tell us, the Dr. Guislain Museum brings together and makes available another invaluable set of artefacts it has preserved. Many of the mentally ill in earlier eras were poor and unlettered, incapable of leaving a written record of their sufferings and states of mind. Some, however, drew or painted, and the Dr. Guislain Museum has a remarkable collection of those works, with its insights into the world of the imagination, and into the inner worlds of the usually silent and silenced.

Alongside those sorts of visual materials, the museum also has a wide range of photographs that provide all sorts of insights into life in the asylum and help to rescue patients from amnesia and anonymity, preserving some sense of their humanity and identity. One of the reasons we possess materials of this sort is because variety of nineteenth-century alienists thought that physiognomy provided a useful source of information about mental illness, and although we have long abandoned such notions, they provided the impetus for taking daguerreotypes and then photographs of patients. Other images document various aspects of life in the asylum and provide a visual reminder of the faces of madness, and

of the character of the institutions in which these lost souls once were mostly found.

In its rich collections, which it plans to supplement with related material borrowed from elsewhere to create a rotating set of exhibitions, the Dr. Guislain Museum provides everyone, from clinicians and historians to those with first-hand experience of mental illness, not to mention the public at large, with an unparalleled and immensely rich storehouse of knowledge. Perusing its exhibits will, I suspect, alternately charm and horrify, amuse and instruct, and above all enlighten those who visit its galleries. The Dr. Guislain Museum will allow visitors to experience for themselves, in ways limited only by their own imagination, a world now largely lost. Not least, its many objects and its ways of putting them into context will bring, one hopes, a broader understanding of mental illness and of the mentally ill, and of the shifting beliefs, interventions and attitudes that have marked the Western response to mental disturbance over the centuries.

Bart Marius

UNHINGED

A User's Guide

What is psychiatry and how might we imagine a museum of psychiatry? That is roughly the essential question underlying this collection of texts that accompanies our new exhibition. Let's start at the beginning.

Psychiatry is not just the science that concerns itself with psychological problems. It is also a form of treatment, and a psychiatric hospital is a physical place where people facing these issues are accommodated. Most importantly, psychiatry is about people who are suddenly confronted by something unfathomable on their life journey, something that paralyses them, that saddens, frightens or exhausts them. Psychiatry is also taboo, a stigma that weighs upon anyone who suddenly finds themselves facing it.

The idea of exhibiting psychiatry might initially seem to have a distinct whiff of the freak show about it. As a museum, we are aware of this. However, we have rejected the option of avoiding the issue by telling a chronological story with historical exhibits. After all, chronology implies evolution. And evolution means that there was once a bad way of doing things that has grown into a better way. That is not the story we want to tell. But we are certain that we do have a story. Why we are telling that story in a museum, what it might be about and how we are going to present it as a whole is something we will try to sketch out in this introduction.

MUSEUM

Two people, Boris Groys and Lucas Devriendt, were sources of inspiration and confrontation in our search for the story we wanted to tell and the way we might present it.

Art philosopher Boris Groys is not interested in historical museums. His work is only intended to prick the conscience of contemporary art museums and to highlight their social and even political significance. The fact that he seems to dismiss all other museums as uninteresting is a thorn in our side. 'Precisely at this time, it seems quite interesting to ask what a museum is and thus to benefit from the new, problematic character of the museum. The museum is often understood as a place of memory, where

everything that has proved to be historically relevant, valuable and important is collected and conserved. (...) All museums, except art museums, are cemeteries of things: the things collected there have been robbed of their vital functions — so they are dead.'

The Dr. Guislain Museum is not an art museum. So that is hard to swallow. What is more, it is housed in a listed building, a former asylum on the outskirts of Ghent. And it is not just the building that is heritage: so is our collection. We operate on the basis of psychiatry itself, and within the physical shell, we turn it into heritage.

But what is it exactly that we have inherited? The building? Yes, but also — and equally — the psychiatric treatments and theories that exist. And certainly the people who were admitted here as patients, residents and clients. Neither the building nor the people who think about it, the people who treat others and are treated inside it are separate from society. Society is changing and every aspect of psychiatry is changing with it. So the museum might contain objects that have been robbed of their (vital) functions, but stories cling to these objects: living stories.

The second person who has profoundly influenced our thinking is Lucas Devriendt (1955–2017). For his doctorate in the arts, Lucas wanted to create an installation in the middle of our former section on *The History of Psychiatry*. The starting points were two black-and-white photos dating from 1924, all that remains of the radiology practice of Lucas's grandfather. The photos clearly show the abstract murals that Leon Devriendt had painted in his consulting room at the Heilig-Hart clinic in Kortrijk, which seem to be an artistic visualisation of the evocative X-rays. For Lucas Devriendt, this was not so much a question of personal fascination as a matter of painterly research. He tried to reproduce the colour patterns in his studio, but soon felt the need for more than merely an interpretation in painting. The details of the photos also inspired a spatial creation. The result, *Kabinet Devriendt,* was an architectural installation with paintings by Lucas along with other media, photography, documents and objects referring to a wider contemporary visual culture. It became a total installation that burrowed through different spaces. The associations between the different media and Lucas's own work were contagious. *Kabinet Devriendt* was an invitation to think more and more deeply about how we can associate our own collection with visual culture to create a fluctuating, vibrating and above all narrative whole.

Many — but far too few — conversations with Lucas, who sadly died before his time, led to the plan to make far greater use of our collection as a tool. Will the historical objects and documents, which Groys says determine our deadness, remain bereft of their vital functions in this new conception of the museum? It is a quest that is far from over, even with these results. And for as long as we keep thinking and challenging ourselves, life is clearly present in the collection too.

MADNESS

Let's go back to the beginning and talk about madness, as if it were a single thing treated with 'psychiatry', itself a single thing. Madness is what disturbs us, throws us off balance and makes us lose our footing. If we talk about psychiatry today, we mean something different from the madness of two centuries ago. It seems likely that people only became aware of different categories, variations and types of madness since mad people started being literally locked up in the first asylums. Pioneers of psychiatry like Joseph Guislain seriously underestimated the capacity of mental hospitals, and early asylums soon became overcrowded. That seems to indicate that, since madness was detected as one major phenomenon, smaller or different forms of psychological complaint have cropped up here and there. Some authors claim that madness is a magnification of normality. But how can something that unbalances and disturbs us so badly be a magnification of the rule, of the ordinary? How can that 'other' throw us into such confusion and fascinate us at the same time? How can it frighten us but at other times make us laugh? Nevertheless, it does.

Madness has been present in every time and place, and above all, it takes many forms. We know Diogenes as an extravagant philosopher from the school of Cynicism, but if any of today's prominent philosophers lived in a large ceramic jar and regularly masturbated in public, the chances are someone would have them sectioned. In 1889 Friedrich Nietzsche had a mental breakdown and clung weeping to a horse in Turin. Nietzsche's great idol, Dostoevsky, wrote like a man possessed to finance his gambling addiction. Jazz pianist Bud Powell was admitted to a French psychiatric institution during a European tour and treated with electroshock therapy. But madness also occurs within the science of psychiatry itself. Who wouldn't consider the use of LSD by its proponent Timothy Leary downright crazy today? Or the orgasm

machine invented by Wilhelm Reich, a student of the famous Sigmund Freud? The list is long.

THEORY AND LIBRARY — TREATMENT AND COLLECTION

Unhinged is a presentation of the story that belongs with the building we are housed in. It is an exhibition that will run for a few years at least. It is the presentation of our physical collection, and yet that is not exactly what it is. Because the physical objects are above all tools for telling our story. In other words, the story, with branches that spread out into many eras, cultures and changes in society, is our most important collection. This means that we can emphasise different aspects of that story at different times, by singling out different objects, adding objects or taking them away. To feed this narrative structure, we can draw on two important sources: a library and a collection.

At the very back of the building, a former section of Dr. Guislain's psychiatric centre has been converted into a two-storey library. Publications both thick and thin, large and small, old and new fill immense shelves that the public never get a chance to see. Tens of thousands of volumes encase hundreds of thousands, perhaps millions of pages with theories about psychiatry, psychology, neurology, pedagogy, institutions and a smattering of general science and art. The Dr. Guislain Museum library is the largest specialised library in Belgium for madness and related topics. If we think about it a little harder, we have to acknowledge that there is a lot of wisdom that is likely to remain enclosed forever in those printed pages. So much knowledge and research, and yet the puzzle has still not been solved. The fact that many books in our library spend long periods unopened says a great deal. Firstly, that the human spirit is the subject of an age-old but unending fascination. Or that many thinkers, writers and scientists have concerned themselves with these issues, but that their theories have not stood the test of time. It seems that the human mind changes as rapidly as the social context we move in. 'Uninteresting' theories find new sounding boards. Ideas that have long since passed out of fashion suddenly become popular again. The hidden library is a specialised Alexandria in miniature, where we have people's thoughts on madness and the mind at our fingertips.

The second most important source is our collection. After more than 30 years, the Dr. Guislain Museum is completely encapsulated

in one of the oldest asylums in Belgium. What began as a small attic museum that some journalists called a museum of horrors now has a carefully constructed collection. Building up the collection began in the wake of anti-psychiatry, at a time when there was little interest in this heritage. It was a specialisation within medicine, and there was not much to be said about it. And that didn't seem likely to change much in the immediate future.

Today, however, the situation is quite the reverse. As social creatures, we seem to consider a growing range of behaviour strange or deviant. Psychological discomfort is getting greater, more frightening or more oppressive all the time. Paul Verhaeghe claims that psychiatry is a magnification of normality. That is something we sense in the composition of our collection, but also in the way certain topics appeal to a broad section of the general public. The twenty-first century seems to be governed by the prefix 'psy'. Not just because of the overwhelming amount of information on social media, the numbers of burned-out employees and the prevalence of depression. The media are increasingly bombarding us with knowledge that comes from psychology and psychiatry. This makes it all the more obvious that our collection has much more to tell than merely the story of the so-called 'severely psychotic' or 'hyper-manic' patients who inhabited the first asylums.

EXHIBITIONS

For more than 30 years, the permanent exhibition on psychiatry has been the heartbeat of the Dr. Guislain Museum. The history of psychiatry provides new inspiration for our thematic exhibitions each year. This has led to an exhibition policy that aims to wrench open age-old, ingrained opinions and rusty old stigmas in order to present exhibitions that address current issues in society once more. Exhibitions such as *From Memory*, *Nervous Women*, *Dark Chambers*, *Another World* and *Sensations* each created a new perspective from which the collection could be viewed and reinterpreted with regard to a specific theme. They expanded our horizons. We have also increasingly come to see youth care and institutions for young people as a crucial part of our story, thanks to exhibitions such as *Dangerously Young*, *Patch Places* and *Adoption*.

Psychiatry does not read like a story in art history: there is no clear beginning, no clear line and certainly no clear plot. Psychiatry, its theories, treating physicians and treated patients are

woven into a general history and share spaces with various other disciplines. In no way does this seem to be a history that builds itself up, evolving in a systematic or structured way. Psychiatry bobs up and down on the wave of history, failing to find a place where it can lower its anchor.

That is why our new exhibition bears the title *Unhinged*. The reference to an unhinged mind speaks for itself. But *Unhinged* means more than that. It is a permanent presentation that is never completely finished, where objects, books and works of art come and go. This turns the fixed nature of a presentation of the collection into something more flexible. Last but not least, it is no longer a chronological history. Following our dominant theoretical practice, we have created five aspects that enter into dialogue with each other in an associative manner. And, as with every temporary exhibition, our starting point is the present day. Abandoning the historical line has enabled us to turn psychiatry into a radically different, dynamic story with contemporary questions about psychological well-being at its core. Historical documents and contemporary works of art are effortlessly interchanged within thematic associations. The final result is a dynamic story in which our own collection, temporary loans and works in progress ask the questions in a constantly changing balance.

The theme of *Power and Powerlessness* investigates how power relations have been woven into the entire history of psychiatry and continue to take on different manifestations. *Body and Mind* questions the apparent dichotomy, and draws parallels, between the classical doctrine of the humours and contemporary holistic thinking. *Architecture* breaks the boundaries of local spaces and leads us to ask whether the psychiatric hospital and institutions for adults or young people are anachronistic anomalies. In the *Classification* section, we examine why psychiatric disease profiles are relevant to all periods of history. Why is it still worth talking about hysterical women and dangerous men, kids with ADHD and autistic people? Lastly, *Imagination* touches this museum's heart: how creativity can be a solution and support a diagnostic system, and above all how vision inspires artistic processes.

TO CONCLUDE

The Dr. Guislain Museum responds to the question of the importance of its permanent collection in ever-changing ways. The contradiction between a temporary and a permanent exhibition

embodies the position of psychological well-being in a society that is growing more and more complex. Exchanging a dusty attic for some of the large exhibition spaces demonstrates the value we attach to mental health today. Madness and inappropriate behaviour have not yet been consigned to the past. The crazies, lunatics, headcases, idiots and nut jobs, the senile, mad and insane often have a bleak past and a stubborn stigma to bear. Age-old psychological vulnerability and the discipline of psychiatry, a mere 200 years old, have swum in deep waters and turned the page on many a dark chapter of history. More than ever before, we are confronted with the controversy of our current mental health. And that is where *Unhinged* takes a stance and joins the debate. It asks whether our urge to achieve perfection or uniformity is excluding people more than ever, and perhaps even earlier. If we follow developments in psychological diagnosis, pharmacology and neuroscience, recognition of subjectivity seems to be returning to the fore. That means a museum might have everything to gain from the words of Boris Groys, the man who declared us dead: 'The modern museum is a closed, transparent space that is clearly separated from the outside world and shrouds it in darkness. There are at least two ways in which the museum excludes "otherness". Firstly, all objects outside the museum are removed from the visitors' view. Secondly, the museum itself, in terms of its materiality, labour and institutionality, is kept invisible and hidden. So you feel locked up inside a museum and want to escape the straitjacket it imposes. This desire is precisely what gives rise to subjectivity. Therefore it is the primary function of a museum to generate the illusion of a refuge or a *free space* that can function as the field of action for free subjectivity.'

BIBLIOGRAPHY

Groys, Boris. *Logica van de verzameling*. Amsterdam: Octavo publicaties, 2013

Leader, Darian. *Wat is waanzin?* Amsterdam: De Bezige Bij, 2012

Wittocx, Eva, Demeester, Ann, Carpreau, Peter, Bühler, Melanie & Karskens, Xander (ed.). *The Transhistorical Museum. Mapping the Field*. Amsterdam: Valiz, 2018

Wolfson, Rutger. *Het museum als plek voor ideeën*. Amsterdam: Valiz, 2007

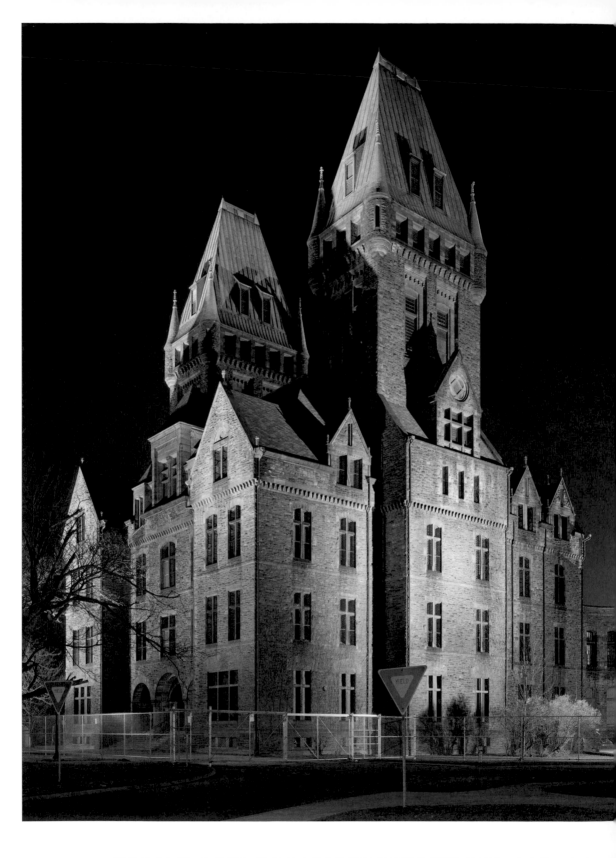

Christopher Payne, *Buffalo State Hospital, Buffalo, New York*, 2003, photograph. © Christopher Payne

ARCHI
TECTURE

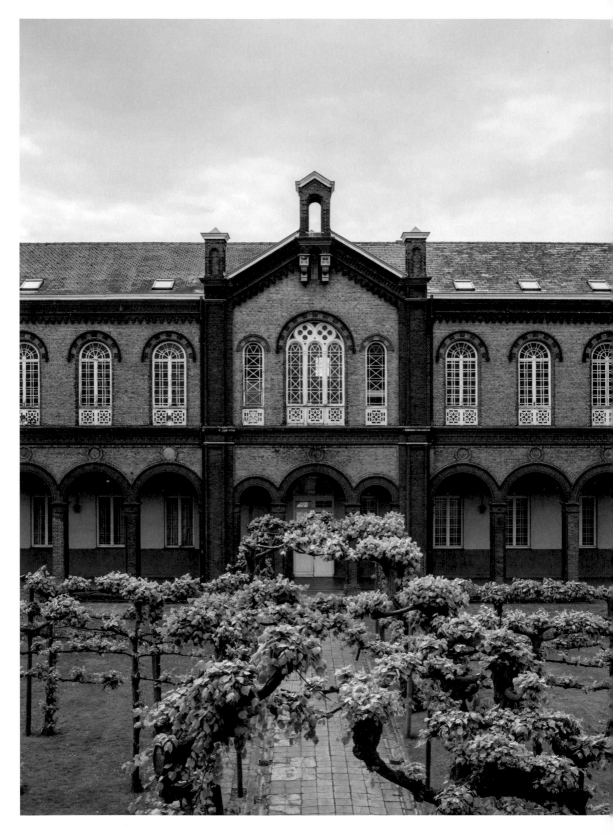

Karin Borghouts, from the series *Museum Dr. Guislain*, 2019, photograph.

Patrick Allegaert

FROM BATTLESHIP TO RUIN

The History and Future of
Life in a Psychiatric Institution

At the first general conference for the mental healthcare sector organised by Flanders (March 2019), life in a psychiatric building was an important topic: 'Institutions like this one are designed for people who don't fit in society. But there is no longer enough space for the original target group', says Werner Peinen, the head of the department De Vallei at Bethanië Psychiatric Centre in Zoersel, Belgium (*De Morgen,* 14 March 2019).

People used to be put into what was known as an 'asylum', an institution that functioned like an island, far from society. In recent years, this segregation of psychiatric patients has increasingly been called into question. The legal clause called 'Article 107', introduced in Belgium in 2002, states the intention to do more to 'socialise' such patients. In other words, it is desirable to get patients to participate in the ordinary life of society again as quickly as possible, letting them live among other people in the city. That is the idea behind outpatient home care: psychiatric nurses or psychologists visit patients at home. But an opposing trend was discussed at the conference. Peinens explains: 'We have experienced on more than one occasion that a patient released from here turned up at our door again ten months later, because the combination of loneliness and poverty had become too much for them. So they give up their own home in favour of a place ruled by chaos, where there is sometimes filth on the floor, where there is shouting at night, where they have to live with 39 other people every day.'

It is surprising to be confronted with a kind of paradox of inclusion and the 'socialisation' of care: the 'traditional asylum' still accommodates people with a psychiatric vulnerability, contrary to the ambitions of policy. Particularly for people with a serious and long-term condition, those in charge of therapy claim that this is sometimes the practical possibility that works best.

Living in psychiatric institutions has always been the subject of discussion. Highly praised solutions have been destroyed shortly after, sometimes literally. The history of these places is a tortuous one.

BRICKS AND MORTAR

The building that houses the Dr. Guislain Museum marks the birth of the psychiatric asylum in Belgium. Since it was first used in 1857, much has happened there and much has changed: from a psychiatric refuge to a school, a museum, a place with various functions combined.

The building's imposing dimensions bear witness to the ambitions of days gone by. The Ghent city council wanted the project to signal that it was capable of tackling the problems associated with the breakneck speed of modernisation and urbanisation. Poor housing and great poverty triggered social and medical problems. Various forms of 'insanity', along with alcoholism and syphilis, painted a gloomy picture. People with academic, social, religious and political motivations all advocated a 'solution' for the new situation: why couldn't the traditional 'madhouses', with their sometimes astonishingly poor hygienic conditions, be replaced by buildings that aimed to offer a cure? Dealing with social problems with 'bricks and mortar' was a characteristic approach in the nineteenth century. This led to the 'psychiatric asylum' as an innovation of the age.

IN A PIT

Before the end of the eighteenth century, there was no such thing as psychiatry as a scientific field, approach or architectural style. As appalling as the situation could be, people did have a concept of 'care' of the insane. The family was responsible for providing this care, to avoid any risk to others. Care meant safety and its quality was often horrifically inadequate: providing a home for someone was reduced to locking them up. There are countless testimonials. In *A History of Psychiatry. From the Era of the Asylum to the Age of Prozac* (1998), Canadian historian Edward Shorter quotes a witness account of how 'madness' was dealt with in an Irish peasant's cabin: 'When a strong man or woman gets the complaint, the only way they have to manage is by making a hole in the floor of the cabin, not high enough for the person to stand up in, with a crib over it to prevent his getting up. This hole is about

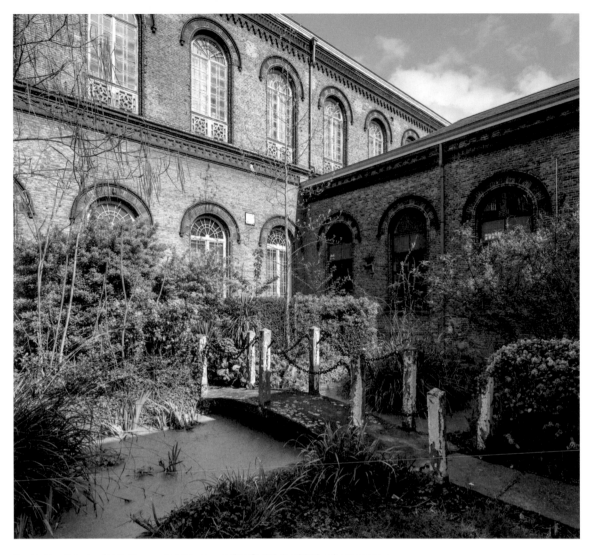

Karin Borghouts, from the series *Museum Dr. Guislain*, 2019, photographs.

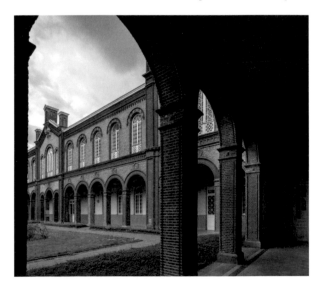

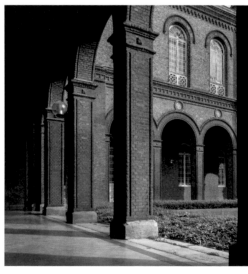

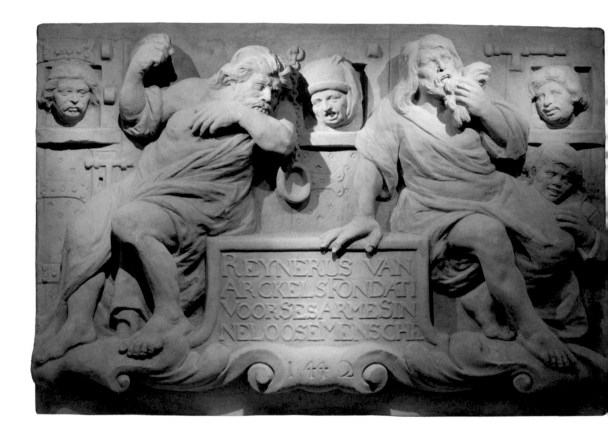

Reinier van Arkel, Stone from the façade of Zinnelooshuis
's Hertogenbosch, 1686, sandstone (replica). Dr. Guislain Museum, Ghent

From the fifteenth century onwards, the insane were housed in shelters
or 'madhouses', often privately run. Reinier van Arkel had the first
Zinnelooshuis (literally, senseless house) in the Netherlands built for
'senseless people' in 1442. As the handcuffs on the stone from the façade
show, it was more about locking them up than providing care. Three
mad people stick their heads out of the 'mad cell'. The other figures are
demonstrating insanity, such as the man on the left who is biting his
own arm. Whether the 'Great Lock-Up' over the next few centuries really
happened is uncertain. What is certain is that inappropriate behaviour
— in the broad sense — by the mentally ill, the poor and the work-shy
was shunned.

five feet deep, and they give this wretched being his food there, and there he generally dies.' Nonetheless, this was seen as the recommended practice. The mentally ill person was 'dehumanised' and seen as half human, half beast, possessed by the devil. The potential risk this person posed needed to be kept under control.

SHIP OF FOOLS

Often the situation was so untenable that mentally ill people were chased from their home and village. Then they had no choice but to join gangs of beggars. In *Folie et déraison. Histoire de la psychiatrie à l'âge classique* (1961), Michel Foucault notes the practice of the Ship of Fools, 'for they did exist, these boats that conveyed their insane cargo from town to town'. The life of the mentally ill was reduced to a wandering existence. The cities drove these people outside their limits. They were allowed their freedom, but somewhere far away. Boatmen were instructed to take the mentally ill away. Foucault continues: 'Confined on the ship, from which there is no escape, the madman is delivered to the river with its thousand arms. He is the Passenger *par excellence*.'

Besides being locked up at home and ritually driven out, places had also existed since the Middle Ages where the insane were locked away: a kind of 'holding institutions', like the Reinier van Arkel in 's-Hertogenbosch (1442), for people who were a danger to themselves and a nuisance to others. As well as locking them up, insight also grew that such asylums could lighten the burden that was the fate of the mentally ill. This was the beginning of residential care, enforced or otherwise, in combination with medical operations, bloodlettings, purges and emetics as 'remedies'. For a long time, this practice was the exception rather than the rule.

APPLICATION OF REASON

Only a handful of individuals had been admitted to such institutions around 1800. In the most famous of these historical asylums — such as Bedlam in London, Bicêtre in Paris and the Narrenturm or 'Fools' Tower' in Vienna — the number of beds was in the dozens, or a few hundred at most. Over the course of the nineteenth century, such initiatives underwent explosive growth under the influence of the Enlightenment. People were convinced that the application of reason would better the approach of previous generations. The Narrenturm was an expression of this conviction: a rationally motivated building was its key feature. In

Stereographic cards of the Hospice Guislain, c. 1860. Dr. Guislain Museum, Ghent

In about 1860, a series of stereographs were made of the newly opened
Hospice Guislain (1857). These are the oldest known images of the Guislain
asylum: they mainly show the architecture, which was well suited to the long
shutter speeds of early photography. Looking at the images in a stereoscope reveals
a three-dimensional image. The plants and trees in the courtyard are still young,
the fields freshly planted. Here and there, residents of the hospital can be seen.

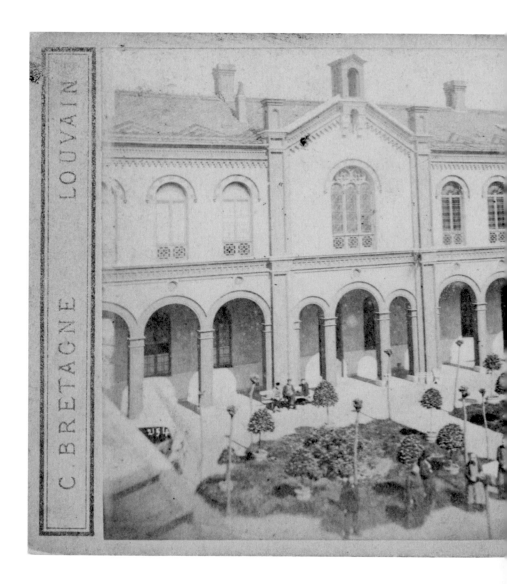

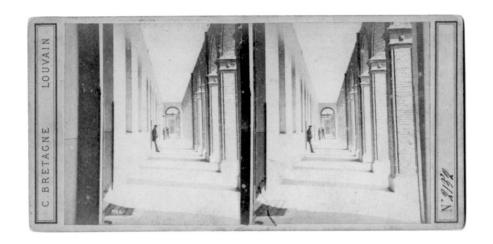

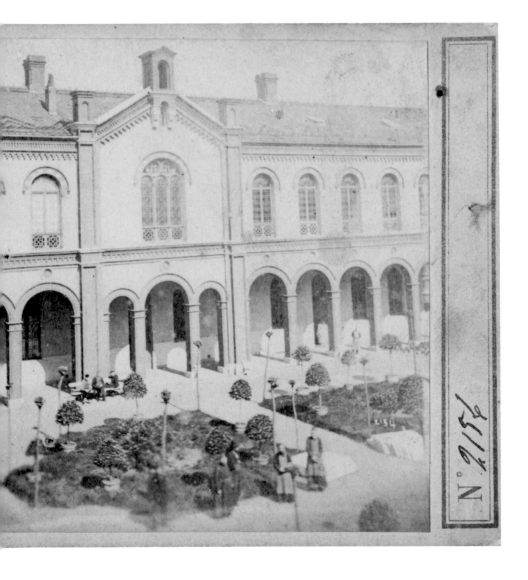

Rede en waanzin (2001), Flemish author Erwin Mortier claims: 'The Enlightenment considered society to be something that could be shaped, and the same applied to its citizens, whom it was considered possible to educate. Human beings, all human beings, could be made to see reason almost literally. (...) Modern psychiatry was the quintessential "enlightened" discipline. The former "madman", previously a creature shunned by society, gained the status of a sick person, which entailed the possibility of treatment and cure.'

TRUST IN BUILDINGS

Joseph Guislain (1797–1860) is referred to as the father of Belgian psychiatry. The honour is due to him for two reasons: besides being a passionate researcher and teacher at the newly founded university in Ghent, Guislain was also involved, at the end of his life, in the creation of the first psychiatric asylum in our country, the Hospice pour hommes aliénés, which was promptly rechristened the Hospice Guislain after his death. He made efforts like no other to improve the living conditions and quality of life of the mentally ill.

After the French Revolution, there was a tendency to house and treat the mentally ill at a distance from other people. Jean-Etienne Esquirol (1772–1840), the chief physician of Charenton in Paris, gave his asylum a strong international reputation. It was praised for its pleasant location, the reliable and progressive spirit of its leaders, and the gentle treatment it offered, also called 'moral treatment'.

This treatment inspired Guislain to create a humane organisation and a medical practice with architectural ambitions: the mentally ill were to be removed from their surroundings and had a right to separate accommodation adapted to their needs. In 1824 Guislain drew up a plan for a hospital for the insane, for which he was awarded a prize by the Société des beaux-arts in Brussels. In 1828 he was officially appointed as the chief physician at the hospital, making him the first officially recognised psychiatrist in the Southern Netherlands. He also helped draft the Law on the Treatment of the Insane, passed in 1850, which subjected the accommodation and treatment of the mentally ill to new, more scientific and humane conditions.

MODEL ASYLUM

During the Ancien Régime, the mentally ill in Ghent were locked away in the towers at the city gates or in the Sint-Jan-ten-

Dullen almshouse. In 1773 the male mental patients were transferred to the eternally damp crypt of the Castle of Gerard the Devil, and in 1828 they were moved to the Alexian monastery. In 1851 the Ghent city council and the Committee for Civil Almshouses decided, at Guislain's suggestion, to build an insane asylum according to the new insights of moral treatment. Guislain insisted on various conditions for the construction of the new asylum. The building needed to be outside the city, in tranquil surroundings. The district north of the Brugse Poort district was chosen; at the time it was still entirely rural.

In 1852 the Committee decided on the design by architect Adolphe Pauli (1820–1895), drawn in close consultation with Guislain himself. Pauli was appointed the first professor and dean of architecture at the Ghent Academy of Fine Arts. He was the city architect of Ghent from 1856 to 1867. During this period, he built various municipal schools, as well as the Bijloke hospital, the Lousberg asylum and the university library in the Ottogracht.

Construction work on the Hospice pour hommes aliénés lasted from 1853 to 1876. The first patients were admitted in 1857. The hospital soon gained the status of a model institution. Just as Guislain himself travelled internationally within his field of expertise, many specialists from abroad were interested in how things were done in Ghent.

NOT A PRISON

Inside the building, the patients were placed together in sections: they lived there in groups. Guislain used terms such as quiet, semi-quiet and disquiet or agitated. The agitated patients were housed and cared for in the semicircular end of the horseshoe-shaped building, furthest away from the street and 'public life'. Thus Guislain created strict categories, with one section per illness or level of curability. Each section contained a treatment station, a place for physical and moral 'education', workshops for handicrafts, and an isolation room. These areas were located on the ground floor. The dormitories were on the upper floor.

The complex was constructed in an eclectic style that combined neo-Romantic, neo-Gothic and neo-Renaissance elements. The iron windows and balustrades had both a decorative and functional purpose. With Guislain's therapeutic concerns in mind, the bars on the windows, required by the Committee, were transformed into an iron lattice (to prevent patients from breaking out):

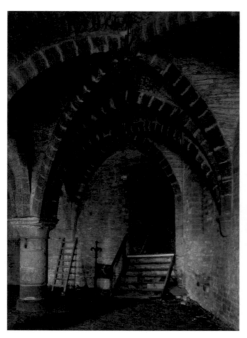

Michiel De Cleene, *GDDS#27032015*, 2015, photograph.

Until the early nineteenth century, the mentally ill were locked up in the medieval crypt of the Castle of Gerard the Devil in Ghent. The intention was to remove from society turbulent, dangerous or non-functional people — the insane, but also criminals, epileptics, addicts, the work-shy and those who had dementia. There was no question of care or therapy, and living conditions were atrocious. Ghent-based photographer Michiel De Cleene (b. 1988) was commissioned by the Dr. Guislain Museum to photograph the crypt.

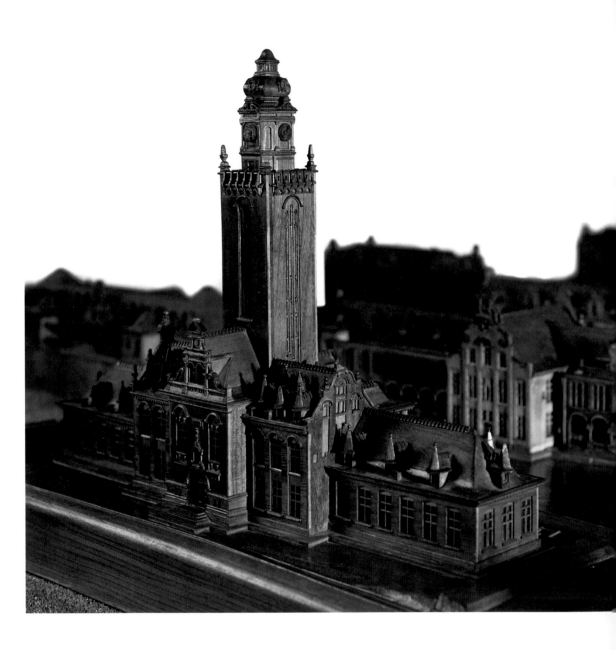

Henri Van den Eede, Model of Sint-Kamillus, 1937–1940, wood carving. UPC Sint-Kamillus, Bierbeek

In the late 1930s, Henri Van den Eede began carving a wooden model of the Sint-Kamillus psychiatric institution in Bierbeek to a scale of 1:100. Van den Eede was a patient there who was not allowed to handle sharp objects.

He carefully pared away the wood with a blunt potato knife. He checked the accuracy of his carving against the blueprints, and if no plans were available, he made his own measurements of the building. The time spent on repair work on the windows and the manufacture of wooden clogs during the war years meant he was never able to fully complete his model.

he did not want the patients to feel that they were in prison. Other aspects of the building can also be understood in terms of these therapeutic concerns, with the architect Pauli taking a subordinate position to the insights of Guislain, the doctor: the building was outside the city ('the city makes people sick'); it was surrounded by countryside, and there was space inside for beautifully landscaped gardens ('greenery induces calm and makes people healthy'). It has two storeys and an attic ('a building that is too high creates the feeling of being locked up').

The patients were looked after by the Brothers of Charity. This Catholic congregation, founded in 1807 by Canon Peter Joseph Triest (1760–1836), was already caring for the male mental patients at the Castle of Gerard the Devil in Ghent. When the new asylum opened, Guislain insisted that care of the patients be entrusted to that congregation. The collaboration between the world of science and the Christian organisation was an inspiring idea for the growth of these new psychiatric asylums.

Until 1985, the building was owned by the City of Ghent. Then ownership of the complex passed to the congregation. In 1986 René Stockman (later to be the Superior General of the Brothers of Charity) took the initiative to open the Dr. Guislain Museum.

BELIEF IN THEIR OWN ABILITIES

The success of Dr. Guislain's hospital had a great effect on the development of new asylums in Belgium. The architectural styles and ideas about organisation did evolve, but 'neo' styles were favoured for a long time to come.

Large psychiatric institutions were built, such as those in Mortsel, Beernem and Zelzate, often initiated by the Brothers of Charity. The last in line was the Sint-Kamillus psychiatric asylum in Bierbeek, built in 1932. This large complex showed the self-confidence that the contractor, the Brothers of Charity *and* psychiatry as a medical specialism all wished to express at that time. Franz Baro, the former chief psychiatrist at Sint-Kamillus, explains: 'The entire complex, not just the striking tower, was intended to manifest the religious, social and therapeutic ideals of the Brothers of Charity. Their pugnacity is reflected in the floor plan and skyline of Sint-Kamillus. The place looks like a battleship, with the church in the middle, surrounded by nursing buildings. The kitchen and farm form the stern. At the front, at the top of the hill, is the administration building with the tower like a bridge dominating the

surrounding area. All the buildings are connected by a terrace with its own garden in the *nouveau jardin pittoresque* style, enclosed by hedges.'

It is no coincidence that the tower of the administration building was a kind of replica of the university library tower in Leuven, which had just been rebuilt following its destruction during the First World War. The rebuilding of that library represented the triumph of knowledge and belief. Sint-Kamillus was all too eager to echo those sentiments. This architectural achievement was the quintessential demonstration of the founders' belief in their own abilities.

ANTI-PSYCHIATRY

The emergence of psychotropic drugs in the 1950s marked another interesting step: the search for more adequate drugs for the treatment of various forms of mental illness experienced success that spread fairly rapidly and intensely. Nevertheless, this development would be followed by a more critical current: that of anti-psychiatry. Edward Shorter points out the irony of the story: the victory wreath was ripped from the psychiatrist's head at the very moment that effective new medicines for psychosis and neurosis had created a certain amount of self-confidence. The criticism of psychiatry was precisely that it had been reduced to 'pill-popping'. There was no time for talking, for a compassionate approach. The 'organisation', 'residential care' and 'the institution' were immediately implicated in this criticism. The buildings symbolised an outdated vision and treatments. The architecture represented a 'dehumanising' approach to mental illness. Life inside the institution was under pressure: dehumanisation became a hot topic.

Changes within psychiatry itself, but also countless other factors led to the emergence of the anti-psychiatry movement. The social climate of the 1960s favoured hostility towards authority and institutions in general. Critical left-wing intellectuals took the lead. *Total Asylums. Essays on the Social Situation of Mental Patients and Other Inmates,* by Canadian sociologist Erving Goffman, appeared in 1961. He launched a frontal attack on the institutionalised manner in which Western society dealt with its criminals, elderly people and psychiatric patients. Goffman claimed that monasteries, hospitals, barracks and psychiatric institutions displayed significant similarities in terms of how they accommodated

their residents. One of the most pertinent was the process of mortification, whereby the individual was stripped of his or her identity. Often such processes were initiated in a ritual manner upon admission, and were then further developed in the daily workings of the institution. Goffman's criticism found fertile ground in various critical movements in the worlds of psychiatry, youth care, and care for people with a disability. Its echoes can be heard even now in the many criticisms of 'traditional' institutions that contribute to the debate on inclusion.

The criticism of the institution functioned as a catalyst and led to a fundamental questioning of 'institutional living and treatment'. A combination of circumstances helped this criticism to take off. Progress in the development of medicines, along with the high financial costs and the processes of dehumanisation described, lent great weight to 'de-institutionalisation'. The institution, once conceived as a 'healing machine' or *'machine à guérir'* (Foucault, 1961), was mentally written off — and later increasingly demolished in practice as well.

REJECTION OF INSTITUTIONS

Recent decades have been characterised by a growing tendency to reject the practice of long-term admission and care in an institution for psychiatric patients. Fewer, shorter admissions have become standard.

In some countries, like Italy, institutions have even been radically rejected. Severe under-financing of psychiatric institutions in Italy had led to poor living conditions. Psychiatrist Franco Basaglia (1924–1980) expressed his criticism in no uncertain terms. There was a great willingness to turn things around. The criticism of 'state psychiatry' in the United States is also famous. There too, institutions were closed. The result was far more homeless people in cities with a history of admissions to psychiatric institutions.

In the Netherlands and Belgium, where the situation was not as critical, there was also great willingness to rethink institutions. The 'psychiatric patient' was increasingly seen as 'a person with a psychic vulnerability'. This change of language represented something deeper: stigmatisation in psychiatry was becoming a hot topic. Care became normalised. People sometimes need specific psychological support in the course of their lives. In that case, it is best to provide it close to 'everyday life'. The example of Amsterdam is highly characteristic. Joost Vijselaar explains, in *Psychiatrie*

Claudio Cricca, from the series *Faceless*, 1998–2007, photographs. Dr. Guislain Museum, Ghent

In 1998 Claudio Cricca (b. 1968) began his project *Faceless*, for which he went to take photographs in five Italian penitentiary units. Although they are hospitals, the focus here is on security rather than care. For many, this is their final destination. As the faces of the inmates are made almost unrecognisable, the surroundings become all the more visible. Bars, high walls, cold corridors: *Faceless* is a condemnation of inhuman living conditions. 'It's easy to take a photo', Cricca claims, 'but taking a photo right in someone's face is difficult. As for taking a photo right in the face of someone who is suffering ... that is contrary to human nature'.

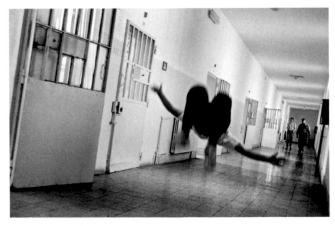

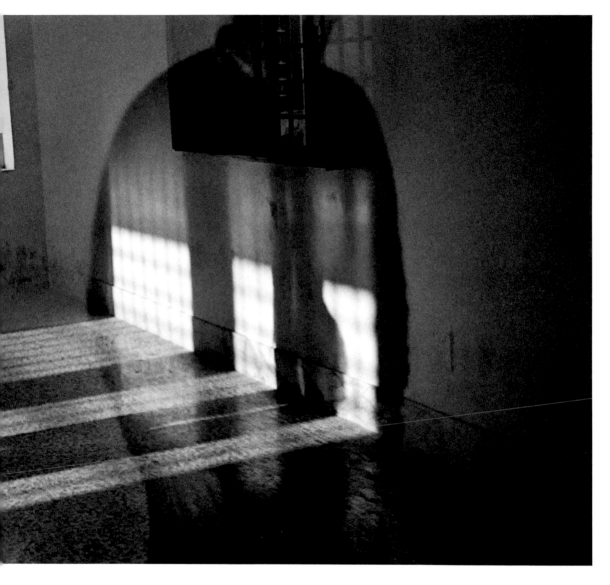

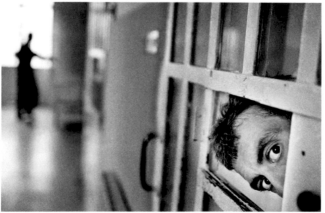

terug in de stad (2008): 'The image of psychiatric care, also in relation to living accommodation, is different to the way it was in the 1980s. Care, support and treatment are offered at more than 90 locations around the city. These are small clinics, outpatient clinics, centres for part-time treatment, sheltered accommodation, apartments and forms of supported independent living. Here living, working and treatment are kept spatially separate from each other wherever possible.'

In Flanders, 'inclusive thinking' and the 'socialisation of care' determined policy: it was best for people who need care to live in the city. That these policy aims are sometimes far from being achieved in practice demonstrates the paradox we pointed out at the beginning of this article.

ELSEWHERE THAN IN THE WEST

Worldwide, the situation regarding 'living' and 'psychiatry' is very varied. Take Japan and South Korea, for example, two countries where the Dr. Guislain Museum will present and has presented exhibitions on the history of psychiatry. Andrew Scull shows in his masterly *Madness in Civilization. A Cultural History of Insanity* (2015) that Japan had a very low level of hospitalisation before 1945. It was only after the Second World War (and a century later than in Belgium) that the 'psychiatric institution' was introduced. This happened under the influence of the West, and more specifically America. The level of hospitalisation and the average duration of a stay in a psychiatric centre rose spectacularly (in 1989, an average stay lasted 496 days).

Policymakers in Japan are aware that this trend needs to be reversed because it is far too expensive. The government has been advocating this since 2011, but progress is slow. The reason is probably the great impact of the stigma of psychiatric illness. In Japanese culture, conforming to the social order is more important than the individual rights of a (sick) person. Confinement and living in an institution are justified because the illness would otherwise reflect upon the entire family as a serious 'defect', thus reducing their position in society (for example, in terms of relationships and marriage). In short, mental illness is a source of shame and embarrassment. Nonetheless, says Scull, the reduction of admissions to institutions has now begun.

Practice is completely different in countries where psychiatric care is virtually non-existent. In African countries, René Stockman

reports, the situation is absolutely disastrous: 'People simply survive on the streets, naked and helpless, chased away by their own families and shunned and ignored by society.' The construction of an institution in Yamoussoukro, Côte d'Ivoire, in 2002 marked a beginning: it was striking that the architect, Patrick Lefebure, needed to convince local authorities of the need for a building that fitted into African architectural culture. According to Laurens De Keyzer, they initially wanted an archetypal, imposing neo-Gothic institution that looked Western.

FIVE-STAR HOTEL

In the foreword to this book, Andrew Scull refers to the new purpose of the former San Clemente institution buildings in Venice, which have been restored and 'upgraded' to create a five-star hotel. The promotional brochure does not mention the history of the place. A similarly luxurious future probably awaits the psychiatric institutions in the village of Den Dolder, just outside Utrecht: psychiatric care will no longer be offered there and the facilities will be replaced by homes in a beautiful woodland setting. Project developers have little trouble attracting buyers with a large budget. This is the high-end segment of the housing market.

The alternative is sometimes discouraging. In his outstanding series of photographs *Asylum. Inside the Closed World of State Mental Hospitals* (2009), American photographer Christopher Payne showed the decline of this impressive architectural heritage. These behemoths have either been converted into luxury homes or simply demolished. The question of how to deal with the 'psychiatric architectural heritage' in our own country is becoming increasingly urgent. Here, likewise, existing institutions or parts of them have been demolished, and new ones are being developed for residential or other purposes. The new architecture often sticks close to old ideas about the 'asylum': Flemish philosopher and architect Gideon Boie speaks of the 'ward' as their typology.

What is striking is that there is no specific awareness or policy about how to treat the heritage buildings. Whether or not a well-considered decision is taken, old buildings are demolished and replaced by new 'wards'. The repurposing of the majority of the buildings that house the Dr. Guislain Museum as a museum is a high-profile exception to the rule. The museum sees it as its task to treat the heritage buildings with great care.

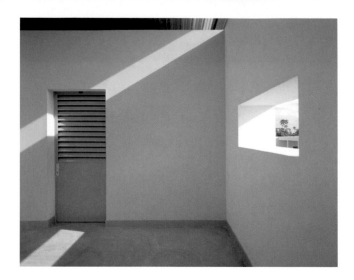

Archipl Architecten, *St Vincent de Paul, Centre d'accueil et des soins des malades mentaux* (St Vincent de Paul, Centre for the accommodation and care of the mentally ill), Yamoussoukro, Côte d'Ivoire, 2000–2004, photographs. © Reinhart Cosaert

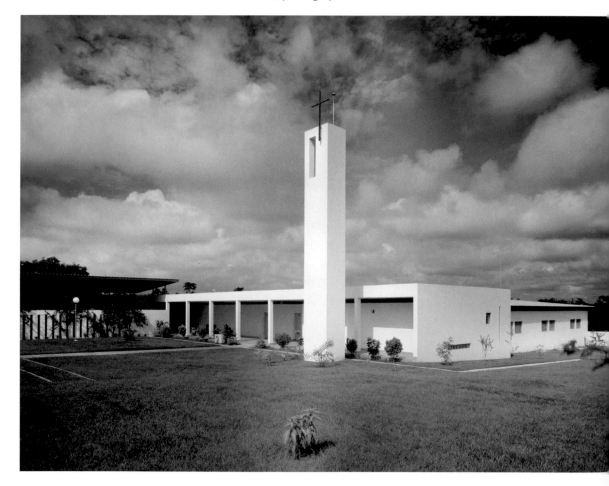

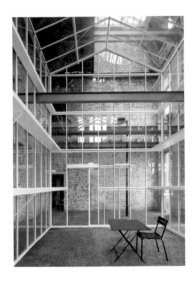
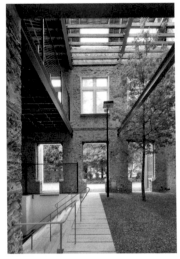
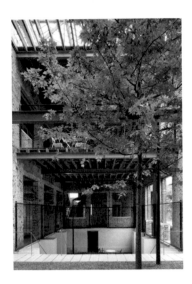

architecten de vylder vinck taillieu, Redesign of the Sint-Jozef building at Karus (Caritas) as an experimental space, Melle, 2016, photographs. © 2019 – Filip Dujardin / SOFAM – Belgium

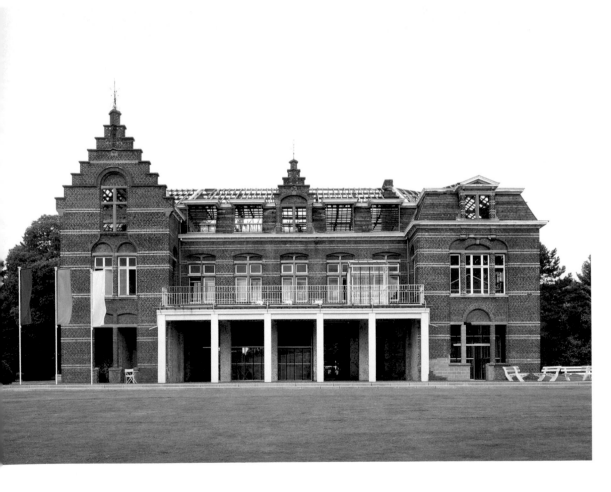

RUIN AS THERAPY

It is clear that the psychiatric asylum is crumbling, ideologically and literally. The new architecture of the former Sint-Jozef building at the heart of the Caritas psychiatric centre in Melle (now called Karus) is remarkable. This building was cleared for demolition, but the realisation grew that an intelligent ruin could be created with the budget provided for demolition: a public space on two levels. The architects De Vylder, Vinck and Taillieu had plaster stripped from the walls, roof tiles removed and floors taken up to create a 'utopian ruin' or 'oasis' (De Cauter, De Caigny, 2018). It has become a very special place, where the rationality of yesteryear is punctuated by deterioration and chance, where 'inside' and 'outside' are called into question, where imagination and daring stimulate encounters, and where people can take time for themselves. The architects planted a tree in the middle of the building.

It is nothing short of encouraging that this architecture has been embraced by psychiatrists and architects, and has also met with international appreciation. It is clear that the building work entails a search for how to treat the building and how to occupy it. Or how, in the future, living and psychiatric vulnerability will be grafted onto a half-derelict but beautifully revived psychiatric ruin: a challenging metaphor.

BIBLIOGRAPHY

Allegaert, Patrick, Cailliau, Annemie, a.o. *Rede en waanzin. Het Museum Dr. Guislain in beeld en tekst*. Ghent: Museum Dr. Guislain, 2001

Buyle, Marjan & Dehaeck, Sigrid (ed.). *Architectuur van Belgische hospitalen*. Brussels: Ministerie Vlaamse gemeenschap – Monumenten en landschappen, 2005

De Caigny, Sofie. 'An Oasis', in: architecten de vylder vinck taillieu. *Unless Ever People*. Antwerp: Flanders Architecture Institute, 2018, pp. 174-179

De Cauter, Lieven. 'Eulogy for a Utopian Ruin', in: architecten de vylder vinck taillieu. *Unless Ever People*. Antwerp: Flanders Architecture Institute, 2018, pp. 162-169

De Keyzer, Laurens. *De geschikte plek*. Tielt: Lannoo, 2008

Foucault, Michel. *Folie et déraison. Histoire de la psychiatrie à l'âge classique*. Paris: Plon, 1961

Goffman, Erving. 'Totale instituties', in: Masschelein, Jan (ed.). *Dat is pedagogiek. Actuele kwesties en sleutelteksten uit de westerse pedagogische traditie van de 20ste eeuw*. Leuven: Leuven Universitaire Pers, 2019

Scull, Andrew. *Madness in Civilization. A Cultural History of Insanity*. Princeton: Princeton University Press, 2015

Shorter, Edward. *Een geschiedenis van de psychiatrie. Van gesticht tot Prozac*. Amsterdam: Ambo, 1998

Vijselaar, Joost. 'Inleiding', in: Duurkoop, Pim. *Psychiatrie terug in de stad*. Haarlem: Het Dolhuys, 2008

Postcard of a youth institution, twentieth century. Dr. Guislain Museum, Ghent

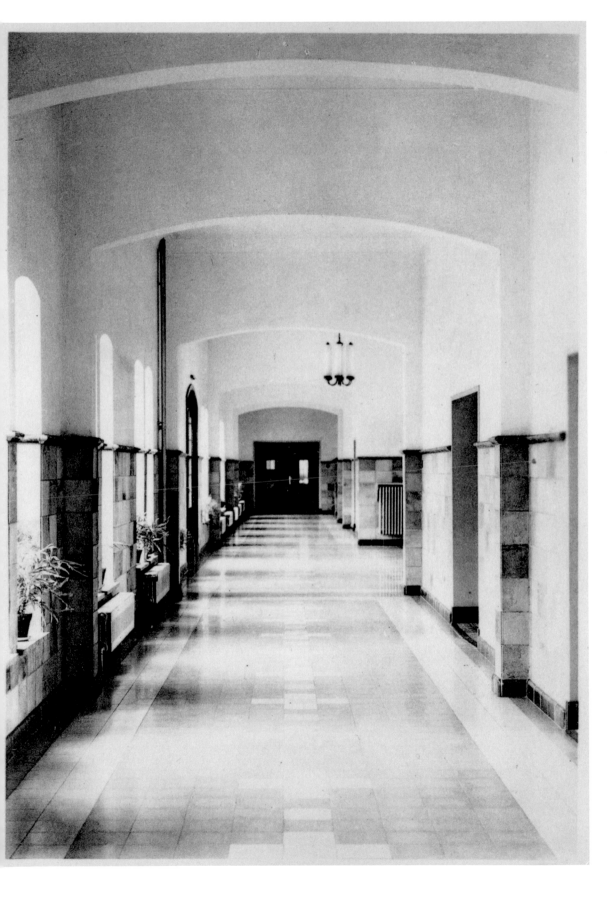

Postcards of youth institutions, twentieth century. Dr. Guislain Museum, Ghent

From the beginning of the twentieth century, series of postcards were made of youth institutions such as orphanages, sanatoriums, preventoriums, national reform schools and holiday camps. This was a limited way for children to keep in touch with their families. The postcards show indoor or outdoor views of the building. It is striking how uniform the images are: architectural features are promoted in the form of clean, functional bathrooms, kitchens, dining rooms and dormitories. Identical imagery can be found in postcards of psychiatric institutions from the same period. They show how people thought in terms of buildings and demonstrate the strong belief in the healing powers of the institution. The emphasis on care and the education or reform of children is highly visible: the focus is on discipline, regularity, hygiene and fresh open air. The children often wore identical uniforms. There was a strict regime and daily schedule. Concern for groups of children at risk — those in delicate health, 'young delinquents' or orphans — was great. Children who deviated from the norm were labelled and corrected. The government intervened and placed young people whose upbringing was problematic or when the children were causing problems themselves. Efforts by parents, social workers, doctors and educators were always made 'in the interests of the child'. But what exactly did that mean? And what were those interests? For many children in institutions, their stay had an impact on the rest of their lives. For a long time, the institution appeared to be the pedagogical solution for providing an upbringing in a protected environment.

In the 1960s and 1970s, this belief was dismantled and there was growing criticism of how institutions such as children's homes and schools worked, as well as prisons and psychiatric hospitals. The idea that a person could be shaped by discipline was questioned by a broad countercultural movement. Growing protest was directed against 'institutional violence' and other forms of abuse. The inadequate material circumstances in which youth care was expected to work were exposed and these actions led to a turnaround in the welfare landscape.

Postcard of a youth institution, twentieth century.
Dr. Guislain Museum, Ghent

Postcards of youth institutions, twentieth century. Dr. Guislain Museum, Ghent

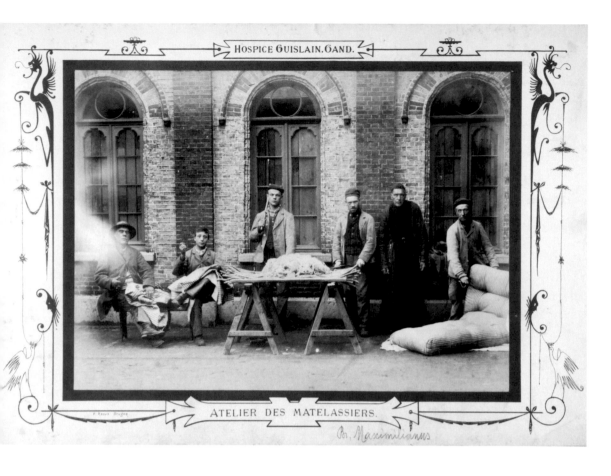

HOSPICE GUISLAIN. GAND.

ATELIER DES MATELASSIERS.

Mattress workshop and cobbler's workshop (next page), Hospice Guislain, 1887, photographs. Dr. Guislain Museum, Ghent

This series of photographs of life in Dr. Guislain's asylum in 1887 was intended to illustrate the exemplary care of the insane in Ghent. At the same time, the photographs depict the architecture of the Hospice Guislain. Like other psychiatric hospitals of the time, the institution looked more like a collection of landscaped parks. The location, deliberately chosen in what was countryside at the time, along with the curved gallery, decorative balconies and highly wrought balustrades, were all intended to serve the same therapeutic purpose: to create an atmosphere of calm, freedom and safety. Disruptive patients were placed at the back of the building, furthest from the inhabited world: the 'gentle' patients were housed close to the gate and freedom.

The group portraits of the cotton workers and mattress makers do depict patients, but they are not a portrayal of disorders and symptoms. They are formal, staged portraits, surrounded by decorative frames and text that emphasises the importance of occupational therapy at the Hospice Guislain. Calming, simple and repetitive crafts were supposed to help the patients recover their mental balance. There were other advantages to working patients. Although some of the mentally ill paid for their stay, admissions cost the government a lot of money. The doctors refused to let the economic aspect dominate, but occupational therapy certainly contributed to the hospital's financial health.

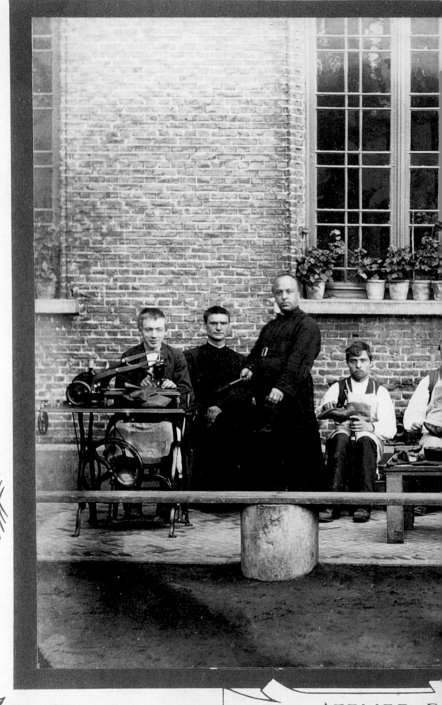

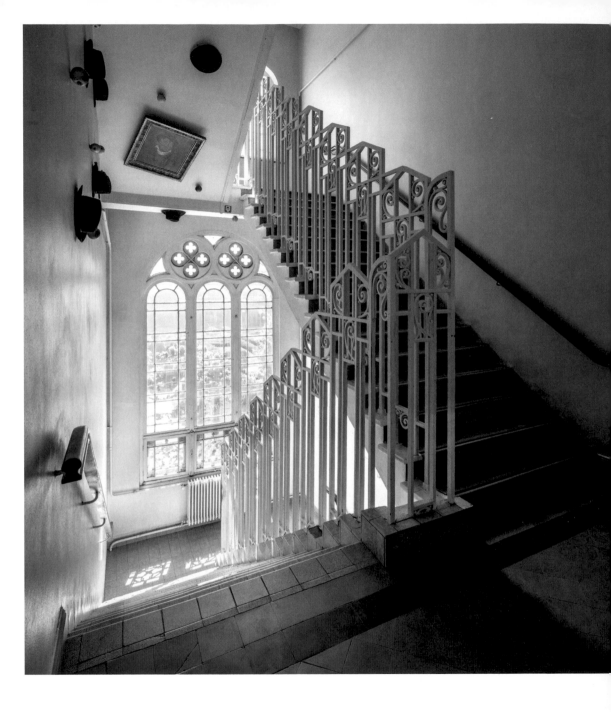

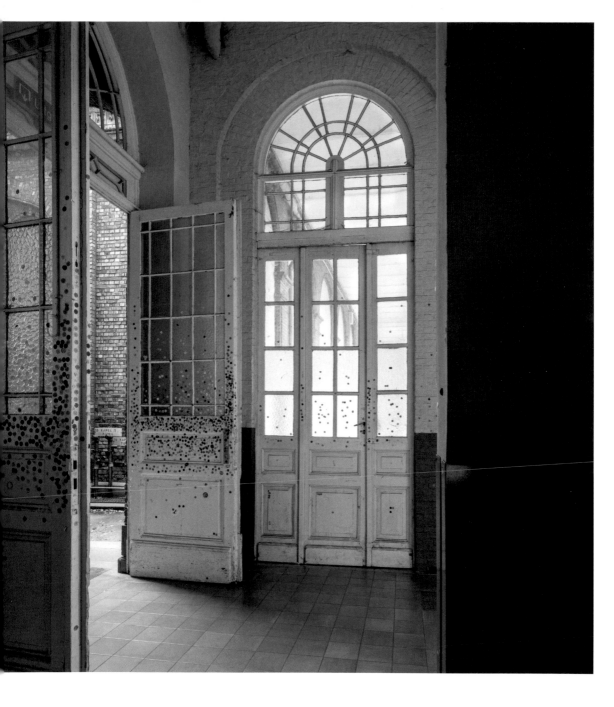

Karin Borghouts, from the series *Museum Dr. Guislain*, 2019, photographs.

Dr. Guislain Museum, Ghent. © 2019 – Karin Borghouts / SOFAM – Belgium

Peter Granser, *Gruppe auf einen Hügel 01* and *04*, from the series
J'ai perdu ma tête (I've lost my head), 2009, photographs.

From the start, psychiatric institutions had struggled with the
'prognosis' of diseases. In the nineteenth century, patients who
had been admitted in adolescence often stayed within the walls
of the institution for many years. After the Second World War,
populations increased dramatically around the world. Overcrowded
dormitories and units were par for the course until anti-psychiatry
made the problem of the chronic patient one of its most important
battlegrounds. That led to many initiatives on the periphery of
the institutions. Anti-psychiatry solved the problem of chronic
patients in many wards through 'phasing out'.
The twenty-first century heralded the socialisation of care: care
in the community. Patients became residents or clients, and
long-term admissions were avoided as much as possible.

In the series *J'ai perdu ma tête*, photographer Peter Granser (b. 1971)
slips almost invisibly into the secure unit of the Centre Hospitalier
Spécialisé de Navarre in Évreux. With a gentle hand and human respect,
he reveals the inner world of an institution that remains closed to
outsiders. Thanks to his characteristic use of colour, the psychiatric
centre is not left shrouded in shadows. The often oppressive archi-
tecture is nowhere to be seen; it is only in subtle details that the
institution is present as a daily environment for the residents of a
secure unit. In this way, Granser manages to portray the socialisation
of care in a subjective and respectful manner.

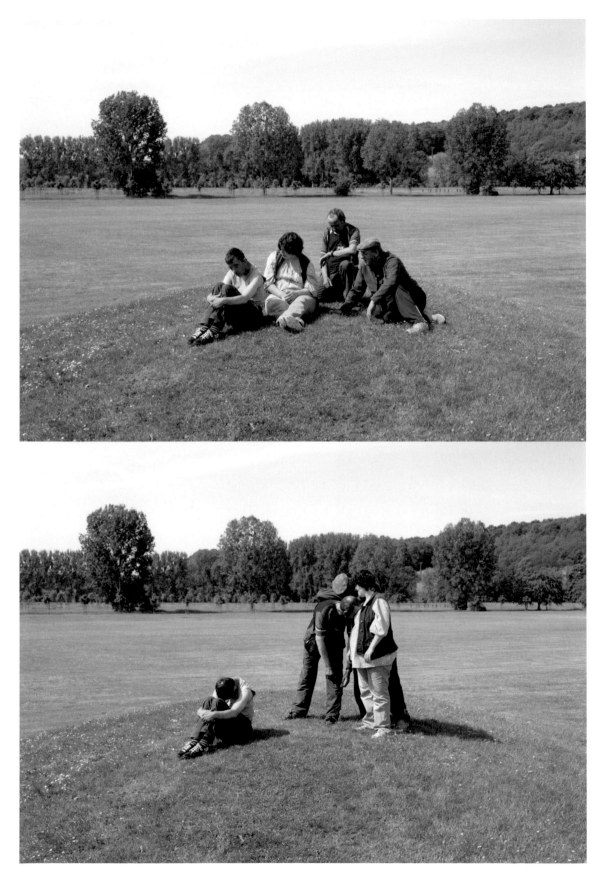

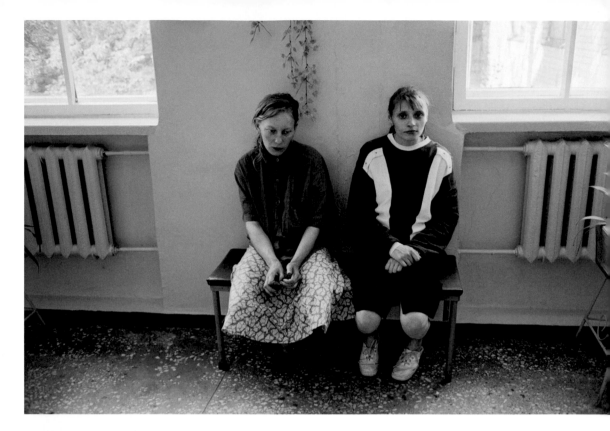

Viviane Joakim, *Les deux amies,
La gamelle, Le fil, Le turban rouge,
La femme enfant,* from the series
Dousha Balit, 2004–2005, photographs.
© Viviane Joakim. Artist's collection.
Dr. Guislain Museum, Ghent

For three successive summers, Belgian
photographer Viviane Joakim visited a
dilapidated psychiatric hospital in Smila,
Ukraine. The subject of the series is not
so much the appalling living conditions
she encountered there; the images are
not simply a condemnation. Joakim uses
her photography to try and restore the
residents' identity. The title *Dousha Balit
— The Soul Suffers,* after a melancholic
Eastern European song — does not make
any explicit reference to psychiatry.
Joakim shows the women in bright colours,
in all their dignity and beauty.

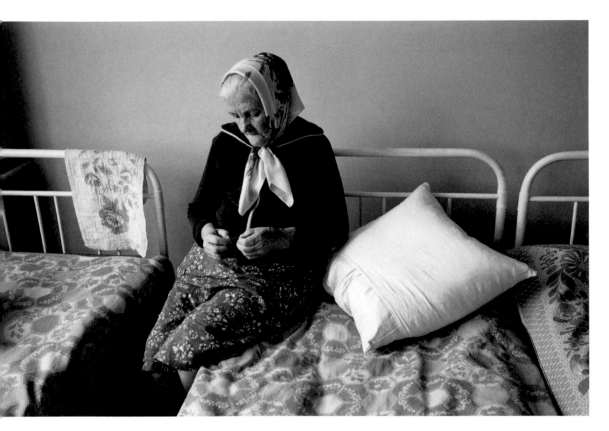

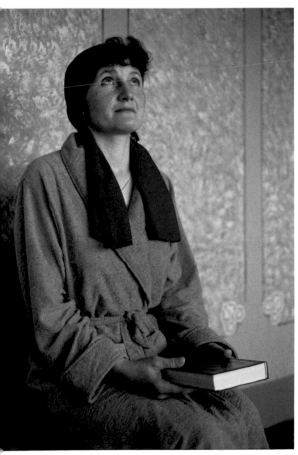

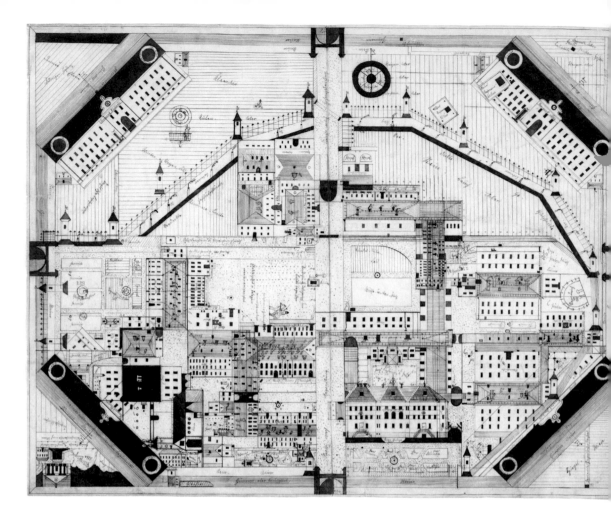

Franz Joseph Kleber, untitled (layout of the institution in Regensburg, Karthaus-Prüll), 1906–1909, inv. no. 4506. © Prinzhorn Collection, University Hospital Heidelberg

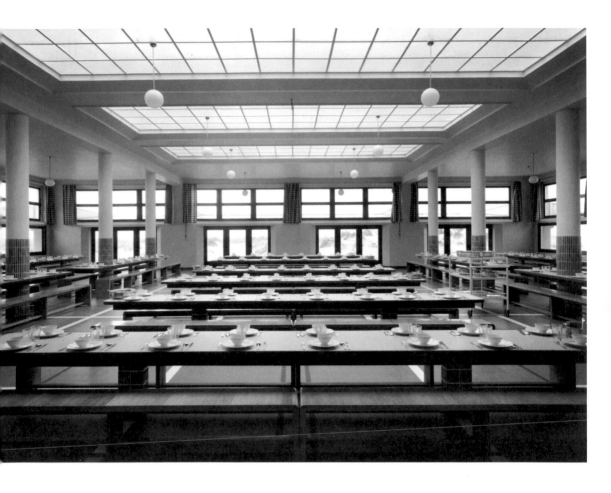

George Theunis Home holiday camp, Oostduinkerke, 1935–1987, photographs.
Kind & Gezin, Brussels

After the First World War, the *Nationaal Werk voor Kinderwelzijn* (NWK) began
setting up holiday camps for 'weak children' at the Belgian coast. The aim
was to fortify 'nervous and pale' children with fresh sea air, good hygiene
and varied meals rich in calories. Designed by the Brussels-based architect
Maurice Haeck, the Georges Theunis Home camp in Oostduinkerke
(1935–1987) was a model institution that featured every architectural
and educational innovation. Some children only stayed there in summer,
while others lived there for longer periods.

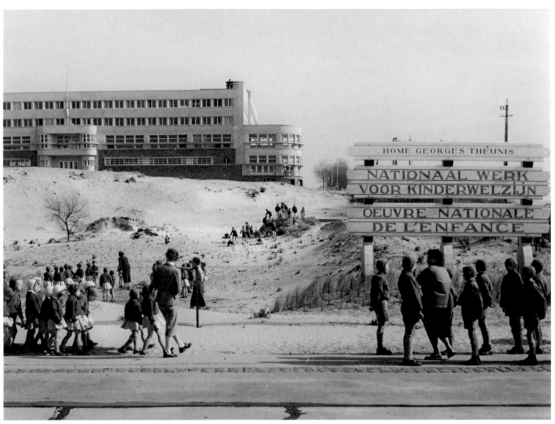

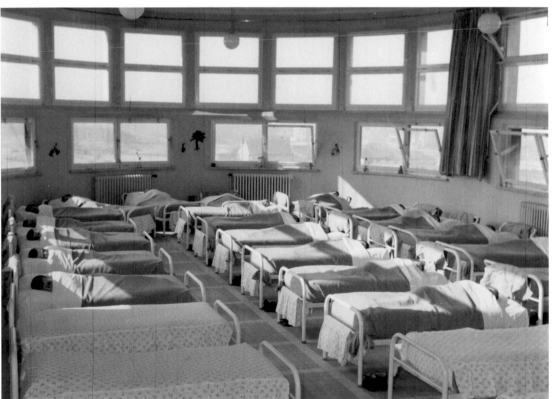

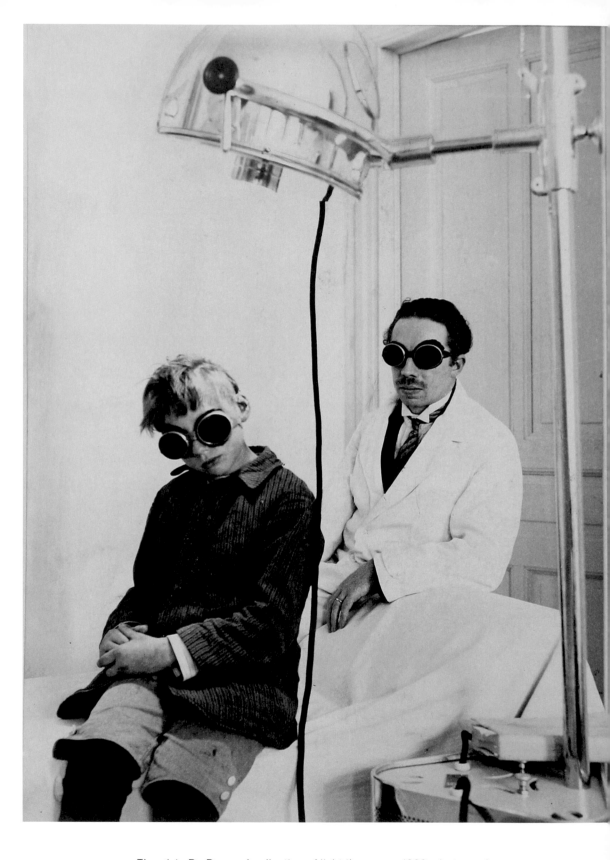

Ebergiste De Deyne, Application of light therapy, c. 1930, photograph. Dr. Guislain Museum, Ghent

BODY
AND
MIND

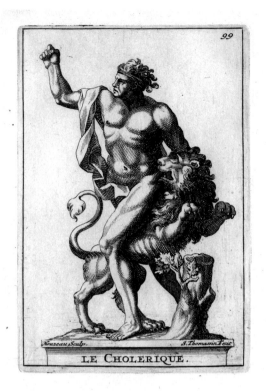

LE CHOLERIQUE.

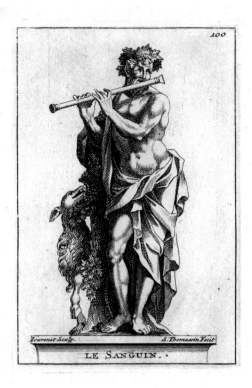

LE SANGUIN.

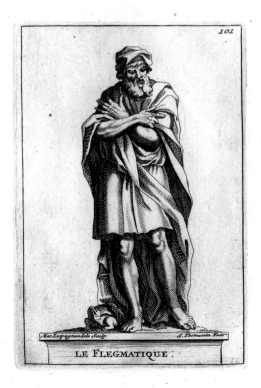

LE FLEGMATIQUE.

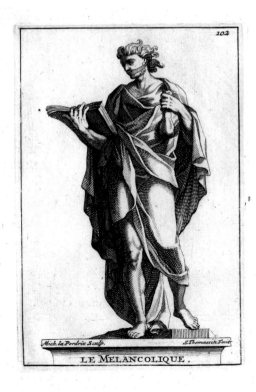

LE MELANCOLIQUE.

Simon Thomassin, *Le Cholerique, Le Sanguin, Le Flegmatique, Le Melancolique,*
1695, engravings. Dr. Guislain Museum, Ghent

Bart Marius

Bart Marius

The Love-Hate Relationship
of Mind and Body

HUMOURS, MAGNETISM AND PERCEPTRONIUM

Madness has fascinated people for centuries, but a theory has yet to be found that can explain it entirely. Where is madness located? What causes it? How can we deal with it? There have been various approaches to understanding psychological disorders through the course of time, and there has always been some kind of substance, channel or organ involved, be it blood, bile and phlegm, or *spiritus*, nerves, electrical charges, hormones and neurotransmitters, which in turn spread through the body along channels, tubes and networks, and it all flows back and forth between the stomach, the bowels, the heart, the sexual organs and the brain. And then there is the soul, the mind, the ego, id, superego, consciousness and the subconscious. But madness has to be located somewhere, surely?

In the course of history we have evolved from the extremely holistic view of Hippocratic medicine to psychiatry and psychology, which have separated themselves from neurology and philosophy, only to return to a holistic view via neuroscience and pharmaceutical knowledge. Where does madness begin and end then?

Let's begin with what seems like a beginning. We all have a body and we all have a mind. Or not entirely. When a newsreader reports that 'the body of [the victim] has been found', a certain distinction is conspicuous. It seems like the body and the victim are two separate things: the victim possesses a body. If we browse the literature, however, it quickly becomes apparent that such a distinction was not always self-evident. The two have a lot more in common than a relationship based on ownership. We do not have enough space here to explain the mind-body problem in its entirety or to list all the different approaches to the subject, however, so just a few prominent figures in the history of psychiatry will be addressed and their thinking about it placed in context.

GALEN AND THE FOUR HUMOURS

In order to address the problem, we have to start by forgetting how we intuitively think of ourselves today. Nowadays, a physical problem is quickly detected and we immediately go and consult a doctor. We distinguish between how our body feels and how our mind deals with it. Originally, however, people thought very differently about the physical body and there was no concept of the mind-body duality. The cosmos consisted of four elements: earth, air, water and fire. There were also four seasons. So the human body had to exist in the same harmony. There were supposed to be four elements, whether we could find them or not. These bodily fluids could also be ascribed four characteristics: wet, dry, warm and cold. To conclude, it seemed that we also had four temperaments or characters.

A short and concise overview of humourism is impossible, however. The oeuvre of Galen of Pergamon (131–211) is large, but what we have today is only fragmentary, unfortunately. The main features stand out, however, and his enormous respect for the teachings of Hippocrates can be seen everywhere. The cause of disease is an imbalance in bodily fluids. This can be caused by behaviour, like the excessive consumption of alcohol, or by external factors, like the weather. It comes down to making the correct diagnosis based on a simple examination, like placing a hand on a forehead if there is a fever. The doctor establishes the distinguishing features: cold or warm and dry or wet. The combination determines which bodily fluid is concerned and where a cure can be found. A distinction between body and mind is not made.

Humourism is largely based on metaphors. Bile, blood and phlegm were recognisable — they could be deduced from bodily secretions — but the distinction between black and yellow bile was an invention of the medical establishment. We now know that there isn't any black bile in the body. It is a theoretical metaphor that proved its usefulness through the centuries, but which ultimately proved to be too simple. Gradually, psychological causes were sought, which weren't just physical. Activities involving a surplus or a deficiency meant that certain characteristics of the humours became excessive. The blood would begin to boil, for example, with a visible effect on behaviour. Galen devised a complicated interplay of humours, brain ventricles and souls to demonstrate how, in his view, illness was caused. Physiological causes played a principal role. Something happened in the body so that the

humours in the blood mixed with *pneumata* or *spiritus*. These moved from the liver via the blood to the heart, where they changed into the vital *spiriti*, which were then sent to the brain ventricles. The ventricles were the seat of human characteristics such as judgement and rationality, but also of perception and memory, which is how the vital *spiriti* had an effect on people. It is also where the problem lay with madness. The higher mental functions — rationality and judgement — were affected but the lower functions — such as perception, imagination and memory — continued to function normally.

The passions also played an important role. They cannot be directly compared with what we now call emotions. There was a clear biological component, because passions were considered actions of the body. Moderation was impossible for people who were mad, which only made the problem worse. A good life meant not just finding the right balance between the humours, but also keeping the passions under control — ideally, eliminating them altogether.

Illustration from: Hippocrates, *Magni Hippocratis medicorum omnium facile principis, opera omnia quae extant*, 1657, Geneva. Dr. Guislain Museum, Ghent

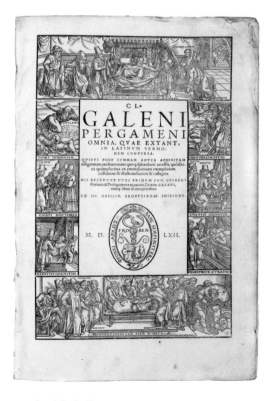

Title page of: Cl. Galeni Pergameni, *Omnia, quae extant, in Latinum sermonem conversa*, 1562, Venice. Dr. Guislain Museum, Ghent

Western medical history for a large part concerned itself with problems of the soul. If God created man, then there must be an inseparable soul that cannot be damaged. Mad, criminal or feeble-minded, the dead are all equal and the human soul returns unsullied to some heaven. Mad on Earth was not necessarily mad in the hereafter. The soul had nothing to do with earthly diseases. Furthermore, such a divine creation could not be damaged by human hand. It was not until the nineteenth century therefore that the mind of a patient became important in describing clinical cases. A way of approaching the mental domain was sought without really entering it. It could not, and even must not, be done.

That was different for the biological part. A large territory of knowledge was tapped because dissections on the condemned were permitted in Alexandria (even while they were still alive). Religion did not permit this for very long, but it had huge consequences for the further development of medical science. Greek and Roman doctors acquired all their knowledge about the inside of the human body from what was discovered in Alexandria. A lot of knowledge was also gained in Egypt when the pharaohs were embalmed. The human body later acquired a religious status, however, and dissection was forbidden. Medical science became purely theoretical with some stubborn consequences.

Until the seventeenth century, people thought that nerves were hollow and contained *pneuma*. This breath, air or *spiritus* allowed the vital organs to work. The *pneuma* was just like the humours, a link between the visible and the invisible. It also fed complicated theories about consciousness. Between the humours and the *pneuma*, however, the two worlds were connected at a theoretical level.

When Galen died, so did the development of Western medicine. After the rise of Christianity, the Bible became the only reference point and Galen's ideas were all that doctors needed. For a long time there was only a written transmission, which determined the importance of a theory. Classical texts were copied on a small scale in monasteries and abbeys, but that did not include elaborating on earlier theories.

The situation was entirely different in the Arab world, however. Doctors such as al-Razi (Rhazes) and Ibn Sina (Avicenna) took Galen's oeuvre, immersed themselves in the philosophy, and gained more insight based on experience. Case histories were also

added for the first time. However, it is only in the twelfth century that Avicenna's work finally reached the West.

THE RESTORATION OF MAGIC

In the eighteenth century, bodily fluids gradually made way for the nerves. And just as the humours had been useful metaphors earlier, so were the nerves now. Scientific explanation and method should have gained the upper hand in respect of 'magical' thinking, but it was still interwoven with the strangest pseudoscientific twists. This is perhaps not so surprising given that the masses were fascinated by all sorts of amazing explanations for such scientific discoveries as electricity, magnetism and gravity.

In the 1770s one of the biggest stars in Europe was Franz Anton Mesmer. After gaining his doctorate in medical astrology, he applied himself to what he called animal magnetism: an invisible fluid that connects us with the planets, on the one hand, and with other people, on the other hand. In the tradition of doctors who had to promote their successful treatments like marketers, Mesmer also needed continual success stories. His method was far from being based on the new scientific approach, however, and was therefore impossible to prove. He would never cut open a body, never have anything to do with anatomy and never prescribe treatments such as purging or bloodletting. Mesmer explained, with his previously acquired 'expertise' in astrology, that the body was connected to the universe via a magnetic field. He could help ailing people restore that connection with magnets and metal. Explanation was impossible. It was the restoration of magic in a rationalised world.

At the same time, another strange pseudoscience arose and became all the rage: the phrenology of Franz Joseph Gall and his pupil Johann Spurzheim. Since Galen, the brain ventricles had played a role as the location of human characteristics such as imagination, memory and common sense. In a way, phrenology was an attempt to translate those insights into the then current scientific theory. The ventricles had lost their value as an explanation for localisation and all the attention was on the cerebral cortex. The phrenologists went a step further. The connection between brain and skull was already implicit in the belief that the bumps on the skull match those on the brain. The localisation of mental capacities in the brain was an incontrovertible assumption. There are still remnants of this theory today, which continues in contemporary

Illustrations from: Friedrich Anton Mesmer, *Mesmerismus, oder, System der Wechselwirkungen: Theorie und Anwendung des thierischen Magnetismus als die allgemeine Heilkunde zur Erhaltung des Menschen*, 1814, Berlin. Dr. Guislain Museum, Ghent

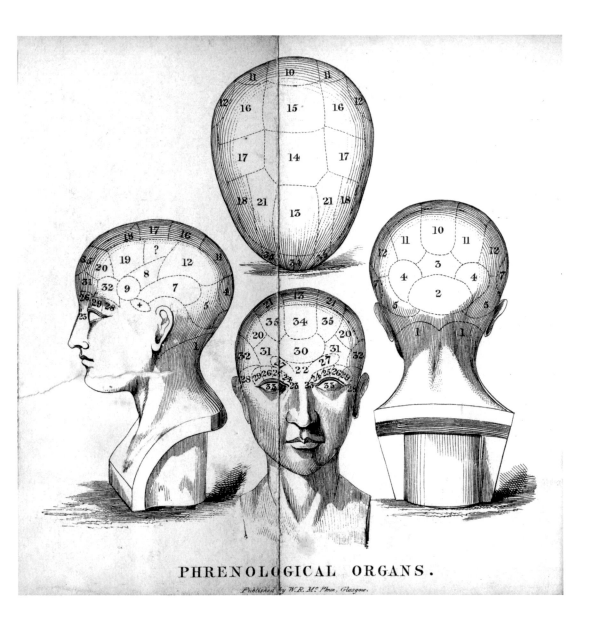

Phrenological organs, from: *M'Phun's Catechism of Phrenology*, 1852, Glasgow.
Dr. Guislain Museum, Ghent

According to Viennese doctor Franz Joseph Gall (1758–1828), the inner person could be read from the 'bumps' on their head. Gall made a chart of the brain localising these bumps in order to ascertain a person's characteristics. A strongly developed trait was thought to be expressed as a bulge in the skull, whereas less developed traits could not be felt. Gall considered the skulls of geniuses and the mentally ill interesting study material because he thought that they presented the most pronounced characteristics. Phrenology became highly influential in the Western world and employers even used phrenologists to vet candidates for jobs.

neurology. Despite the fact that phrenology is a pseudoscience, the popular and accessible translation of the much older physiognomy has left its mark. The names Paul Broca and Carl Wernicke are still connected to two areas of the brain that are linked to speech and language understanding, respectively.

THE START OF PSYCHIATRY

Before he was appointed chief physician of the Hôpital de la Salpêtrière in 1795, Philippe Pinel believed in mesmerism and animal magnetism, and he was also no stranger to phrenology. It was only later that his personal mission changed. Whereas some of Pinel's earliest articles described case histories in terms of temperaments and humours, his interest would slowly shift to the English 'moral treatment', and he applied himself to the passions. In contrast to his earlier physiological approach, he began to approach madness in moral terms.

Pinel's translation of William Cullen's work was of great importance to the development of his own theories. Cullen was a doctor from Edinburgh who undertook the first serious attempt to classify syndromes. He is still known today for his categorisation of neurosis, a group of complaints that can be distinguished from what was known as 'delirium'. Cullen placed all sorts of illnesses in the group which we would not want to lump together today (such as tetanus, epilepsy, apoplexy, diabetes and hysteria). Delirium was, for Cullen, a 'false judgement (…) commonly producing disproportionate emotions'. Madness was a sort of delirium, an 'impairment of the mind', which, given the connection between mind and body, must be traceable to a 'state of the bodily part'. We see a return to old ideas. Even with Cullen there is something intangible in the mind-body problem. He talked of 'nervous power', a very fine, subtle and active fluid that was present in people 'in a way that we do not clearly understand'.

A lack of clarity remains, and it seems that scientists dare not make statements about what has been known for centuries as spiritual, religious or even divine: the soul or the mind. But what is the difference between the soul and the mind? Was there a difference? And can that 'discovered' mind also be responsible for what Pinel attempted with his moral treatment? These questions remain as yet unanswered. People did not give up their centuries-old proclivity for spirituality just like that, but looked for a new soul and spiritual nature in, for example, romanticism.

GUISLAIN AS DIPLOMAT

The early days of institutional psychiatry were saturated with humourism. The treatments advised by doctors remained very traditional: 'The brain was always affected, sometimes by an infection or by the pressure of blood, so bloodletting, cold compresses and causing blisters were always necessary. Hot baths were recommended for nerves and an eye had to be kept on various organs such as the stomach, the bowels and, don't forget, the sexual organs' (van den Bosch, 2018). The great about-turn came with the moral treatment. As well as physical causes, the mental aspect began to gain ground and in this historical period, nationality began to play a great role. English classical physiognomic psychiatry was not based on the same characteristics as the French, where observation and descriptions in fine detail occurred. German psychiatry was also completely different, with so-called *'Somatiker'* and *'Psychiker'* directly opposing each other. Those two approaches to psychiatry would only unite in a sense in the idea of the unitary psychosis. Because it had not been possible to get a grip on every manifestation of psychiatric syndromes, the idea arose that although there were various symptoms, it was still one illness.

This is where Joseph Guislain enters the story. If we consider psychiatry from the perspective of nationalities as stated above, we recognise a typically Belgian compromise in Guislain's approach. Guislain probably does not need much introduction in a book like this for a museum like ours, but he is more than the architect of a building, the name of a museum or a historical figure who became famous as the Belgian Pinel. Guislain's life and work developed in various ways. First of all, there is, of course, the building; secondly, his importance in the introduction of legislation; and thirdly, his role as a thinker and academic. The latter is often neglected because of theoretical difficulties, but the fact that he introduced the moral treatment is not unimportant. Guislain was a master in combining theory and practice. Together with Canon Peter Joseph Triest, he drew up internal rules, a tool in the application of the moral treatment that should not be underestimated.

Triest had great faith in the chief physician. The rules left nothing to chance: the doctor was of prime importance in the recovery of the patient, and the success or failure of the moral treatment depended on his authority. In order to make the approach possible, Guislain developed an ingenious theory that combined the most important European psychiatric schools: the

Pl. II. V 2.

A. *Roue munie d'une détente.*
B. *Corde.*
c. *Roulette.*
d. *Moufle.*
E. *Cage de fer.*
f. *Poulie.*
g. *Niveau de l'eau.*
h. *Lit du bassin.*
i. *Barre de fer.*

Surprise bath as shock therapy, engraving from: Joseph Guislain, *Traité sur l'aliénation mentale et sur les hospices des aliénés*, 1876, Amsterdam. Dr. Guislain Museum, Ghent

According to Joseph Guislain (1797–1860), causing sudden anxiety could have a positive therapeutic effect. Shock therapies usually in-volved water: cold showers, a 'shower bath' or a 'surprise bath'. 'The device consists of a small Chinese temple', wrote Guislain, 'in which the interior contains a moveable iron cage whose own weight causes it to sink in water. One leads the mad person into this house: a helper closes the door on the outside while another operates a lever so that the sick person is immersed in the water. Once the treatment has been carried out, the contraption is lifted up again.'

French clinical approach of Pinel and Esquirol, with the radical organisational approach of the German 'Somatiker'.

'Wise is the doctor who knows the passions.' It was with this maxim that Guislain embraced Pinel and Esquirol's approach. Moral causes were more important than physical ones, and, of the moral causes, the passions were the most important. In a subtle way, Guislain connected the moral issue with the organisational approach of phrenology. In contrast to Gall's theory, mental illness, according to the psychiatrist from Ghent, could not necessarily be blamed on an injury to the brain, but could just as well be caused by moral problems. The brain was the seat of mental illness, but not necessarily the cause. Guislain did not deny Gall's biological view, but allowed space for the moral causes which were currently dominant in French psychiatry.

According to Guislain, a strong stimulus could lead to the experience of pain. Stimuli were the moral cause of pain. In a certain sense we can read this as a 'traumatic experience', a way of thinking heavily reminiscent of Freud. The consequence of that pain experience was an excessive sensibility of the nervous system, so that all subsequent stimuli could be experienced as equally painful. The pain of the mind was central to Guislain because the reaction was of a psychological nature. The term he coined was phrenopathy, which literally means: the suffering of the mind. Guislain is often considered an important forerunner of the psychological approach in psychiatry because of this given: mental illness as a psychological reaction.

FROM NEURONS TO PERCEPTRONIUM

When psychiatry started, theories took off. In less than two centuries, a great deal of work was done at an increased pace to unravel the mysteries of the human body. It is telling that the most famous doctor and psychologist of the twentieth century, Sigmund Freud, evolved in his own career from physiologist to psychoanalyst. Freud wrote in his early days about psychic energy and traumas in a way that was heavily influenced by his biological introduction to his career. All sorts of insights followed in relation to the way that the nervous system, neurotransmitters and hormonal regulation worked. It is almost impossible to keep track of the evolution. Belgian research at the Psychiatrisch Ziekenhuis Duffel (Duffel Psychiatric Hospital) has very recently shown that certain bacteria play a role in depression. It seems like history is repeating

Mathew Kneebone, *Curse of the Walking Techbane*, from the series *Mechanical Systems Drawing*, 2016, IBM Electrographic and graphite pencil on paper. Dr. Guislain Museum, Ghent

In the nineteenth century, spiritualists believed in the link between magnetic fields and the 'life force'. According to them, the human body generated an invisible magnetic field, also known as an aura, which had an effect on the emotional and spiritual state of a person. The *Techbanes* of today believe that an overactive power in their body causes interference to the magnetic field. A walk outside can make a street light fail or cause a car radio to tune to another frequency. The work of Mathew Kneebone (b. 1982) investigates how we relate to technological innovation.

itself because, according to Pinel and Esquirol, the digestive system holds the cause of psychiatric syndromes.

The influence of contemporary physics appeals even more to the imagination. That the human brain is as great a mystery as the universe is a witticism, but research projects like BRAIN are attempting to map every neural network in the brain, just as telescopes from NASA are searching for unknown terrain in the darker reaches of space — and since quantum mechanics, nothing surprises us any more. It has not only taught us that the very smallest subatomic particle has an effect on huge heavenly bodies, but that humankind floats around between them somewhere as well. In the same way, astrophysicist Max Tegmark is also trying his luck at deciphering that extraordinary characteristic which we ascribe to our mind. He argues that there may be a substance like *perceptronium*, the material missing link in order to understand our consciousness. That dark matter, the homunculus of astrophysics, has been proven to really exist means that it is not implausible that the human mind and consciousness can be found in a small substance. For the time being, however, no sufferer of depression has benefited from someone looking at the bacteria in his or her intestines, and the existence of *perceptronium* can probably offer more solace to someone in the middle of a psychotic episode as a delusion than as a reality.

Since the advent of modern times, the concept of madness has changed completely. The indivisibility of the mind has been banished to the realm of fiction for good. The mind can fragment, disintegrate and dissociate, and within that context the concept of schizophrenia arose. The mind can suddenly break open, so that mental products can exist independently of each other and become realities in themselves. They are gaining more and more interest in hallucinations and delusions, and the search for an explanation soon leads the patient to external influences. This looks very much like how psychiatry has occupied itself with the causes of madness through the centuries. Someone who is struggling with a psychosis uses delusion to transform thoughts into voices. Or the influence of ideas via television and computers into objective rays against which he or she must protect him- or herself. The subjective changes into what is objectively perceptible, the mental seems too unfathomable and changes again into something physical. Psychiatry also tries to find the causes of psychological realities in something biological, and vice versa.

Psychiatry is perhaps one of the most mysterious scientific paradigms. It deals with certain syndromes which we necessarily want to call syndromes — in any case, an aberration from socially acceptable human behaviour, which is not regarded as normal. When you begin to think about how the mind and body move through that mysterious history, you risk losing sight of who it is actually about. Psychiatry becomes a way of prescribing treatment methods, or a description of how something biological disrupts something psychological. However, you then seem to exclude the thing, or more accurately, the person, that it is actually about.

BIBLIOGRAPHY

Arikha, Noga. *Passions and Tempers. A History of the Humours.* New York: HarperCollins Publishers, 2007

de Kroon, Jos. *Omzien naar de psyche. Een kritisch-historische benadering van de psychiatrie.* Amsterdam: Boom, 1999

Dixon, Thomas. *From Passions to Emotions. The Creation of a Secular Psychological Category.* New York: Cambridge University Press, 2003

Liégeois, Axel. 'Guislain en de Europese psychiatrie', in: Allegaert, Patrick, Caillau, Annemie, a.o. *Geen rede mee te rijmen.* Ghent: Museum Dr. Guislain, 1996

Millon, Theodore. *Masters of the Mind. Exploring the Story of Mental Illness from Ancient Times to the New Millennium.* Hoboken, New Jersey: Wiley, 2004

Scull, Andrew. *Madness in Civilization. A Cultural History of Insanity.* London: Thames & Hudson, 2017

Tegmark, Max. *Our Mathematical Universe. My Quest for the Ultimate Nature of Reality.* London: Penguin Books, 2015

van den Bosch, Rob. *Gedaanten van de waanzin. Van schaamteloze razernij naar onbegrepen belevingswereld.* Amsterdam: Athenaeum-Polak & Van Gennep, 2018

Vijselaar, Joost. *De magnetische geest. Het dierlijk magnetisme 1770–1830.* Nijmegen: Sun, 2001

Viviane Joakim, from the series
Secrets of Souls, 2004–2005, photograp
© Viviane Joakim. Dr. Guislain Museum, Ghent

Viviane Joakim, from the series *Secrets of Souls*, 2016, photograph. © Viviane Joakim. Dr. Guislain Museum, Ghent

The sofa is one of the most iconic images from psychotherapy. It has become an essential part of psychoanalytic practice since the 'talking cure' of Sigmund Freud (1856–1939). Freud became fascinated by hypnotherapy after he met Jean-Martin Charcot (1825–1893) in Paris. Charcot used the technique to treat hysteria. Freud's hypnotic abilities were not good enough, however, and he would soon abandon this path and apply what ostensibly seems an easier and more accessible method: free association. Ostensibly, because the free association employed in psychoanalysis in order to penetrate the subconscious is an extremely intensive and difficult process. Each patient soon experiences for him- or herself that the condition for free association, the abandonment of all inhibitions when speaking, is not easy. Freud started out as a physiologist. When he began his studies he spent day and night for years bent over a microscope. It was only after his visit to Paris and Charcot's Hôpital de la Salpêtrière that an important shift in his thinking took place. The physical influence is still tangible in his first psychoanalytical writings, however. Freud talked about psychic energy. The original hypnosis arose out of the animal magnetism of Franz Anton Mesmer (1734–1815). Mesmer also spoke in terms of energy that is released and can be transmitted to people by means of metal objects. Psychoanalysis was the most important foundation for many forms of counselling in the twentieth century which were increasingly orientated towards the mind and behaviour.

Study of the brain by Professor
André Dewulf, twentieth century,
brain slices. Dr. Guislain Museum, Ghent

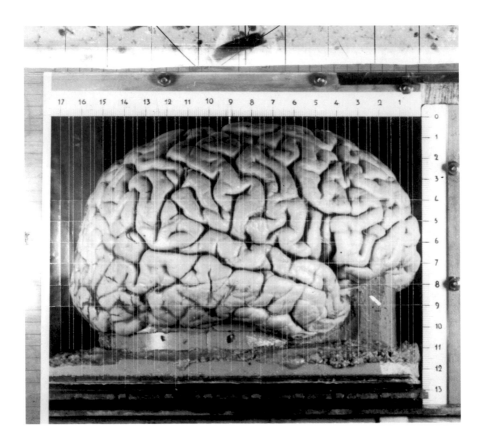

Study of the brain by Professor André Dewulf,
twentieth century, photographs. Dr. Guislain Museum, Ghent

Professor André Dewulf's Brain-Cutting Machine, twentieth century, photograph. Dr. Guislain Museum, Ghent

Franz Joseph Gall (1758–1828) and Johann Gaspar Spurzheim (1776–1832) were the pioneers of contemporary psychology, according to some. Their 'bump theory' was a first step in the localisation of human characteristics or functions. Although craniology or phrenology was quickly written off as pseudoscience, it nonetheless exerted an influence on the founders of institutional psychiatry. Joseph Guislain (1797–1860) explicitly allowed himself to be inspired by these 'bump-ologists'. The discovery of the brain's speech and language centre by Paul Pierre Broca (1824–1880) and Carl Wernicke (1848–1905) was a direct consequence of the theory.

The first X-rays of Wilhelm Röntgen (1845–1923) in the twentieth century didn't just affect psychiatry, they led to the creation of other medical disciplines. In a strange way, Röntgen, Freud, Turing and Einstein entered the new century hand in hand, ensuring the genesis of more refined and more specific methods of examination. With the arrival of the computer in the second half of the twentieth century, the evolution went even faster. In the middle of this technological hurricane, Professor André Dewulf (1903–2000) was working in an attic on his own *polytoom* for neuroanatomy research at the Sint-Kamillus University Psychiatric Centre in Bierbeek. The device, made of rusty metal and parts that were actually intended for the building industry, allowed him to take fine slices of brain tissue for study under the microscope. Dewulf conducted groundbreaking research into the structure of the hypothalamus with it. Thanks to the insights of contemporary physics, we are now further advanced today in studying the brain. Neurologists can dig deeper and use diverse techniques to undertake more specific research.

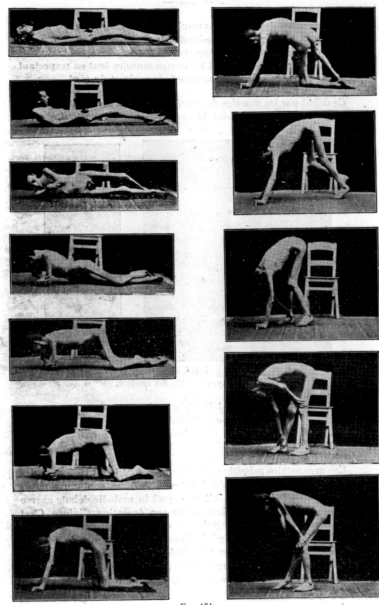

Fig. 171.

Chronophotography from: Arthur Van Gehuchten, *Les maladies nerveuses*, 1920, Leuven. Dr. Guislain Museum, Ghent

Arthur Van Gehuchten (1861–1914), the first Belgian professor of neurology, illustrated his research with drawings and film. He was a world authority in his field and his work had an influence on the most renowned scientists of his time. One of these was Ramón y Cajal (1852–1934), with whom Van Gehuchten exchanged letters all his life and with whom he also shared an interest in illustrating his research results. Van Gehuchten used pictures of patients with Parkinson's disease, chorea, dystonia and hysteria in his lectures, at conferences and in journals.

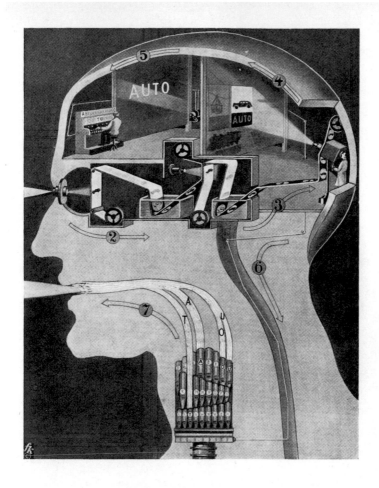

Infographic of the human body, from: Fritz Kahn,
Het leven van de mens (Human life), 1939, Amsterdam. Dr. Guislain Museum, Ghent

The German-born Jewish doctor Fritz Kahn (1888–1968) was a pioneer in
infographics, a method of conveying information by means of diagrams.
He was, in a sense, the forerunner of the popular French animation series
Once Upon a Time … Life, which explained the workings of the human body.
The *Das Leben des Menschen* books were extremely popular and were
translated into several languages. Kahn was able to illustrate complex aspects
of how the human body works with drawings that could be understood,
but despite this and the popularity of his books, they were still burned on
Kristallnacht with piles of books by other Jewish academics and writers.
Several editions of his work were published after the war, but not in Germany.

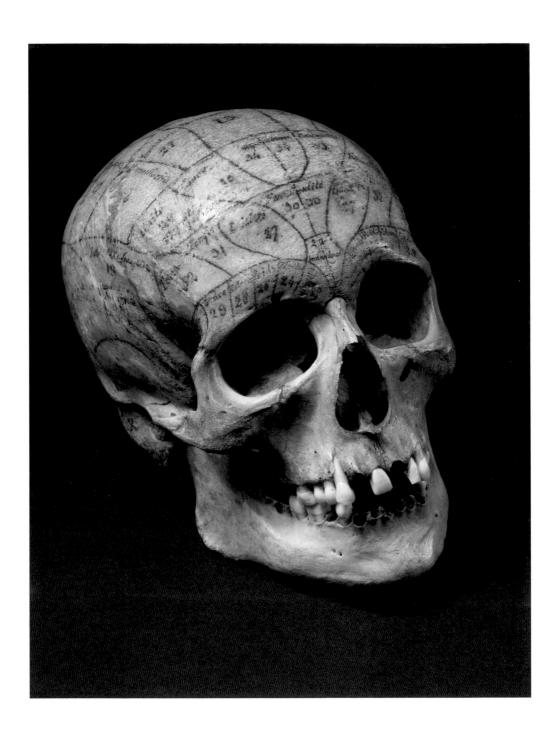

Phrenological skull, nineteenth century, bone and ink. Dr. Guislain Museum, Ghent

3° stadium v. syfilis.

Tertiary syphilis, 1930s, wax. Dr. Guislain Museum, Ghent

Dementia paralytica, also known as general paresis of the insane, is the third stage
of untreated syphilis, first described in the nineteenth century. It was prevalent in
psychiatry then but the diagnosis is extremely rare today. Symptoms included
megalomania, dementia, depression and mental decline. Before the discovery
of penicillin, *dementia paralytica* was treated with pyrotherapy. The symptoms
of the disease are depicted on this wax head from the Sint-Norbertusinstituut
in Duffel. Wax models were used for medical teaching until the first half of
the twentieth century.

Scarificators, undated, metal. Dr. Guislain Museum, Ghent

In the Middle Ages, bloodletting was used to remove an excess of blood or to 'purify' the 'bad blood' of the mentally ill. Blood was brought to a specific area on the body by placing heated glass cups on the skin. A 'scarificator' had small blades that made incisions in the skin, which caused the person to bleed. Bloodletting is still performed today. Leeches are used in some medical treatments, for instance.

Dollond microscope, late
eighteenth century, copper.

Dr. Guislain Museum, Ghent

Electroshock device,
undated, wood and metal.

Dr. Guislain Museum, Ghent

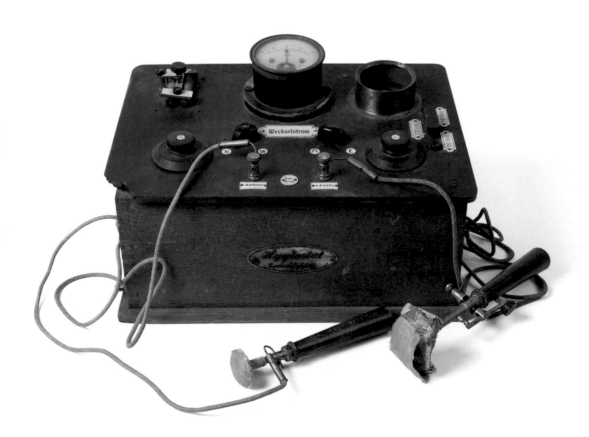

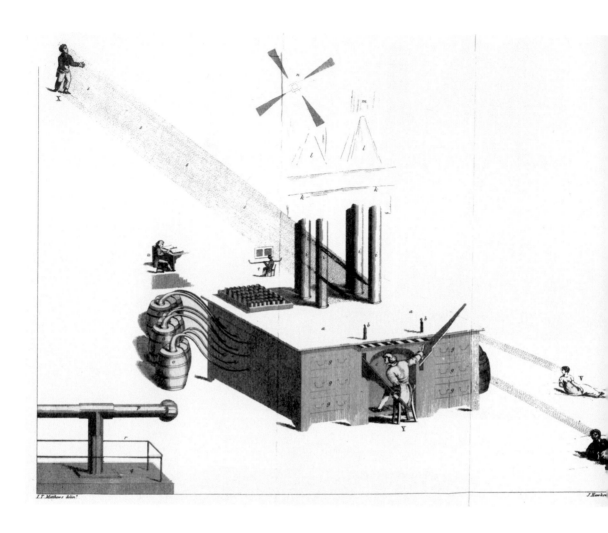

James Tilly Matthews, illustration from: John Haslam, *Illustrations of Madness: Exhibiting a Singular Case of Insanity, and a No Less Remarkable Difference of Medical Opinion: Developing the Nature of Assailment, and the Manner of Working Events; with a Description of the Tortures Experienced by Bomb-Bursting, Lobster-Cracking and Lengthening the Brain. Embellished with a Curious Plate*, 1810, London. Bethlem Museum of the Mind, Kent

James Tilly Matthews (1770–1815) believed that a device called the 'Air Loom' interfered and controlled his mind and body. The London tea broker was admitted to the Bethlem psychiatric hospital in 1797. Matthews made detailed descriptions and drawings of the device. According to him, the Air Loom was controlled by the 'Glove Woman', 'Sir Archy', 'Jack the Schoolmaster' and the 'Middleman': a gang that not only tortured him remotely, but continuously made drawings of what he did. Or how the psychotic man invented alternative ways to name and understand his delusions in order to understand his world.

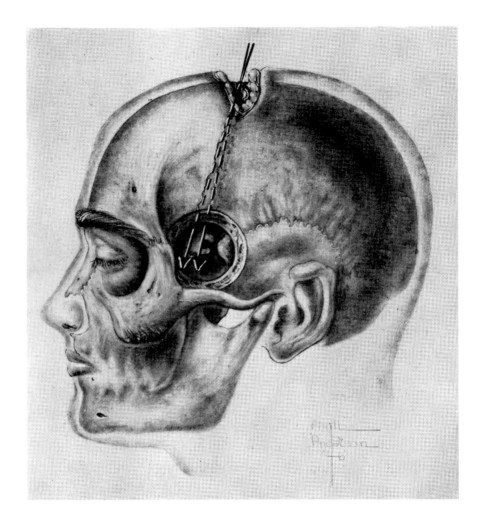

Figure 18. The tip of the cannula is resting on the sphenoidal ridge.

Lobotomy, from: Walter Freeman, *Psychosurgery in the Treatment of Mental Disorders and Intractable Pain*, 1950, Oxford. Dr. Guislain Museum, Ghent

If psychiatric disorders have their origins in the body, as psychiatrists believed in the first half of the twentieth century, then experimental treatments directly affecting the body could help. Electroconvulsive therapy is familiar and still used, but lobotomy is now notorious. In lobotomy, connections between the prefrontal cortex of the brain and the brain stem were cut. The technique, frequently applied by American neurologist Walter Freeman (1895–1972), was not without risk. Although depression and anxiety disorders seemed to be cured by it, the patient often lost all emotion and self-awareness.

Rosemary and lavender, from: Rembert Dodoens,
Cruydt-Boeck (Book of herbs), 1608, Antwerp.

In his *Cruydt-Boeck* (Book of herbs, 1608), doctor and botanist Rembert
Dodoens (1517 or 1518–1585) attempted to categorise various plants and their
'potencies' based on their outer appearance and their similarities to each
other. He acquired his knowledge by going into the countryside and studying
the flora itself. Dodoens was extremely interested in the medicinal power of
plants, such as rosemary and lavender, two ingredients in a recipe for a 'syrup
for disturbances of the mind'. The intention of the book of herbs was to give
people access to this knowledge and to convince colleagues of the scientific
importance of botany.

In the centuries that followed, people continued to experiment with herbal
mixtures, also in a psychiatric context. Joseph Guislain (1797–1860) was
aware of the active substances of plants such as valerian and St John's wort,
and calla had been used to treat mental illnesses for centuries. In the mid
twentieth century, reserpine was distilled from the latter for use in medicines
like Serpasil, which was prescribed to psychotic and highly strung patients.

In the 1950s and 1960s, the emphasis shifted to psychotropic drugs. It was
characteristic of a new period in psychiatry, often called the time of the
'chemical calm'. The side effects of the drugs were immense and how they
worked was not entirely understood, but they brought about a revolution
in psychiatry. The discovery of new ingredients in medicine was often just
a question of chance. The multitalented 'psy' professor and psychoanalyst
from Ghent Jacques Schotte (1928–2007) described a telephone conversation
in the 1950s with his friend and colleague, Swiss psychiatrist Roland Kuhn
(1912–2005). Kuhn had used imipramine with patients with heart problems
and had discovered that the medicine also had an effect on the symptoms
of depression that some of the patients had complained of. Imipramine
was the first successful antidepressant.

Gmundner Keramik, Janssen Neuroleptika coffee set (Haldol, Triperidol, Semap, Orap, Dipiperon), c. 1970, ceramic. Dr. Guislain Museum, Ghent

The death of his four-year-old sister to tuberculosis had such an impact on Dr. Paul Janssen (1926–2003) that he would carry it with him throughout his life. Janssen had absolute faith in the importance of chemistry for medicine and studied it with physics and biology in Namur during the Second World War. The establishment of his own laboratory in the city of his birth, Turnhout, was the start of a successful career. Paul Janssen developed more than 80 medicines, of which the antipsychotic Haloperidol is considered one of the greatest pharma-cological breakthroughs in psychiatry. His lab moved in 1964 to Beerse, where Janssen Pharmaceutica is still a world authority.

De Figure der Aderen.

Hier volcht nv de verclaringe der Figure, van de Ader Vena caua, in de welcke dat de Letteren maer oē syde aen en teyckenen. Den nederdalenden Struyck, is geteyckent op de slincke syde: eñ den opclimmenden, inde rechte syde: vande welcke dat ghy so veel sult mogē oordeelen van d'ander syde.

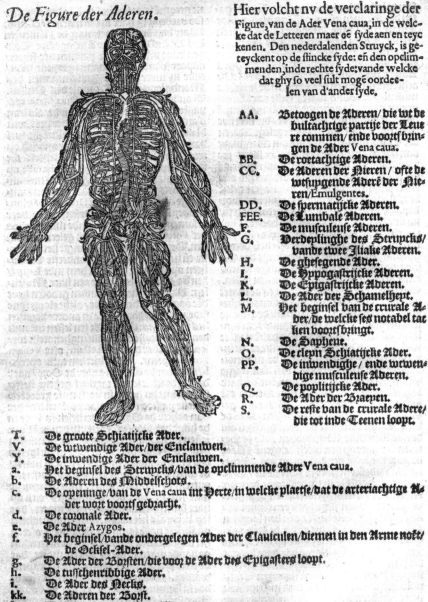

AA.	Betoogen de Aderen/ die wt de bultachtige partije der Leure commen/ ende voortsbzingen de Ader Vena caua.
BB.	De voetachtige Aderen.
CC.	De Aderen der Nieren/ ofte de wtsupgende Aderē der Nieren/Emulgentes.
DD.	De spermatijcke Aderen.
FEE.	De Lumbale Aderen.
F.	De musculeuse Aderen.
G.	Verdeplinghe des Struycks/ vande twee Iliake Aderen.
H.	De ghesegende Ader.
I.	De Hppogastrijcke Aderen.
K.	De Epigastrijcke Aderen.
L.	De Ader der Schamelhept.
M.	Het beginsel van de crurale Ader/ de welcke ses notabel tacken voortsbzingt.
N.	De Sapheue.
O.	De clepn Schiatijcke Ader.
PP.	De inwendighe/ ende wtwendige musculeuse Aderen.
Q.	De poplittjcke Ader.
R.	De Ader der Bzaepen.
S.	De reste van de crurale Adere/ die tot inde Teenen loopt.
T.	De groote Schiatijcke Ader.
V.	De wtwendige Ader/der Enclauwen.
Y.	De inwendige Ader der Enclauwen.
a.	Het beginsel des Struycks/van de opclimmende Ader Vena caua.
b.	De Aderen des Middelschots.
c.	De openinge/van de Vena caua int Herte/in welcke plaetse/dat de arteriachtige Ader wort voortsgebzacht.
d.	De coronale Ader.
e.	De Ader Azygos.
f.	Het beginsel/vande ondergelegen Ader der Claviculen/diemen in den Arme noxt/de Ocksel-Ader.
g.	De Ader der Bozsten/die voor de Ader des Epigasters loopt.
h.	De tusschenribbige Ader.
i.	De Ader des Necks.
kk.	De Aderen der Bozst.
l.	De inwendige ingulare Adere.
m.	De wtwendige jugulare Adere/waer van dat b de vier tacken bertoocht worden/door 1,2,3,4.
n.	De Ader des Voozhoofts.
o.	De Toxculare Ader.
p.	De clepne Ader des Schouders die wtwendich naer den Arme loopt.
q.	De Ader des Schouders/die somtijts haren oozspzonc neemt van de Ocsel-Ader.
r.	De plaetse/van de musculeuse Ader.
ss.	De Aderen/die van de Aderen des Schouders loopen/tot de naeste musculen des Schouderblats.
t.	De Ocsel-ader/die haer stracx daer na vdeplt/in een diep-loopende/ende bouen op loopende Adere/waer van dat de dieploopende gheteyckent wozt/met 1.ende de bouen oploopende/met 2.
u.	Verdeplinge/van de opper Ocsel-ader/waer van dat den inwendige tack/met den inwendighen des Schouders de Mediaen-ader maken. Den wtwendige tack/gaet lancfst den Elleboge/tot iu de Hant. X. De

De achtste Figure.

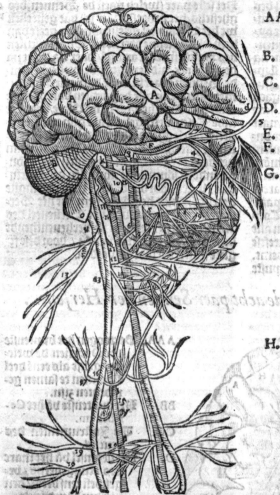

AAA. Vertoogen het buptenste der Hersenen/ghelijck als die van hare Membranen gebloot zijn.

B. Het buptenste van het Cerebellum.

C. Een van de Instrumenten des reucks.

D. Een van de Mammilaren Processen.

E. Een vande Senuen des gesichs.

F. Een van de Senuen van het seste paer.

G. Een porcie / van het derde paer/ van het welcke/ dat eenen tack naer het Voorhooft loopt/gheteeckent met een (1.) ende waer van dat oock een deel gaet/ nae de Membrane des Neusen/getepckent met (2.)oock noch een ander deel / naer het opperste Caecksbeen / ghetepckent met (3.)ende noch eē ander deel / dat naer de Musculen vandeSlapen des Hoofts loopt/ghetepckient met(4.)

H. Vertoocht het meeste deel / vā het derde paer/ waer vā dat de eerste tackinghe / die v ghetoocht wort door (5.) naer de Tanden/ ende naer het Tandvleesch (vā het opperste Caecksbek) loopt. d'Andere tackinghe/die v door (6.)vertoocht wort/die loopt na het onderste Caecksbeen : Van de welcke/dat v een porcie door (7.)vertoocht wort / die naer de onderste Lippe loopt: Ende de reste/ die met(8.)ghetepckent wort/ die verliest haer inde Tunijcke der Tonghen.

I. Vertoocht het vierde paer Senuen/het welcke hem gaet verliesen/ in de Tunijcke van het verhemelse des monds/die door de(9.)vertepckent wort.

K. Vertoocht het alderclepnste Senuken der Hersenen/het welcke (van de oude Anatomisten nagelaten wesende)daer loopt nae de Musculē/die het onderste Caecksbeen doen roeren:Het neemt synen oorspronck/aldernaest de Senue des gehoors de welcke wy hebben vertepckent/in de figure der Senuē/voor het achtste paer.

L. Vertoocht het vijf de paer Senuen/die haer in dry deelen verdeplen/ waer van dat het grootste deel/geteeckent met (10.)de Tunijcke van het gehoor maect. De andere clepnste/diet met(11.ende (12.)getepckent staen/trecken na de Musculen van de slapen des Hoofts/met een seker porcie van het derde paer vereenicht wesende/ de welcke gemaect zijn/in maniere van Wijngaert-baerdekens/de welcke alhier in dese figure vertoocht worden.

MM. Vertoogen de Senuen van het seste paer/de welcke haer verdeplen/ gelijck als hier naer volcht:Door eersten/so senden sy haer eerste tacken/ ind: leste Musculen des Hals/

The Figure of the Arteries and The Eighth Figure,
from: Ambroise Paré, De chirurgie ende alle opera,
1592, Dordrecht. Dr. Guislain Museum, Ghent

Illustrations from: Gerbrandus Jelgersma, *Atlas anatomicum cerebri humani.*
168 doorsneden van menschelijke hersenen, 108 lichtdrukplaten naar photographische
opnamen van praeparaten, 1931, Amsterdam. Dr. Guislain Museum, Ghent

Gerbrandus Jelgersma (1859–1942) is known
for his research into neuroanatomy and the
famous brain atlas he worked on for 25 years.
The anatomy of the brain played an important
part in his thinking about conditions such as
neurasthenia, hysteria, chorea and epilepsy.
He believed at the beginning of his career that
every sickness could be traced to a defect
in the body, but he later became interested in
the 'unconscious mental life' and in Freud's
insights into the subconscious. Jelgersma sup-
plemented his neurological and anatomical
knowledge with opinions from fields where
psychological approaches were applied.

PHOTOTYPE NÉG. A. LONDE

PHOTOCOLL. BERTHAUD

AILERON DE FAISAN TUÉ A LA CHASSE

Épreuve obtenue par la photographie ordinaire. Épreuve obtenue avec les rayons X.

L. BATTAILLE ET Cⁱᵉ
ÉDITEURS

Albert Londe, *Note sur l'application de la méthode de M. Roentgen*, from:
Nouvelle Iconographie de la Salpêtrière, volume 9, 1896, Paris. Dr. Guislain Museum, Ghent

Until the end of the nineteenth century, the inside of a human body could only
be seen by means of an autopsy. When Wilhelm Röntgen (1845–1923) discovered
the X-ray in 1895, psychiatrists and neurologists were immediately interested:
'As soon as the wonderful discovery of Mr. Roentgen was published, we wanted
to repeat the foreign scientist's experiments, which, given the implications in
pure physics, must demonstrate applications in medicine and surgery. (...)
We will continue with these experiments and hope that we will be able to submit
the proof of this to the readers of the *Nouvelle Iconographie de la Salpêtrière*
in respect of various subjects with regard to diverse bone lesions, or fractures
where we are looking for foreign bodies when it was previously impossible to
determine the location.'

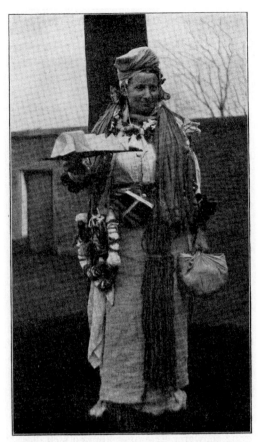

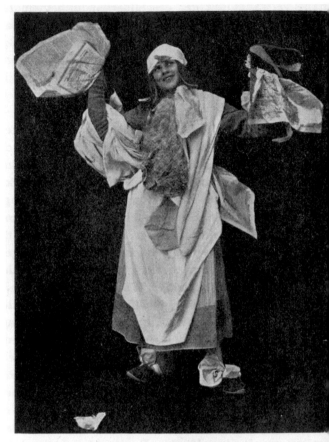

Fig. 213. Aufgeputzte manische Kranke.

Fig. 281. Kranke im hysterischen Dämmerzustande.

Fig. 213. Aufgeputzte manische Kranke (Manic depressive, tied up), and
Fig. 281. Kranke im hysterischen Dämmerzustande (Patient in hysterical
dazed state), from: Emil Kraepelin, Psychiatrie. Ein Lehrbuch für Studierende
und Ärzte, 1913, Leipzig. Dr. Guislain Museum, Ghent

CLASSIFYING

Denmark, *Headlines*, 1994, black ink on white blotting paper.
Dr. Guislain Museum, Ghent. © SABAM Belgium 2019

The mounds of books and knowledge that were left stacked against the walls of his room after studying art history did not bring Denmark (b. 1950) the expected peace. In the 1970s, in reaction to the unmanageable flow of information, he started cutting, folding, pressing and gluing books, newspapers and magazines, which he transformed into sculptures and installations. *Headlines* is a visual statement that can be read in the margins of the archive installations. The work consists of 365 different meticulous prints of his forehead, in black ink on white blotting paper. Twenty-four mental activities were embossed underneath the paper with stamps, such as classifying, deciding, desiring, doubting, fearing, forgetting, knowing and understanding.

CONCENTRATING LEARNING

FORGETTING REMEMBERING

MEMORIZING

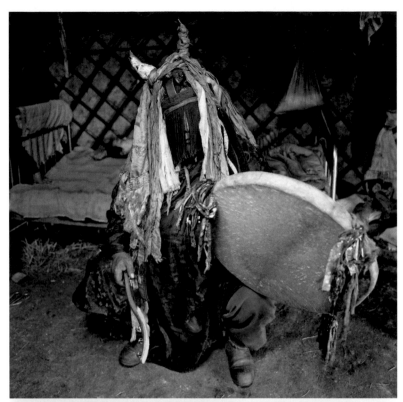

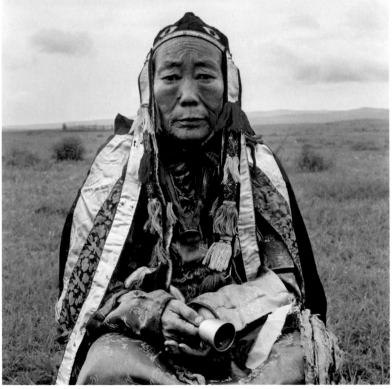

Karin Borghouts, from the series *Museum Dr. Guislain*, 2019, photograph.

Mark De Fraeye,
*Mongolia, Male &
Female Shaman*,
1998, photographs.
De Fraeye-Verburg
collection. King Baudouin
Foundation. Dr. Guislain
Museum, Ghent

The shaman, who is believed to have healing powers, is the bridge between two worlds. Certain rituals can bring him or her in contact with ancestors or spirits. These rituals often involve repetitive music and dance allowing the shaman to enter into a trance and into the spirit world. Usually, no one but the shaman knows what the signs mean that the spirits send to this world. Those who suffer a great deal psychologically often make use of such practices. In some cultures, shamanism co-exists with other religious practices.

Paul Regnard, *Attitudes passionnelles* (Passionate postures), photograph of Augustine Gleizes, from: *Iconographie photographique de la Salpêtrière*, volume 2, 1877–1878, Paris. Dr. Guislain Museum, Ghent

IMAGI
NATION

Roger Ballen, *Consolation*, from the series *Asylum of the Birds*, 2011, photograph.

Artist's collection, Johannesburg. Dr. Guislain Museum, Ghent

Yoon Hee Lamot

FASCINATED WITH THE OTHER

Imagination and Psychiatry

Imagination and psychiatry are closely linked. The first psychiatrists drew or painted portraits of their patients to illustrate specific syndromes. It is no surprise then that photography and psychiatry arose at about the same time. Photography was regarded as a useful tool in the observation of patients: their behaviour, facial expressions and uncontrolled movements appealed to the imagination and were recorded as accurately as possible. However, patients themselves also created pictures and drawings. When doctors began to pay attention to the visual creations that arose within the walls of the hospital, it was the start of what is now called outsider art. The term is drawn from the publication of the same name written by Roger Cardinal in 1972. It means more than just art made by psychiatric patients. Cardinal used the word as a synonym for *art brut* (raw or rough art), a concept coined by Jean Dubuffet in 1945. Dubuffet also looked beyond the hospital walls for 'authentic' art, which, for him, was separate from 'cultural' art.

The term outsider art now covers an endless spectrum of subcategories and has even become a brand. Paradoxically, the attention that Dubuffet and Cardinal drew to outsider art has isolated it from 'professional' art. For a long time now, many arguments have been made to abandon outsider art as a separate category. It is a fierce debate which already has an interesting history in curation. Outsider and professional art have been presented together in exhibitions for a long time, but the distinction is still often tangible. Why is it so difficult? Why do people keep looking for art that, in their opinion, differs from the norm? The answer can be found in people's fascination.

Albrecht Dürer, *Melencolia I*,
undated, engraving.

Nauta Collection, Rotterdam

Homo melancholicus — the vulnerable genius —
was immortalised in an iconic way in 1514 by
Albrecht Dürer (1471–1528). The composition
is dominated by an androgynous figure with
wings in the typical melancholic pose. She is

wearing a garland of water plants to avoid
dehydration, because her nature is cold and
dry. Attached to her belt are keys and a purse,
references to Saturn, the god of the earth. The
unused tools on the ground also refer to him.
Dürer depicts the modern artist in *Melencolia I,*
who is not only a craftsman but someone who
undertakes intellectual work. Theory and physic
rest are both parts of artistic practice.

MADNESS

Fascination for what? Humankind has always been fascinated by that which is different, that which transcends reason, and madness has been an object of fascination since ancient times. A well-known example is the double nature of melancholy. For example, the opening line of *Problemata XXX.1*, attributed to Aristotle, reads: 'Why is it that all those who have become eminent in philosophy or politics or poetry or the arts are clearly of a melancholy temperament, and some of them to such an extent as to be affected by diseases caused by black bile?' The apex of this fascination was during the romantic movement, when artists set aside reason to work from emotion. The irrational was central to this. Mad people were regarded as primitives who were not inhibited by reason or by what was regarded as morally correct. The romantics saw madness as the liberation of instinct. This fascination and curiosity led artists to asylums, where they observed not only the inmates but the art created by them.

PATIENT PORTRAITS

Even before the emergence of psychiatry at the end of the eighteenth century, mad people were being drawn and painted. Sander L. Gilman examines the way in which mentally ill people have been depicted from the Middle Ages to the nineteenth century in *Seeing the Insane. A Visual and Cultural History of Our Attitudes Toward the Mentally Ill* (1982). In the Middle Ages and the Renaissance, the 'otherness' of the insane was indicated by giving a melancholic person a darker skin, or by depicting specific postures, gestures and movements. Treatment methods were also illustrated, like exorcism, music therapy and 'cutting the stone'. In some cases, the mentally ill were depicted in a group, as in the *Ship of Fools* by Hieronymus Bosch, but in all cases we see 'the' mad person: a stereotype without any individuality. Artists maintained the conventional visual language.

One of the most famous depictions of the insane in the eighteenth century is the last of the eight engravings of *A Rake's Progress* made in 1735 by William Hogarth (1697–1764). The series illustrates the eight stages of the ruin of Tom Rakewell, a young man who leads a loose and immoral life. He ends up in Bethlem Hospital, then better known by its nickname, Bedlam. Rakewell is depicted in the foreground, surrounded by eight insane men. The engraving shows that Hogarth was aware of the most important

Hogarth pinxt

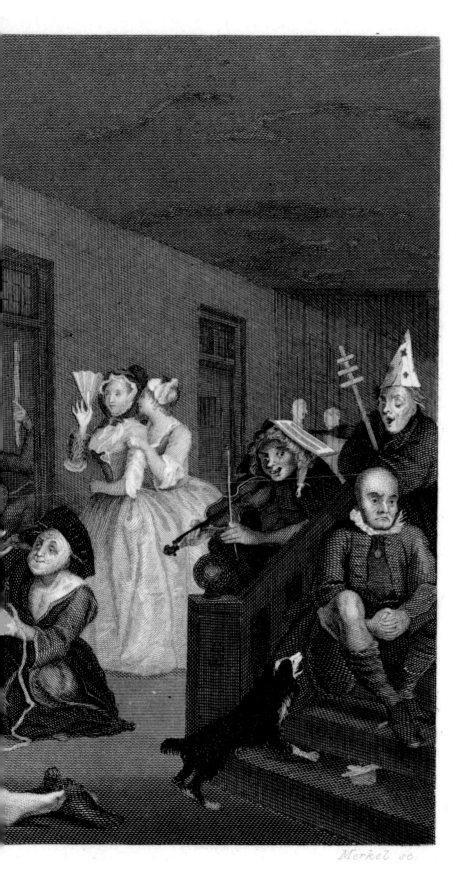

Merkel sc.

Anonymous, *The Rake's Progress: in Bedlam*, after William Hogarth, c. 1850, engraving.

Dr. Guislain Museum, Ghent

psychiatric symptoms of his time. He depicts Tom's fellow inmates in a characteristic way, with identifiable diagnoses. Although he employs a recognisable visual language, he also tells a personal story. We also see a patient drawing on the wall. In so doing, William Hogarth is, according to John M. MacGregor, author of *The Discovery of the Art of the Insane* (1989), one of the first artists to depict the artistic work of a psychiatric patient. He asserts that the investigation of the art of the insane began here and in similar Bedlam scenes.

The engraving is also important for another reason, however. Two ladies clearly do not belong among the insane: they are voyeurs. Bethlem Hospital allowed people to visit for a fee and considered itself one of the top places of interest in London — an early tourist attraction, if you will. Curiosity for the other, the sick and the mad could easily be satisfied, as long as you could pay for it.

Doctors also made portraits of their patients, or had them made. The first medical illustrations of mad people can be found, according to Gilman, in the *Traité médico-philosophique sur l'aliénation mentale ou la manie* (1801) by Philippe Pinel (1745–1826), where the French doctor combined physiognomy with a case study, just as, 20 years later, his student Jean-Etienne Dominique Esquirol (1772–1840) created portraits of specific cases, individuals, and not just stereotypical depictions of categories of illness. Portraits of patients can also be seen in *Leçons orales sur les phrénopathies* (1852) by Joseph Guislain. In the same period, Etienne-Jean Georget (1795–1828) asked his friend Théodore Géricault (1791–1824) to paint ten of his patients. Both men died before the project was completed and the pictures were never published, but five were preserved, including *Portrait of a Kleptomaniac* (c. 1820).

The interest in portraits of individuals reflects the development of psychiatry and the ethical approach towards the end of the eighteenth century. The idea that mental illness could be cured meant that sick people were given a place in society again, albeit within the walls of a hospital. The asylum was also abandoned by artists in the nineteenth century in their depictions of the mentally ill, but there was always a clear reference to confinement.

Photography began to be adopted by psychiatry in the mid nineteenth century. It was assumed that a photo was always an objective representation of reality. Jean-Martin Charcot (1825–1893),

Mélancolie (Melancholy) and
Extase (Ecstasy), from: Joseph
Guislain, *Leçons orales sur
les phrénopathies*, 1852, Ghent.

Dr. Guislain Museum, Ghent

a doctor specialising in hysteria at the Hôpital de la Salpêtrière in Paris, was at the birth of the best-known photographic publication in the realm of psychiatry: *Iconographie photographique de la Salpêtrière*, which appeared between 1877 and 1880 and illustrated Charcot's findings in hysteria. Albert Londe (1858–1917) played a large role in the resumption of the journal in 1888 as the *Nouvelle Iconographie de la Salpêtrière*. He expanded the photographic service of the hospital, paying close attention to chronophotography, which allowed movement to be captured. The photos, including that of Augustine, the 'star' of hysteria, had a very theatrical quality and became iconic.

Charcot gave a lecture twice a week. He presented cases of hysteria in an amphitheatre that could accommodate 400 spectators. It is apparent from the descriptions of the participants, from which Frans Gilson distilled the atmosphere in *Tijdschrift voor Psychiatrie* (Journal of Psychiatry) (2010), that the audience did not consist exclusively of medical practitioners: 'The hall was filled to the rafters with a diverse audience drawn from all over Paris: writers, famous actors and actresses, the fashionable *demi* and *beau monde*, all morbidly curious. Just as in a theatre, you enter from the back of the hall and you walk down to join the row at the front. The dark red walls are also reminiscent of a theatre.' Gilson talks of the 'Circus Charcot', in which young women under hypnosis on the stage were lit by a spotlight while they went through the various stages of a hysterical fit.

The lectures attracted spectators from abroad as well as from Paris. The link with the paying visitors in Bethlem is obvious, but what was different about the spectators for Charcot's 'Tuesday lessons' was that many of them didn't just come for entertainment, but for inspiration. One of the spectators was Sarah Bernhardt (1844–1923), whose performances were inspired by the hysterical movements she saw at Charcot's lectures. Sigmund Freud was, in his own words, 'enthralled' when he saw her in the play *Théodora* by Victorien Sardou in 1885. Bernhardt was a star who had studied that other star, Augustine, very carefully. Augustine was often photographed and presented, not just because of how she looked, but also because her symptoms presented themselves in clear and definite acts. She was quickly christened the 'Sarah Bernhardt of the Salpêtrière' and she still appeals to the imagination even now. She was the subject of the film *Charming Augustine* (2005) by

Paul Regnard, *Attitudes passionnelles* (Passionate postures), photograph of Augustine Gleizes, from: *Iconographie photographique de la Salpêtrière*, volume 2, 1877–1878, Paris. Museum Dr. Guislain, Gent

Planche XXVI.

ATTITUDES PASSIONNELLES

MOQUERIE

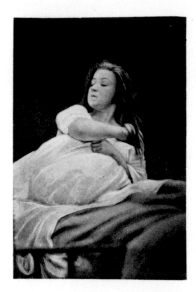

Planche XVIII.

ATTITUDES PASSIONNELLES

MENACE

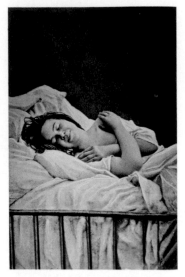

Planche XXI.

ATTITUDES PASSIONNELLES

EROTISME

Paul Regnard, *Attitudes passionnelles* (Passionate postures), photographs of Augustine Gleizes, from: *Iconographie photographique de la Salpêtrière*, volume 2, 1877–1878, Paris. Dr. Guislain Museum, Ghent

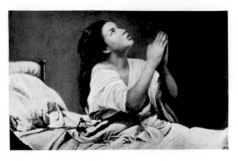

Planche XX.

ATTITUDES PASSIONNELLES

SUPPLICATION AMOUREUSE

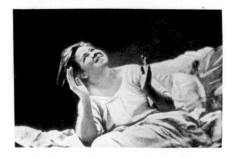

Planche XXII.

ATTITUDES PASSIONNELLES

EXTASE (1876).

(p.121) Paul Regnard, *Léthargie* (Lethargy) and *Catalepsie* (Catalepsy), photographs of Augustine Gleizes, from: *Iconographie photographique de la Salpêtrière*, volume 3, 1879–1880, Paris. Dr. Guislain Museum, Ghent

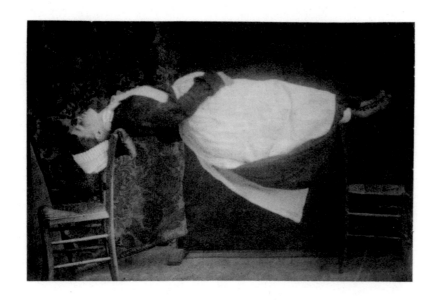

Planche XIV.

LÉTHARGIE
HYPEREXCITABILITÉ MUSCULAIRE

Planche XV.

CATALEPSIE

Planche XVIII.

CATALEPSIE
SUGGESTION

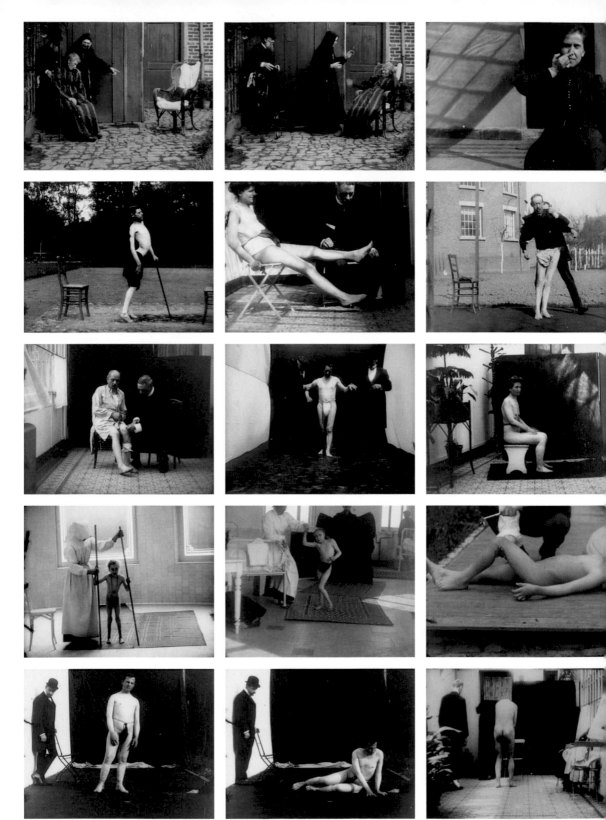

Arthur Van Gehuchten, untitled, 1900–1910, film. Dr. Guislain Museum, Ghent

American artist Zoe Beloff, and she has also been portrayed in plays and books.

Sarah Bernhardt was not the only person who sought inspiration within the walls of a psychiatric institute, however. According to literature professor Rae Beth Gordon, other practitioners of the performing arts looked to the jolting and uncontrolled movements of the patients of La Salpêtrière to add spice to their work. An entirely new genre of performing artist arose in France in the 1870s and 1880s: *la chanteuse épileptique, le chanteur agité, le comique idiot*, etc. The tics and strange ways of walking found their origin with doctors such as Edouard Brissaud and Georges Gilles de la Tourette, who researched problems with walking caused by neurological disorders. Actors like Charlie Chaplin became famous with their characteristic way of moving.

Besides drawings and photos, film was also used to observe patients. Belgian neurologist Arthur Van Gehuchten (1861–1914) began filming his patients systematically at the start of the twentieth century. He made short films of one to two minutes which he used to illustrate his lessons and lectures. Van Gehuchten was a world authority in neuroanatomy and was the first professor of neurology at a Belgian university. According to researcher Geneviève Aubert, his films demonstrate a diverse range of cinematography. He used various camera angles, close-ups to capture certain reflex reactions and long shots to demonstrate patients' postures and ways of walking. Choreographer Alain Patel of the dance company les ballets C de la B had his dancers watch Van Gehuchten's films for the production *vsprs* (2006). He was looking for the tension between the subconscious and the superconscious, between uncontrolled movement and the classical rules of choreography. Platel also focused on the body language of the subconscious, spasms, convulsions and ticks for *Out of Context – for Pina* (2010). The spectrum of movement varied from blinking or frowning, jerking limbs and movements to falling over or a *silly walk*.

PATIENTS' VISUAL ART
What is now called outsider art has its roots in psychiatry. John M. MacGregor argues that, although the art world was responsible for the discovery of outsider art as art, it was doctors who first showed interest in it. They began to collect, classify and study the work of their patients systematically at the end of the nineteenth

les ballets C de la B / Alain Platel, *Out of Context – for Pina*, 2010, photograph. © Chris Van der Burght

les ballets C de la B / Alain Platel, *vsprs*, 2007, photograph. © Chris Van der Burght

century. Initially, this was for diagnostic reasons. Doctors like Cesare Lombroso (1835–1909) saw a link between creativity and mental illness. He compiled the work of prisoners and psychiatric patients, concluding that artistic talent was a form of hereditary insanity. It was a regression to an earlier stage in evolution, the reappearance of the sickly characteristics of distant ancestors. This fitted in with the theory of degeneration, which was highly influential in the late nineteenth century.

By the early twentieth century, psychiatrists were interested in the aesthetic qualities of the work and publications appeared for the first time that were accessible to a wider audience. Marcel Réja (1873–1957), the pseudonym of French doctor Paul Meunier, considered the work of psychiatric patients through the eyes of an art critic in *L'art chez les fous* in 1907. He is thought to have worked with Dr. Auguste Marie (1865–1934), who established the Musée de la folie in the psychiatric hospital in Villejuif in 1905 with work from patients. He pointed to Bethlem Hospital as his inspiration, where he had seen a similar exhibition in 1900.

The book that gave the art of psychiatric patients a podium for the first time was *Bildnerei der Geisteskranken* (*Artistry of the Mentally Ill*) (1922) by Hans Prinzhorn (1886–1933). The German psychiatrist and art critic was recruited by the psychiatric hospital in Heidelberg in 1919 to expand the existing small collection of works by psychiatric patients and to write about them. He wrote to the directors of hospitals in various countries in his search for original work that had already been created, and he gathered a collection of almost 5,000 pieces from more than 400 patients. He also advised the hospital boards to provide patients who wanted to draw with the necessary materials. His letter explained that the intention was to allow some of the work to be exhibited in a museum. In contrast to Jean Dubuffet, Prinzhorn was not anti-cultural and did not want the work to be excluded from the art world. He even tried to have it exhibited in fine art galleries. In his introduction, Prinzhorn wrote that he did not want to use the word 'art', because a value judgement is intrinsic to it: the distinction between 'art' and 'non-art'. Instead of drawing new boundaries, he wanted to demolish walls. Prinzhorn chose *Bildnerei* as an alternative for the term, and wrote that, above all, the work showed similarities with contemporary art, an art that, 'in its search for intuition and inspiration, consciously strives for psychiatric attitudes that can be found in schizophrenia'.

This is why many expressionistic and surrealistic painters were very interested in the book. They saw an authenticity and power of imagination in the work that wasn't reflected in the established art world. Similarly, Paul Klee saw a 'direct spiritual vision' in the work of psychiatric patients and argued that art does not reproduce the visible; rather, it makes visible. In his view, the child and the savage could also do this. Max Ernst attempted to enter this 'no man's land' with specific techniques such as frottage and collage.

The artist who would play a key role in making the art of psychiatric patients more widely known, however, was Jean Dubuffet (1901–1985). In July 1945 he travelled to various psychiatric hospitals in Switzerland, where he saw the work of Adolf Wölfli. After his return, he wrote a letter to the painter René Auberjonois in which he used the term art brut for the first time. This was the beginning of a collection that was housed in Lausanne as the Collection de l'Art Brut in 1976, and which has enjoyed world fame ever since. Art brut was strictly defined, and the biography of the artist and his or her unfamiliarity with the art world played an important role. According to American art critic Hal Foster, transgression was central to Dubuffet, and it was expressed in, among other things, instinct, passion and madness. He was looking for another, authentic, primitive art on which he could take a clear position: art brut against *art culturel*. By maintaining such a sharp distinction, however, these works were confined to a restrictive term and anxiously excluded from the established art world.

Although outsider art is a controversial term, it still inspires artists. The Quay Brothers' stop-motion animation *In Absentia* was inspired by the writings and drawings of Emma Hauck, an artist included in the Prinzhorn Collection. Hauck was admitted to the psychiatric hospital in Heidelberg in 1909 at the age of 31 and wrote love letters to her husband. 'Come, darling' (*Herzensschatzi komm*) can often be read, repeated obsessively or sometimes just 'Come'. The words fill the sheet so that it is no longer a letter but a picture.

The word outsider is also linked at several levels with photographer Roger Ballen. He made portraits of marginalised white people in the isolated rural areas of South Africa in the 1980s and 1990s. The camera was unforgiving, but their portrait made their existence a reality, albeit a confrontational one. Stage-managing

his work became more prominent at the start of this century. By moulding reality into 'installations', the absurd and alienation were given free rein. Series such as *Shadow Chamber* (2005), *Boarding House* (2009) and *Asylum of the Birds* (2014) can be regarded as metaphors for the soul and are full of recurring elements such as animals, broken objects, organised chaos and body parts. Drawings also play an important role and seem to have an effect on the living protagonists in the photo. Ballen himself says that he was inspired by outsider art. He also recognises what his predecessors saw in the works, 'something very basic, very primitive and psychological'. His photos must, he says, be able to transform people and let them discover places in the soul that have never been visited before.

THERAPEUTIC AID

Since the 1940s, creative therapy has been based on the idea that the imagination can have a role in healing. The idea itself dates back to the Egyptians or to the cathartic effect of Greek drama.

Roger Ballen, *Consolation*, from the series *Asylum of the Birds*, 2011, photograph.
Artist's collection, Johannesburg. Dr. Guislain Museum, Ghent

Joseph Guislain (1797–1860) also allowed his patients to paint, preferably in the open air. In his *Traité sur l'aliénation et sur les hospices des aliénes* in 1826, he wrote: 'It is there that a beautiful sky, groups of trees, romantic places, picturesque views and colour nuances of whatever subject demand attention and allow him to forget the dominant idea of his insanity.'

Creative therapy was introduced in the 1940s as a new form of occupational therapy. It also had a therapeutic effect because drawing and painting were believed to make unhealthy thoughts visible. The idea was that one would then be able to understand the illness better.

In the 1960s the diagnostic function was abandoned and visual creativity took on the form of non-verbal psychotherapy. Artists started working in psychiatric hospitals with patients and set up studios, as Vincent Halflants did in the psychiatric hospitals in Tienen and Diest from 1969. The work of his 'students' was meant to have a stabilising effect, was a means of finding balance. He allowed them to draw and make sculptures in order to discover themselves. The Speelhoven Collection, which Halflants gathered as an archivist and curator, was donated to the Dr. Guislain Museum in 2018.

Jan Hoet (1936–2014) recognised the importance of the collection by including work in the *Open Mind* exhibition at the Museum of Contemporary Art in Ghent in 1989. Hoet was the son of a doctor in Geel and grew up with patients who lived with his family (a form of 'foster care' that is still common in the area). His introduction to the publication for the exhibition *Y.E.L.L.O.W*, which he curated in Geel in 2001, contained words that are evidence of the centuries-old fascination with madness: 'For us children, our housemates were fascinating because they did not have to comply with the rules and standards of society, but created their own laws and conditions. We saw this as proof that they had more imagination and freedom than others. I see that differently now, of course; reality is much more complicated than that.'

Roger Ballen, *Deathbed* and *Threat*, from the series *Asylum of the Birds*, 2010–2011, photographs. Artist's collection, Johannesburg. Dr. Guislain Museum, Ghent

Peter Cuyvers, untitled, undated, coloured pencil on paper.

Speelhoven Collection, Tienen and Diest. Dr. Guislain Museum, Ghent

Tower of Eben-Ezer, 2005, scale model. Bozar, Brussels. Dr. Guislain Museum, Ghent

MUSEUM OF OBSESSIONS

Between 1948 and 1963, Robert Garcet (1912–2001), a stonemason, worked with family and friends on a tower that was 20 metres high. The tower of Eben-Ezer, built in Eben-Emael in the north of Liège after the Second World War, is a symbol for peace and against all forms of violence. The name refers to the place where, according to the Bible, Samuel erected a stone to commemorate the victory of the Israelites over the Philistines in 1038 BC. Garcet also undertook geological, paleontological and archaeological research, and formulated theories about the origin of humankind. His pacifist message attracted many guests and the tower can still be visited today.

Swiss curator Harald Szeemann (1933–2005) discovered Robert Garcet's work in 1982 and became a regular visitor. He showed work by Garcet in *Der Hang zur Gesamtkunstwerk* (The tendency towards the total work of art) (1983), and had a model of the tower made for *Visionair België* (Visionary Belgium), an exhibition in 2005 marking the 175th year since the founding of Belgium. It was also Szeemann's last exhibition. Garcet is representative of the artists who do not follow a particular style or tendency but create their own 'individual mythologies'. According to Szeemann, the subjective, inner world of the maker contributed to a large degree to a better and deeper understanding of the work. He wanted to escape pigeonholing and fought for a *Gesamtkunstwerk* and a *Museum of Obsessions*, where art and life are entwined. He brought art brut and recognised artists together, and combined their work with documentary material and artefacts, such as dolls and votive offerings, but also folk art, for example. In 1963 he exhibited the by then forgotten Prinzhorn Collection in the Kunsthalle Bern under the title *Bildnerei der Geisteskranken — Art Brut — Insania Pingens*. The title of the book by Hans Prinzhorn also became the name of one of the sections in *Documenta 5*, where Adolf Wölfli's cell was reconstructed, and works and artefacts from the psychiatric hospital in Waldau were exhibited. He also endeavoured to show the work in the way it would have been seen in the hospital.

For Harald Szeemann, limits were there to be transcended: art brut was just as valid as any other art. The most important thing for him was the intensity, the passion with which work was made and how the art is anchored in the life of the artist. Obsession was the same as positive energy and freedom of expression.

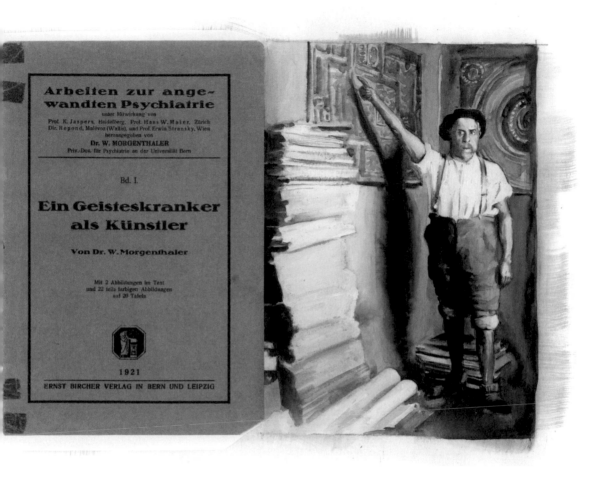

Jan De Maesschalck, *Untitled*, 2007, acrylic and acrylic medium on paper.

In 1921 the psychiatrist Walter Morgenthaler (1882–1965) wrote a monograph on the work of one of his patients, Adolf Wölfli (1864–1930), *Ein Geisteskranker als Künstler* (A mental patient as artist). Wölfli began to draw in the psychiatric hospital in Waldau when he was 35. The result was a *Gesamtkunstwerk* of about 25,000 pages, consisting of drawings, text and musical compositions. In *Untitled*, Jan De Maesschalck (b. 1958) confronts the cover of Morgenthaler's book with an iconic photo of Wölfli in his cell. He also looks to existing images for inspiration in other pieces. He selects, fragments and interprets them, creating new, often melancholic tableaus.

Jan Hoet shared this view and concluded his introduction in the publication *Y.E.L.L.O.W* with the following words: 'Although *Y.E.L.L.O.W* has nothing to do with the *Museum of Obsessions*, it is a conviction that I share with Szeemann. *Y.E.L.L.O.W* should demonstrate, albeit indirectly, that commitment and passion are the motor of artistic creativity. I also have the feeling that we can only gain an insight into "the other" if we direct our attention to the way he expresses himself, to the form of expression he chooses. And this applies just as much for artists and psychiatric patients as it does for people in general.'

The other has been regarded, examined and categorised with fascination throughout the centuries. The other was found fascinating because different from us, from our reality. However, we must not forget that the other is also a part of this reality and there is therefore no difference. Just as plants can be diverse, so can people, and therefore imagination can also be diverse. Will all inequality end when outsider art is no longer called such but fully accepted by the art world? Or should there be an openness in respect of different forms of expression, which all arise out of the same *obsessions*? Thomas Röske, director of the Prinzhorn Collection, concluded his essay *Outsider Art — The Past and Present of an Idea* (2019) with the following thought: 'For Outsider Art to be truly integrated (and hence included) in the art world, we will have to broaden our understanding of art to such an extent that we no longer expect the individuals behind artworks to have the same apprehension of reality as we have. This in turn means being open to a wealth of alternative messages, no matter how weird and bizarre they appear to be.'

BIBLIOGRAPHY

Faupin, Savine & Boulanger, Christophe (ed.). *Danser brut*. Villeneuve d'Ascq: LaM, 2018

Fol, Carine. *From Art Brut to Art without Boundaries. A Century of Fascination through the Eyes of Hans Prinzhorn, Jean Dubuffet, Harald Szeemann.* Milan: Skira Editore, 2015

Foster, Hal. 'Blinded Insights: On the Modernist Reception of the Art of the Mentally Ill', in: Cooke, Lynne (ed.). *Martin Ramirez: Reframing Confinement*. Madrid: Museo Nacional Centro de Arte Reina Sofia, 2010

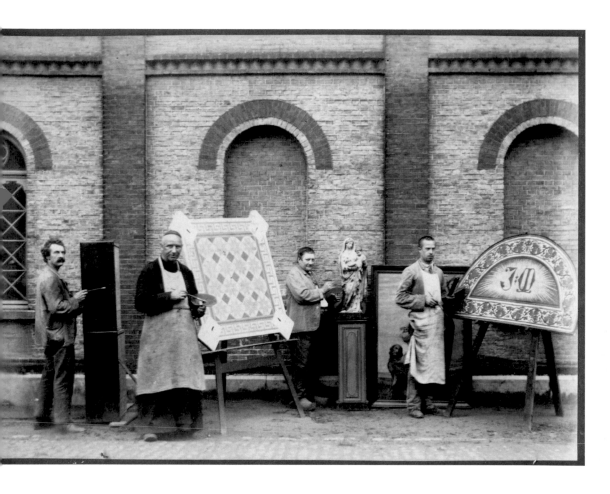

Painting studio, Hospice Guislain, 1887, photograph. Dr. Guislain Museum, Ghent

Gilman, Sander L. *Seeing the Insane. A Visual and Cultural History of Our Attitudes Toward the Mentally Ill.* New York: John Wiley & Sons, 1982

MacGregor, John M. *The Discovery of the Art of the Insane.* Princeton, New Jersey: Princeton University Press, 1989

Prinzhorn, Hans. *Artistry of the Mentally Ill.* Vienna: Springer-Verlag, 1972 (reprinted 1995)

Quaghebeur, Rolf (ed.). *Y.E.L.L.O.W. Tentoonstelling over actuele kunst en psychiatrie.* Ghent: Stedelijk Museum voor Actuele Kunst, 2001

Illustration from: Robert Burton, *The Anatomy of Melancholy*, 1652, London.

Dr. Guislain Museum, Ghent

In 1621 Robert Burton (1577–1640) published his masterwork *The Anatomy of Melancholy*, in which he brought together two thousand years of medical knowledge from ancient Greece to the seventeenth century. *The Anatomy of Melancholy* was a standard work about the causes of, and remedies and treatments for, melancholy. Melancholy was considered an imbalance of the humours with an excess of black bile. The symptoms were despondency, depression and inactivity. Burton suffered from melancholy himself and hoped that writing would help him.

From the third edition in 1628 onwards, a title plate was included in which the various forms of melancholy were depicted in characteristic ways. A poem explains the plate. The philosopher Democritus can be seen in the middle at the top, in a typically meditative pose leaning his head against his hand. He is sitting in a garden with the sign of Saturn in the sky, a planet that was linked to the melancholic temperament. Two causes of melancholy can be seen left and right of the scene: jealousy and loneliness. Inamorato, the melancholy of love, is depicted under 'jealousy'. Hypochondria, the worst form of melancholy, is depicted under 'loneliness'. Below left is a kneeling monk who represents religious melancholy; to the right, a raving madman. At the bottom, borage and hellebores are depicted, a herb and a plant that were used as medicine. Underneath the text in the middle we see the writer himself with the book in his hand. He is depicted with two symbols that refer to scientific research: the armillary sphere and the ferula, which in turn can be connected with the stick and inflated pig's bladder of the madman. It symbolises the journey of discovery that Burton undertook with his book in the universe of melancholy.

Jealousia.

Democritus Abderites.

Solitudo.

THE
ANATOMY OF
MELANCHOLY.
What it is, With all the kinds causes,
symptomes, Prognostickes, & seuerall cures of it.
In three Partitions, with their seuerall
Sections, members & subsections.
Philosophically, Medicinally,
Historically, opened & cut vp.
By
Democritus Iunior.
With a Satyricall Preface, Conducing
to the following Discourse.
The Sixt Edition, corrected and
augmented by the Author.
Omne tulit punctum, qui miscuit vtile dulci.

Inamorato.

Hypocondriacus.

Superstitiosus.

Democritus Iunior.

Maniacus.

London
Printed & are to be sould by
Hen: Crips & Lodo: Lloyd at
their shop in Popeshead alley

Borago.

C: le 1652 Blon: fe:

Helleborus.

*Variétés de la grande
attaque hystérique,*
from: Paul Richer, *Études
cliniques sur la grande
hystérie ou hystéro-
épilepsie*, 1885, Paris.
Dr. Guislain Museum, Ghent

2º Période de clownisme. 3ºPériode des attitudes passionnelles 4º Période de délire.

F G H I J K L

aye et E. Lecrosnier, Editeurs.

Anonymous,
Fever-induced
visions, 1821,
ink and water-
colour on paper.

Nauta Collection, Rotterdam

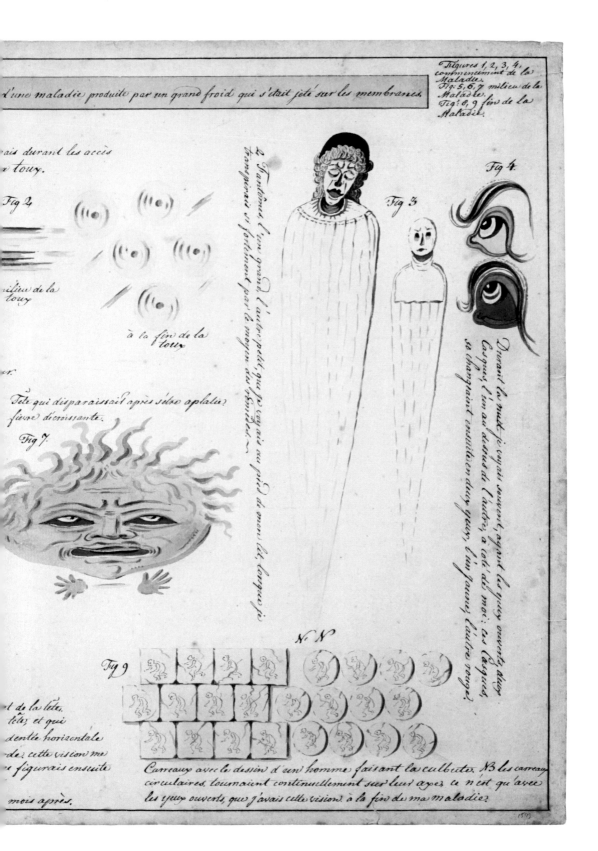

Figures 1, 2, 3, 4, le commencement de la Maladie.
Fig: 5, 6, 7 milieu de la Maladie.
Fig: 8, 9 fin de la Maladie.

d'une maladie produite par un grand froid qui s'était jeté sur les membranes.

...ais durant les accès ...e toux.

Fig 2

...ilieu de la ...toux

à la fin de la toux

Le fantôme l'un grand, l'autre petit, que je voyais ou au pied de mon lit, lorsque je transpirais si fortement par le moyen du fantôme.

ir.

Tête qui disparaissait après s'être aplatie. fièvre décroissante.

Fig 7.

Fig 3

Fig 4

Durant la nuit, je voyais souvent, ayant les yeux ouverts, deux Casques, l'un au dessus de l'autre, à côté de moi; ces Casques se changeaient ensuite en deux yeux, l'un jaune, l'autre rouge.

...t de la tête. ...têtes; et qui ...dentée horizontale ...de cette vision me ...e figurais ensuite

...mois après.

N. 8

Fig 9

Carreaux avec le dessin d'un homme faisant la culbute. NB les carreaux circulaires, tournaient continuellement sur leur axes ce n'est qu'avec les yeux ouverts, que j'avais cette vision à la fin de ma maladie.

Oswald Tschirtner, *Eine Sardinenbüchse* (A sardine can), 1971, ink and gouache on paper. De Stadshof Collection Foundation. Dr. Guislain Museum, Ghent

Psychiatrist Leo Navratil (1921–2006) started using drawing tests for his patients in the Maria Gugging psychiatric hospital near Vienna in 1954. He gave them the instruction to draw a human figure in pencil on a piece of paper the size of a postcard. He quickly realised the quality of many of the works and started a form of creative therapy. A number of patients drew his particular attention, including Johann Hauser, August Walla and Oswald Tschirtner. In the late 1960s Jean Dubuffet confirmed that the work of these artists was, indeed, art brut. In 1981 Navratil set up the Centre for Art and Psychotherapy in a pavilion that had become free and where patients could live and work. Psychiatrist and artist Johann Feilacher succeeded Navratil in 1986 and changed the name of the centre to 'Haus der Künstler', the House of the Artists. From that moment on, the focus was on the artist and his or her work, entirely separate from their status as patients.

The work of Oswald Tschirtner (1920–2007), who began to draw in the 1960s, is conspicuous because of its simplicity. His figures consist of a head and two arms and legs. They look mostly left and are stripped of any clothes and any characteristic that could distinguish them from each other. Even the haircut is the same. Tschirtner writes the title of his work at the top, and it is often as minimalist as his style. Because of his faith, he often drew religious scenes, such as Judith with the head of Holofernes. The figure of a crucified Christ is also a recurrent theme. Besides people, he drew *Ein Buch, Eine Banane, Ein Hut, Eine Windmühle* and even *Ein Punkt* (a book, a banana, a hat, a windmill, a dot). Occasionally he fills his contours in with colour, always pure colours, applied with the same sensitivity. Although his subjects have been reduced to their essence, we see what is undeniably his essence, suddenly allowing us to see things in a different way.

Eine Sardinabüchse

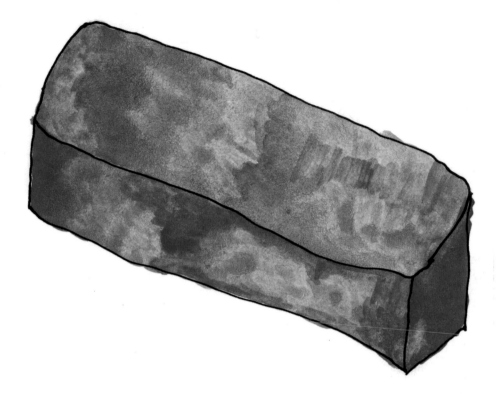

Tschüptner Oswald
Riethnau 26. Okt. 1971

Marie Lieb, untitled (photograph of the floor
of the room), 1894, inv. no. 1771/1.
© Prinzhorn Collection, University Hospital Heidelberg

Two photos were taken in the psychiatric hospital in
Heidelberg in 1894. The name Marie Lieb was stated
on both of them. One of the photos was published
in *Atlas und Grundriss der Psychiatrie* (1902) by Wilhelm
Weygandt (1870–1939), the assistant of Emil Kraepelin
(1856–1926). The caption reads: 'Patterns of figures,
made of pieces of bedclothes, spread out on the floor
of her room by a manic woman.' Women often tore their
hospital clothes and sheets into pieces in order to
make new clothes out of them and other things. Marie
Lieb (1844–unknown) may have regarded this piece
as a strategy in order to reverse the balance of power.

Katharina Detzel, untitled
(photograph of Katharina Detzel
with handmade male rag doll),
1914, inv. no. 2713a.
© Prinzhorn Collection, University Hospital Heidelberg

Katharina Detzel (1872–unknown) resisted
the hierarchical structure in the psychiatric
hospital of Klingenmünster in which patients
were oppressed and subjected to inhuman
punishments. She used her imagination to
express her need for freedom. She made keys
from wood and a human figure with wings, for
example. In addition to the many small dolls
she made from dough, she also made this
life-size male rag doll from sacks and straw.

Karin Borghouts, from the series *Museum Dr. Guislain*, 2019, photograph.

Félicien Rops, *La tentation de Saint Antoine* (The Temptation of St Anthony), 1887, etching by François Courboin, inv. G E0839.

Sigmund Freud (1856–1939) wrote in *Der Wahn und die Träume in W. Jensens 'Gradiva'* (1907) that artists could be interesting allies whose testimony deserved a lot of attention because they have insight into matters 'in heaven and earth'. According to Freud, *La tentation de Saint Antoine* by Félicien Rops (1833–1898) illustrated his theory about repression. What distinguishes the work from other depictions of St Anthony is that the sin — the woman — appears on the cross in the same pose as Christ, while 'other painters, who did not possess such penetrating psychological insight', always depicted the sin in a provocative pose next to the Saviour. According to Freud, Rops would have been aware of the fact that that which is repressed (sexuality) will always resurface in that which does the repressing (religion).

LA TENTATION DE SAINT ANTOINE

Klaas Koopmans, *'Gerritsen' met curieuze hoofdtooi* ('Gerritsen'
with strange headdress), 1959, pencil and watercolour on paper.
Stichting Klaas Koopmans. Dr. Guislain Museum, Ghent

Like other members of the Frisian artists' collective Yn 'e Line, Klaas Koopmans
(1920–2005) painted mainly landscapes and people around him in an expressionist
style. His institutional drawings are also conspicuous. He made them during his
admission to several hospitals. He did it secretly, because drawing and painting were
forbidden during three of his four admissions as they were not considered therapeutic.
He depicted his fellow patients with found materials. The portraits inspired him.
They also helped him to deal with being in the institutions.

Eric De Volder, untitled, undated and 1982, pencil on paper.

Theatre director Eric De Volder (1946–2010) recorded his dreams in sketches and always dated and described them. The subconscious played an important role in his work. De Volder used 'the dance of the shadow of the subconscious' during his creative process and described his dreams as follows: 'Just as the sun throws a shadow in front of me and that shadow moves when I move, I imagine that my subconscious also throws a shadow.' De Volder's view is inspired by a quotation from Carl Gustav Jung, who defined the subconscious as 'everything in the future that prepares itself in me and of which I will only become conscious in the future'.

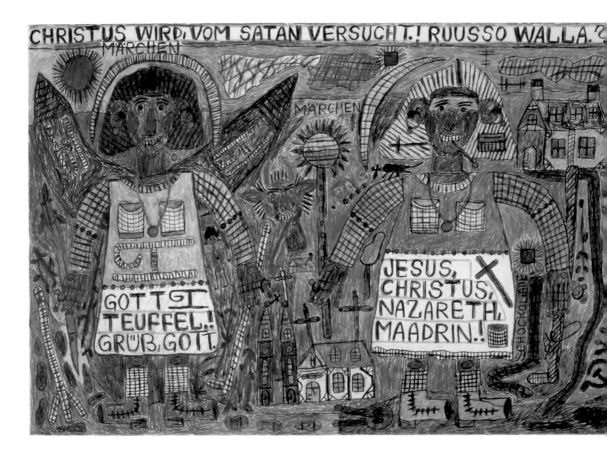

August Walla, *Christus wird vom Satan versucht* (Christ is tempted by Satan),
undated, crayon on paper. De Stadshof Collection Foundation. Dr. Guislain Museum, Ghent

August Walla's (1936–2001) drawings are larded with symbols and words.
The hammer and sickle and the swastika are motifs that refer to the occupation
of Vienna by the Soviet and Nazi regimes during his childhood. Walla's work
invokes its own mythology full of angels, gods and demons. He added self-made
words to his drawings as well. He mixed German with other languages — sometimes
understandable, sometimes not. These words occupy a prominent place in
his work. Walla expresses his thoughts with an arsenal of materials, on paper
and walls in clay, chalk, paint or felt-tip pen, in a variety of colours and forms,
sometimes monumental, sometimes so small that it can fit in one's hand.

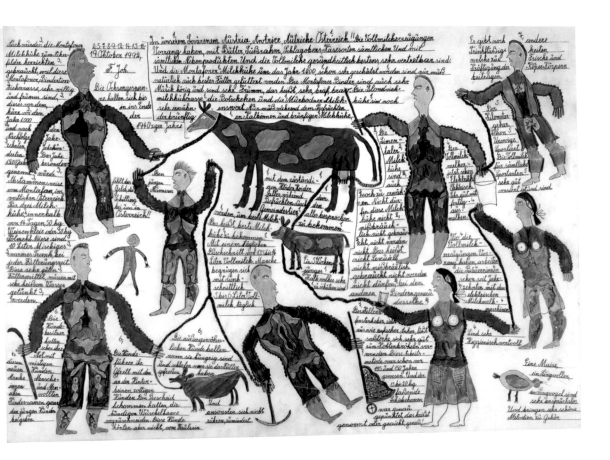

Johann Fischer, *Die Vollmicherzeugungen* (The whole-milk generations), 1992, pencil and colour pencil on paper.

Johann Fischer (1919–2008) began his artistic career when he was admitted to the psychiatric institution in Gugging, near Vienna. He made some drawings in pencil inspired by his daily life: farm scenes, plants, animals, etc. His work evolved: not only did he use more and more colour, but the compositions grew more complex. The narrative became more important. The text that is written around and between the figures refers to what can be seen, but also reflects Fischer's view of religion and society.

Zoe Beloff, *Charming Augustine*,
2005, film. Dr. Guislain Museum, Ghent

Past and present meet in the work
of artist Zoe Beloff, who was born in
Scotland in 1958 and lives in New York.
She mixes historical fact with fiction
and uses new techniques to honour
old ones. To do so, Beloff makes
use of diverse media, such as film,
performance, installation, drawing
and text. She pays attention to the
fringes of society, which she defines
as 'women, the working class, dreamers and utopians'.
She considers herself 'a medium between the living and the dead, between
what is real and imaginary'. The human psyche is often a source of inspiration.
Everything comes together in the 3D film *Charming Augustine*.

Zoe Beloff was inspired by the photos of Augustine, a psychiatric patient
who suffered from hysteria. These photos were taken at the Hôpital de la
Salpêtrière in Paris and published in the *Iconographie photographique
de la Salpêtrière*, which appeared from 1877 to 1880. The artists of her time
were inspired by the theatricality she exhibited during the various phases
of a hysterical attack. She became a star. *Charming Augustine* tells the story
of this young woman who was admitted in 1875
at the age of 15. There was a history of abuse.
Her history, which ended with her escape from
the asylum, is entwined in *Charming Augustine*
with the birth of the medium of film. Photographers
at the Hôpital de la Salpêtrière experimented with
chronophotography by quickly taking successive
pictures in order to capture movement. It was
hoped that this would allow doctors to penetrate
more deeply into the mind of the patient. By employing
stereoscopy, the predecessor of 3D, in this work,
Beloff investigates what film may have looked like,
had it been invented in the 1880s. *Charming
Augustine* intriguingly combines both histories.

Planche XXVIII.

DÉBUT D'UNE ATTAQUE

CRI

Paul Regnard, *Début d'une attaque* (Onset of a
hysterical attack), photograph of Augustine Gleizes,
from: *Iconographie photographique de la Salpêtrière*,
volume 2, 1877–1878, Paris. Dr. Guislain Museum, Ghent

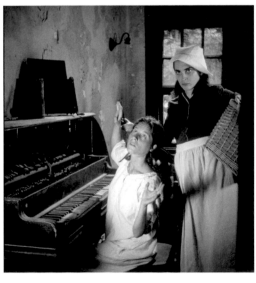

a b

Abb. 10a und b. Schizophrenie. Infolge ungeeigneter Isolierung in einer Einzelzelle h
der Kranke ein Bettuch zerschlitzt und sich aus den Streifen eine phantastische P
kleidung geschaffen.

Abb. 10a und b. Schizophrenie (Ill. 10a and b. Schizophrenia),
from: Oswald Bumke, *Lehrbuch der Geisteskranken*, 1929, Munich.
Dr. Guislain Museum, Ghent

'Because of inappropriate isolation in a cell,
the patient has torn a sheet and made a fantastic
piece of clothing from the strips.'

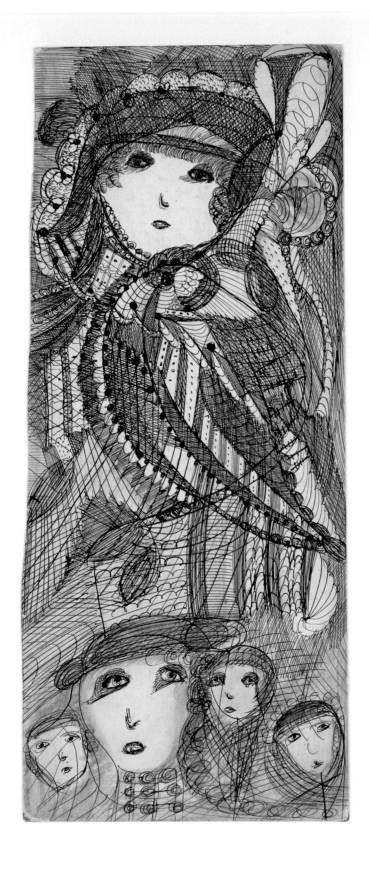

Madge Gill, untitled, undated,
Indian ink on paper.
De Stadshof Collection Foundation.
Dr. Guislain Museum, Ghent

Guided by the spirit
Myrninerest, Madge Gill
(1882–1962) drew her
mysterious female figures
all night long. It always
seems to be the same
woman, but it is anyone's
guess who she is: herself,
her mother, aunt or unborn
daughter. Gill's interest and
belief in spiritualism was
encouraged by her aunt
and was the mainspring
of her artistic creation.
She regarded Myrninerest
as her spiritual guide and
inspiration, but the spirit was
also a burden because of its
compulsiveness. Most of Gill's
work consisted of black-and-
white drawings, from the size
of a postcard up to canvases
several metres high. She
produced an enormous oeuvre,
which was only made public
after her death.

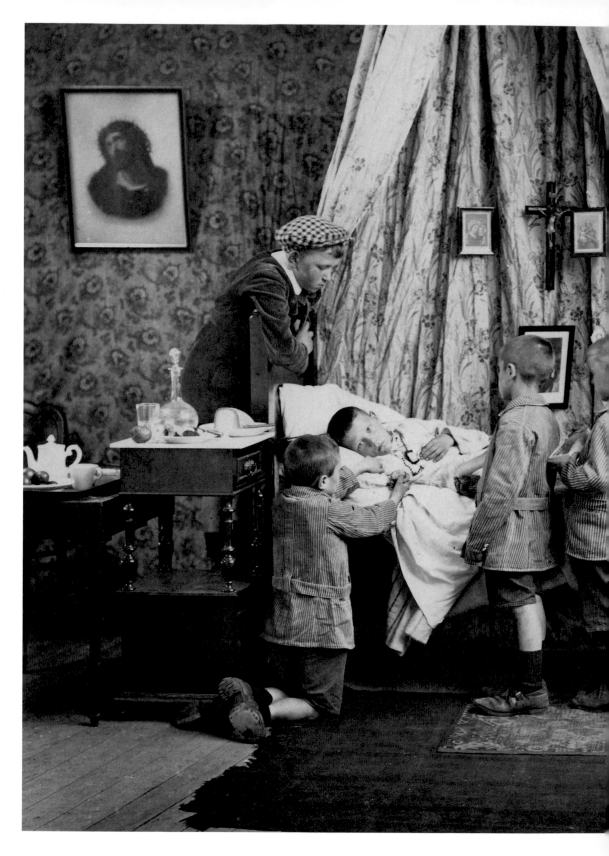

Ebergiste De Deyne,
untitled, first half of the
twentieth century, photographs.

Dr. Guislain Museum, Ghent

The generic scenes by
brother, educationalist and
photographer Ebergiste
De Deyne (1887–1943)
demonstrate how pupils
from the Sint-Jozefinstituut
in Ghent were supposed to
behave in certain situations.
The didactic photos depicted
everyday activities like polishing
shoes, grinding coffee and
reading the newspaper, but
also professions and the
husband-wife relationship
in the family context. They
are extremely posed and
arranged in the tiniest detail.

Jasper Rigole, *In Search of a Place on the Art Market, I Decided to Become a Painter. Part 1: Early Drawings 1983–1985*, 2008, eight drawings on paper, video.
Artist's collection, Ghent

According to psychoanalyst Melanie Klein, free association cannot be used with children under a certain age and so a play situation was used. The child could then establish contact with the therapist by using objects and drawing materials. Drawing became an important means of communication. In 2008 Jasper Rigole (b. 1980) decided to submit a collection of his own childhood drawings to a psychologist specialising in the subject. He did not tell her that they were his own drawings. The psychologist came to her conclusions, including that the drawings were made by a boy and that the often sombre and atypical colours could indicate a mild depression. Another possibility was that he was colour-blind.

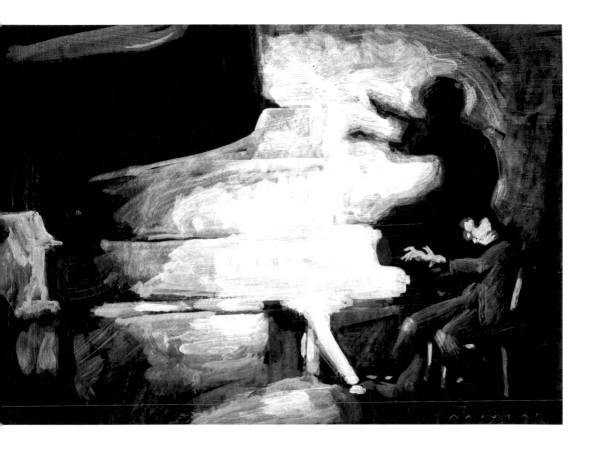

Koen Broucke, *Liszt-Broucke,*
Our Travelling Circus Life II, 2004,
acrylic on paper. Dr. Guislain Museum, Ghent

The psychiatrist Hahneman is a fictional character who
has compiled work by equally fictional patient-artists.
He is convinced that contemporary art is sick and
that artists are seriously disturbed. The work of Koen
Broucke (b. 1965) treads a fine line between fact
and fiction in which his characters are actually light-
hearted self-portraits. Each of his characters has his
or her own biography, idiosyncrasies and longings.
It gives Broucke the opportunity to explore art in every
possible direction.

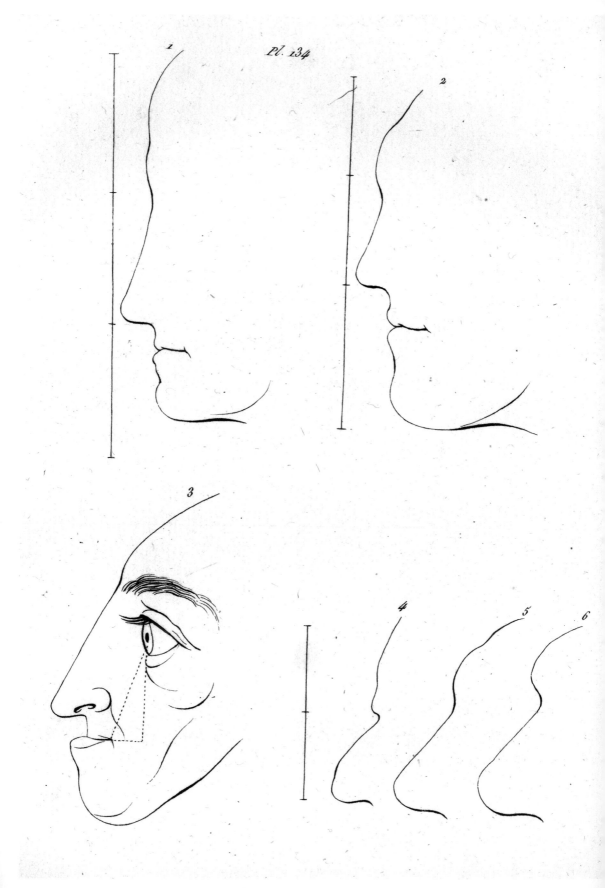

Pl. 134

CLASSI FICATION

Abb. 22. Melancholia attonita
(nach Kieser).

Abb. 46. Beide Korrugatoren und
ein Stimmmuskel in Tätigkeit.

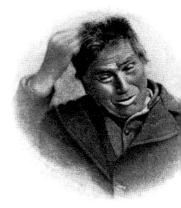

Abb. 25. Heitere Phase bei
demselben Mann.

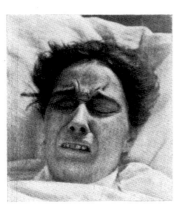

Abb. 44.

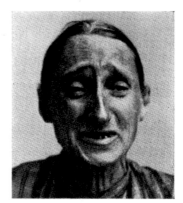

Abb. 45.

Abb. 44—45. Ausbreitung des Affekts auf die untere Gesichtshälfte (nach Turner).

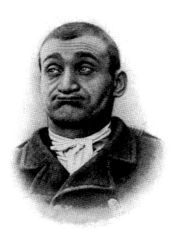

Abb. 47. Nur die äußere Hälfte des rechten
Frontalis in Tätigkeit (nach Turner).

Abb. 53. Katatone Muskelspannungen.

Abb. 32. Heiterkeit im durchfur
Gesicht.

Illustrations from: Theodor Kirchhoff, *Der Gesichtsausdruck und seine Bahnen beim
Gesunden und Kranken, besonders beim Geisteskranken* (Facial expressions and their traces
in the healthy and diseased, especially in the mentally ill), 1922, Berlin. Dr. Guislain Museum, Ghent

Sarah Van Bouchaute

NAMING IN ORDER TO UNDERSTAND

Behaviour and Mind
Compartmentalised

Categories create clarity of mind: we give things names in order to grasp the world around us. That is useful, but it is also misleading if we risk forgetting that we are talking about artificial constructions. English philosopher John Stuart Mill (1806–1873) described the principle as early as 1869: 'The tendency has always been strong to believe that whatever received a name must be an entity or being, having an independent existence of its own.' Categories give us grip, but they are still only definitions that evolve along with the historical and cultural context. So they can never be definitive. How do we define the border, then, between what is normal and what is disturbed, and what does this say about how a society functions? When is someone declared mentally ill? When does a grieving process become depression? Why do we say a fidgety child has ADHD? Do we find solutions more quickly by labelling everything?

IMPACT OF THE LABELLING CULTURE

The Greeks and Romans divided human beings into four types: sanguine or optimistic, phlegmatic or resigned, choleric or passionate, and melancholic or gloomy. In the view of Hippocrates and Galen, the balance in the proportions of blood, phlegm and yellow or black bile in the body determined physical and psychological health. The doctrine of the four humours was one of the first clear classification methods, a system for distinguishing between normal and abnormal, analysing human characteristics and defining typologies.

Today we order a multiplicity of symptoms into an almost endless list of disease profiles. The fifth edition of the *Diagnostic and Statistical Manual of Mental Disorde*rs (DSM-5) was presented in 2013. This diagnostic guide, used around the world, contains descriptions of all the mental conditions based on their symptoms. The categories range from anxiety to depressive, bipolar and addictive disorders. Therapists can add or reject symptoms from

checklists to arrive at a clear diagnosis. A disorder is determined by the occurrence of a number of characteristics from among the classification criteria over a given period. The underlying assumption is that all disorders are quantifiable. As the different versions of the DSM have been released, more and more characteristics have been described. Has opening up the borders of diagnoses led to more precise diagnoses or to over-classification? Critics such as clinical psychologist and psychoanalyst Paul Verhaeghe have pointed out the dangers of the contemporary culture of labelling, where we classify all deviations from the norm as psychiatric disorders and treat them with medication. According to Allen Frances, an American psychiatrist who chaired the team that compiled the DSM-IV, we live in a time of diagnostic inflation and a psychiatry that is out of control, a time when millions of people are labelled too quickly and when it is no longer normal to just be sad, agitated, frustrated or anxious now and again.

Labelling can have both a positive and negative impact. A diagnosis can create a sense of relief, acknowledgement and a possible path to recovery, a certificate of incapacity for work or benefits. The flip side is a brand on the forehead or a feeling of isolation and shame. In recent decades, we have started using and discussing psychiatric labels in our living rooms and schools as well as on television programmes. We speak and think in terms of diagnoses. Does this reduce stigma and encourage open debate? Or has it increased the risk of slipping into stereotypical thinking patterns? Medical science is certainly achieving successes: belief in the effectiveness of drugs is the norm and an enormous range of treatments is available. How do we reconcile the immense efforts being made for our mental health with the growing array of psychiatric diagnoses? Is the DSM the guilty party, or are we all suffering from a labelling compulsion?

THE VISIBILITY OF SYMPTOMS

Although the compulsion in the human psyche to understand and investigate is an eternal constant, modern psychiatric diagnostics began when the first psychiatric hospitals emerged in the late eighteenth century. Until then, madness had been approached through religious and political beliefs: the insane were considered to be possessed, dangerous madmen and women, or people who were socially and economically useless. The first psychiatrists believed in the ability of science to recognise disease profiles and

find ways of curing them. This optimism was expressed in a compulsion to survey and take stock. Pioneering French psychiatrist Philippe Pinel (1745–1826) — the head doctor at the Hôpital de la Salpêtrière, an institution near Paris with 7000 female patients — published his observations in *Nosographie philosophique ou méthode de l'analyse appliquée à la médecine* (1798). Pinel and his contemporaries tried to comprehend the incomprehensible and to categorise the indescribable. The first Belgian psychiatrist, Joseph Guislain (1797–1860), likewise developed a classification three decades later, which he applied in practice in the form of the architecture and wards of his Hospice pour hommes aliénés in Ghent. The intention was to group patients' individual symptoms into collective disease profiles. The details of diagnoses such as melancholy, dementia and mania depended on the personal interpretations of the doctors in charge, which resulted in ambiguous diagnoses.

A first attempt at a systematic survey and collective language was undertaken by German psychiatrist Emil Kraepelin (1856–1926). In his *Psychiatrie: Ein Lehrbuch für Studierende und Ärzte* (1883), he created categories based on shared patterns of symptoms among hundreds of mentally ill people who had been described throughout the nineteenth century. He drew inspiration from the clear classification of the plant and animal kingdoms by Swedish doctor, botanist and zoologist Carolus Linnaeus (1707–1778). Kraepelin's encyclopedic work was successful — a classic example is his influential distinction between manic-depressive disorder and dementia praecox — but he did not succeed in achieving a standardisation effect. Institutions continued to uphold their own diagnostic frameworks. Nevertheless, his work is seen as the most important early contribution to the classification of psychiatric disease profiles, and traces of his classification system can still be found in the DSM.

In early psychiatric handbooks like Kraepelin's *Lehrbuch*, the descriptions of disease profiles were supported with portraits of patients. Psychiatrists immediately picked up on photography as an 'objective' scientific instrument to use in observations and classifications and to lend legitimacy to diagnostic categories. This idea refers to the physiognomic tradition: reading a person's inner being by means of external characteristics. Various publications refer to typical facial expressions, physical characteristics and postures of mania, melancholy or hysteria. The focus is not so

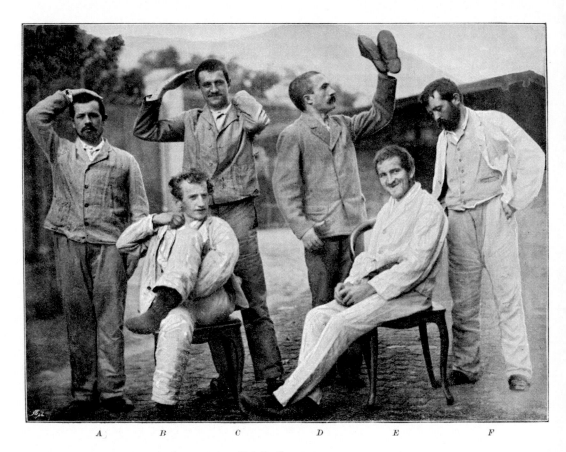

Katatonikergruppe.

Katatonikergruppe (Group of catatonics), from: Emil Kraepelin, *Psychiatrie.
Ein Lehrbuch für Studierende und Ärzte*, 1899, Leipzig. Dr. Guislain Museum, Ghent

German psychiatrist Emil Kraepelin (1856–1926) writes that the patients in this
Katatonikergruppe can be put in the desired pose without difficulty. Some are
smiling, others are serious, but they keep their own position when they are placed
in groups. One is holding up his shoe; another is resting his hand on his head.
The wall of the institution is subtly visible in the background. An index has been
added below the photograph: the patients were allocated letters referring to
the different phases in the diagnostic category. Patient E is completely mentally
disabled; A, B and C are in an early stage. Some have experienced a relapse,
whereas others are recovering. They are all suffering from catatonia, with
ecstatic and theatrical characteristics.

much on the sick patient: the portraits are used to visualise the disease. The individual is shifted to the background; the disease profile is central.

The visibility of symptoms — external signs that immediately catch the eye — have always played a key role in psychiatric diagnosis. The first psychiatrists initially focused on mood swings, violent acts, extreme passions and hallucinations. They attempted to describe the symptoms and searched for unique characteristics and shared traits to situate them within a classification. To apply a system that is as universal and objective as possible, the DSM also focuses on visible symptoms and behavioural characteristics, not the underlying structures. British psychoanalyst Darian Leader claims that madness is not necessarily visible. Only the delusions or other symptoms of people who come into conflict with the outer world are noticed. Seemingly healthy people who function perfectly in society can equally well suffer from 'silent madness'. Without a conflict, however, no diagnosis and treatment will follow. To put it otherwise: people can be mentally ill without ever being referred to as such. This is an approach that sets normality and madness side by side rather than in opposition. Leader believes that it is impossible 'to make a diagnosis based on a classification of external behaviours; that is only possible by listening to what the people in question have to say about what has happened in their lives; by taking the perspective from which they tell their story seriously'. Various critical voices today place the emphasis on the individual story, the experience and thoughts of people subject to mental suffering.

HYSTERIA AND HOMOSEXUALITY

One of the most famous series of photographs in psychiatric history was published in (Nouvelle) Iconographie de la Salpêtrière. The photographs show women in various stages of hysteria attacks. They are patients at the Hôpital de la Salpêtrière, where Jean-Martin Charcot (1825–1893) carried out research into hysteria from the 1870s onwards. The hysterical woman was depicted stereotypically with uncontrolled body movements and cramped or paralysed limbs. The symptoms were inexplicable pains, panic attacks, sleeplessness, sexual dysfunction, passionate or sexually forward behaviour, and wilfulness. Hysteria became the most fashionable nervous disorder of the second half of the nineteenth century.

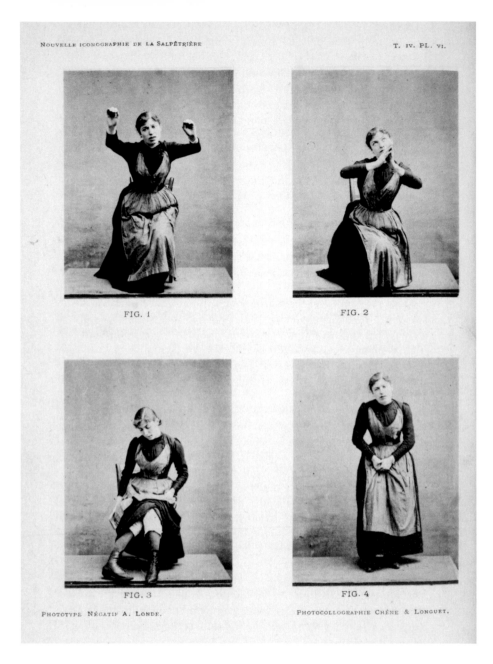

FIG. 1

FIG. 2

FIG. 3

FIG. 4

PHOTOTYPE NÉGATIF A. LONDE.

PHOTOCOLLOGRAPHIE CHÊNE & LONGUET.

Albert Londe, *Suggestions par les sens dans la période cataleptique du grand hypnose* (Suggestions from the senses in the cataleptic phase of deep hypnosis), from: *Nouvelle Iconographie de la Salpêtrière*, volume 4, 1891, Paris. Dr. Guislain Museum, Ghent

'After hypnotising her, we placed a red glass in front of her eyes. Great fear immediately appeared on her face. She raised her arms, and her eyes, which were staring into the distance, seemed to be witnessing a terrifying scene (Pl. VI, fig. 1). *Blue glass.* — she turns her eyes heavenwards, raises her hands in the air in a gesture of prayer and, finally, sinks to her knees. (Pl. VI, fig. 2). *Yellow glass.* — she frowns, blinks and places her hands like a shade in front of her eyes, as if to protect them from light that is too bright.'

The symptoms of 'women's diseases' often affect the body, sexuality and the emotions. According to the Greeks, hysterical symptoms were caused by a lack of sexual activity. In the Middle Ages, that reasoning was reversed: now it had to do with fear of female sexuality. In the mid nineteenth century, Joseph Guislain also described the risks of the female body and the associated emotional instability. The patient registers of female mental patients at the Sint-Jozefhuis in Ghent record symptoms such as excited, sad, fearful, despairing and jealous, or erotic thoughts, extravagant behaviour and disorder of the mind. The menstrual cycle was to be monitored closely, because it could provoke a 'manie érotique' or 'passion hystérique'. What is striking is the way Guislain described patients' progress: works all day, makes her bed, tidies her room, starts talking about her children, goes to church, takes care of her appearance. In other words, psychiatric health was connected to conforming to expected roles. When the patient assumed her conventional female tasks again, she could be declared cured. In his Leçons orales sur les phrénopathies (1852), Guislain put it clearly: women who got involved in the male world of money, power and culture were making themselves particularly vulnerable to mental illness. Or, conversely: headstrong women who did not fit within patriarchal norms risked being labelled mentally ill.

In essence, this has to do with freedom of movement. In Mad, Bad and Sad (2008), British writer and historian Lisa Appignanesi describes how Charcot's hysterical woman could be considered a catch-all for the fears and ambitions of his age. She is a caricatured version of the generally accepted vision of femininity: passive, pliable and extraordinarily desirable. But the hysteric also embodies the desire for freedom and liberation from what Freud later called 'civilized sexual morality'.

The increased freedom of movement at the beginning of the twentieth century offered new opportunities but also different fears: agoraphobia, or the fear of going outdoors alone, emerged. Today the freedoms obtained are coupled with high expectations regarding the family, career and social status, and this in turn entails new risks. Hysteria as a disease profile was removed from the DSM-III in 1980 — and replaced by theatrical (DSM-IV) and histrionic personality disorder (DSM-5) — but in our use of language, the clichéd meaning of the word 'hysterical' is never far away. Implicitly sexist tendencies can still be perceived in the

DSM. This is logical, since the diagnoses in the manual are based on the standardisation of social behaviour and current expectations of such behaviour inevitably creep into diagnoses. Should we call the hormonal fluctuations that occur in the period shortly before menstruation, with symptoms such as irritability, instability and tantrums, a psychiatric disorder? Why is female aggression still more likely to be labelled 'inappropriate'?

Gender-related disease profiles demonstrate nicely how classifications are built on conventions and are morally laden. Although hysteria is mainly known as a female phenomenon, men also received this diagnosis. Decades after the hysteria epidemic, comparable symptoms occurred among soldiers at the front during the First World War. They were overcome by extreme panic, paralysis and nervousness, which led to their being declared unfit for military service. The military labelled the men cowards and considered their symptoms attempts to escape from the front. Severe punishments were the result, such as sham executions and electric shocks to the genitals. Doctors called it hysteria. The female disease was twisted into another stubborn cliché: 'male weakness'. When it turned out that the term did not really fit, concepts like 'shell shock', 'soldier's heart' and 'combat neurosis' emerged. It was only after the Second World War that post-traumatic stress disorder became a recognised disease.

The stubborn dichotomy of male and female leads to problems whenever male or female behaviour deviates from the norm imposed on the category. The label of homosexuality was — and in some cultures still is — not merely a reference to a sexual orientation, but a way of pushing the bearers of the label into the margins of society. Things were not always that way. The Greeks did not make a moral distinction between heterosexuality and homosexuality. It was only later that homosexuality became successively sinful, dangerous and disturbed. In the sixteenth century, sodomites were burned at the stake. At the end of the nineteenth century, German psychiatrist Richard von Krafft-Ebing (1840–1902) included homosexuality in his *Psychopathia Sexualis* (1886), a catalogue of sexual perversions and disorders. It was not until 1974 that homosexuality was removed from the DSM, not due to scientific insight but under pressure from the gay rights movement that was demanding a place in society from the margins. Likewise today, science and society ponder questions of gender diversity; the meaning of a normal man or woman is shifting.

Gender-specific generalisations and prejudices still lurk in popular culture, language use and scientific studies.

ADHD AS A FASHIONABLE DIAGNOSIS

Classifications are based on the desire to name things, and they use language and terminology as their tools. Kraepelin and his contemporaries used terms derived from Greek and Latin. From the twentieth century onwards, scientific-sounding acronyms have also been used. ADHD (Attention Deficit Hyperactivity Disorder) is the best-known example. Like hysteria in the nineteenth century, ADHD has emerged as a fashionable, contemporary diagnosis. But when we place the symptoms — agitation, no self-control, lack of concentration — in a wider time frame, it is striking that concern for these 'children at risk' is not a recent phenomenon. It has been

Ebergiste De Deyne, Diagram of normal and abnormal development, early twentieth century, paper. Dr. Guislain Museum, Ghent

a slow process that began in the late nineteenth century and fully developed during the twentieth, which Swedish pedagogue Ellen Key heralded promisingly, and not coincidentally, as 'the century of the child'. There was no such term as ADHD at the time; people spoke of a 'moral deficiency' in children, 'instability' (*instabilité*) and 'nervousness' (*Nervösität*). Psychiatrists and educationalists complained about the negative influence of stimuli, the pressure of 'modern society' and 'mental overload' as the cause of an explosion in nervous disorders. In pupils' reports from the Medisch Pedagogisch Instituut Sint-Jozef in Ghent — which was founded in 1901 and grew out of the children's ward of the Guislain asylum — a few boys were described as constantly nervous. The metres-long archives kept by the institute are stored at the Dr. Guislain Museum and offer insight into perspectives on children at the time. A report from 1930 labels the ten-year-old Jacques as suffering from *nervosité extrême*. He is generally disruptive, makes silly comments, bursts out laughing at nothing and is easily distracted: 'He pays attention to whatever stimulates his senses. He ignores all rules and orders to satisfy those impulses.'

These specific, child-oriented descriptions were relatively new. Concern about 'difficult' children has always existed, but it is only since the beginning of the twentieth century that their behaviour has been increasingly labelled as a disorder. German psychiatrist Hermann Emminghaus (1845–1904) was one of the first to attempt to classify disease profiles in children and adolescents, in *Die psychische Störungen des Kindesalters* (1887). Before then, broad terms such as 'idiots', 'imbeciles' and 'cretins' were used. This changed around the turn of the century with the growing medical attention to abnormal behaviour in children. An illustration of this is the work of the Centraal Observatiegesticht (COG) in Mol, an institution for young people that screened young delinquents from 1913 onwards over a period of at least three months, then gave them a diagnosis and placed them in a corresponding institution. It might be a 'farm school for the abnormal', an 'insane asylum' or a national educational institution. On the basis of the observation data and the results of measurements, the minors were classified into four categories: the medically, mentally, socially and morally disturbed. The psychological emphasis in the classification marks a turn in the way the 'abnormal' child was dealt with. Psychiatric terminology — such as 'psycho-nervous weakness' — was increasingly used. Institutions like the COG

mainly focused on re-education. The emphasis was on reducing immoral behaviour and delinquency. Concern for children at risk, but also children as a risk, provided the basis for the classification of disorders — or disturbing behaviour — in young people. A growing trust in scientific explanations powered the pathologization of abnormal behaviour, the development of child psychiatry as a fully fledged discipline and specific diagnoses such as ADHD.

Today the ADHD concept is still considered useful, but reservations have been expressed. There are children who meet the classification criteria but do not experience any difficulties. Other children do not tick enough boxes, but suffer so badly from their symptoms that treatment is required. What is more, all children are agitated or inattentive sometimes. How do we determine when 'agitated behaviour' stops being normal?

ADHD has taken on epidemic proportions since the 1990s. In the United States, Allen Frances witnessed the number of diagnoses of ADHD tripling after the publication of the DSM-IV; autism occurred 30 times as often and bipolar disorder in children doubled. Have we all become more disturbed? Frances believes that we should read the steep increase more as 'false epidemics'. ADHD has not increased: we have simply given the behaviour a different name and reduced the thresholds, so that diagnoses are made more quickly.

Veertienjarig schizophreen meisje: Stereotyp grimasseeren (Fourteen-year-old schizophrenic girl: stereotypical grimaces), from: René Nijssen, *Leerboek der kinderpsychiatrie en der heilopvoedkundige behandeling*, 1942, Antwerp.

Dr. Guislain Museum, Ghent

92. *Veertienjarig schizophreen meisje : Stereotyp grimasseeren*

93. *Veertienjarig schizophreen meisje : Stereotyp grimasseeren*

The hype surrounding ADHD shows how deeply diagnoses can be integrated into society. Today fidgety people are likely to be told they are suffering from ADHD. The pendulum has swung so far that people seek an explanation for the symptoms in the label itself: 'I'm fidgety because I have ADHD' or 'I feel down because I'm depressive'. This is circular logic, in which the disorder becomes the explanation for the symptoms. ADHD then becomes the cause of the problems rather than a description of the characteristics that define the diagnosis. Canadian historian and science philosopher Ian Hacking describes this as 'making up people': 'inventing' classifications or constructing categories of people. The categorisation process contributes to the creation of the group described. The bearers of labels can appropriate the label in turn, increasingly identifying with the characteristics of the group and even changing its meaning so that the definition needs to be readjusted. Hacking calls this the looping effect. Classifications are not purely descriptive: they influence and change the way people think about themselves and how they behave.

CLASSIFICATIONS SHIFT

Concern about our mental state is great, not only in the professional arena but right across society and, in particular, among individuals. We are constantly reviewing our own boundary between normal and slightly abnormal. Both human suffering and the naming of these complaints in disorders are subject to historical change. What is considered a disorder of the mind today may have had a different meaning in the previous century, and may not even have existed in the century before that. Diagnostics arise from a delicate interplay between an evolving science and the cultural context determined by prevalent norms and social expectations. Systems emerge and may also disappear or be put into a different context. Today fear and stress-related diagnoses dominate an achievement-based society that makes high demands in terms of work and relationships. A label can acknowledge suffering, but also entails the message 'do something about it'. Resilience is required; solutions exist in all shapes and sizes. The step towards medication — and self-medication — has become smaller. In a psychologised society, medical terminology is appropriated and we seek answers in self-help books and online testimonials, and in visits to psychologists and life coaches. We name things in order to grasp them.

There is no point searching the history of diagnostics for disorders that have always existed. Bipolar disorder is not the same as manic-depressive disorder as Kraeplin described it, and nineteenth-century melancholy is not the equivalent of depression. Such comparisons assume that age-old problems meet with a correct diagnosis and better treatment in today's classification system, which is an optimistic but incorrect assumption. Our classifications are constantly shifting. Suffering of the human soul is constantly given different names and interpretations according to medical and social beliefs. The important thing is the meaning attached to the classifications. If the DSM contains ever more disorders, what does that say about how we think about psychological vulnerabilities? Does it mean that there are ever more human characteristics we no longer accept?

In an attempt to understand psychological issues, the enigmas of the mind are constantly being rewritten. The redefinition of disease profiles constructs a new psychological reality. Diagnostics are particularly sensitive to changing social conventions regarding the border between normal and abnormal behaviour. It is still difficult, if not impossible, to determine fixed characteristics of a given mental illness. In 1826 Joseph Guislain wrote: *'On veut les contenir dans le cercle d'un système nosologique; on les groupe; on les classe vainement: toujours la nature franchit nos limites'* (One wishes to contain them within the circle of a diagnostic system; one groups and classifies them in vain: nature always breaks through our boundaries). Diagnoses will remain flexible, which means they will always be susceptible to taking on epidemic proportions.

BIBLIOGRAPHY

Appignanesi, Lisa. *Gek, slecht en droevig. Geschiedenis van vrouwen en psychiatrie van 1800 tot heden*. Amsterdam: De Bezige Bij, 2009

Bolt, Timo. *Van zenuwachtig tot hyperactief. Andere kijk op ADHD*. Amsterdam: Uitgeverij SWP, 2010

Dehue, Trudy. *Betere mensen. Over gezondheid als keuze en koopwaar*. Amsterdam: August, 2014

De Koster, Margot. 'Tot maat van recht. De vroege ontwikkeling van de wetenschap van het ontspoorde en criminele kind in het Centrale Observatiegesticht in Mol (1913–1941)', in: Bakker, Nelleke. *Kinderen in gevaar. De geschiedenis van pedagogische zorg voor risicojeugd*. Assen: Van Gorcum, 2007, pp. 94–119

Frances, Allen. *Terug naar normaal. Inside informatie over de epidemie van psychische stoornissen, DSM-5, Big Pharma en de medicalisering van het dagelijks leven*. Amsterdam: Nieuwezijds, 2013

Hacking, Ian. 'Making Up People', in: *London Review of Books* 28 (2006) 16, pp. 23–26

Leader, Darian. *Wat is waanzin?* Amsterdam: De Bezige Bij, 2012

Verhaeghe, Paul. *Het einde van de psychotherapie*. Amsterdam: De Bezige Bij, 2009

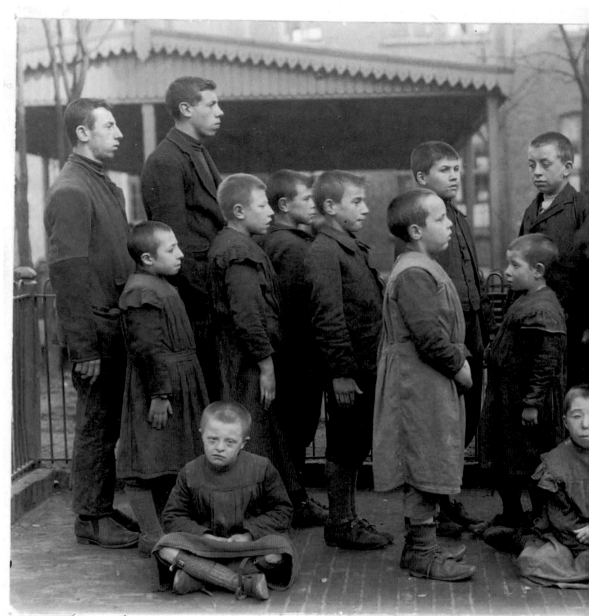

Quelques Caractéristiques Frontales

Ebergiste De Deyne, *Quelques caractéristiques frontales* (Various frontal characteristics), photograph, c. 1930.

Dr. Guislain Museum, Ghent

The '*kinderkoer*' or children's section at the Hospice Guislain was long the only residential home for children with learning difficulties in Belgium. In the early twentieth century, the importance of special institutions designed for children became apparent. From 1919 onwards, educationalist and Brother of Charity Ebergiste De Deyne (1887–1943) headed the Sint-Jozefinstituut in Ghent for *enfants anormaux*: 'teachable children of feeble mind', or in contemporary terms, children with a slight mental or physical disability. The 'unteachable children of feeble mind' were placed in a different institution. De Deyne had a great interest in photography and regularly took pictures of the children. The richest collection of photographs he left to posterity — with portraits, medical images and didactic photographs — gives insight into the view of 'abnormal children' at the time.

This group portrait shows 'various frontal characteristics'. The children wear uniform clothing and most are pictured in profile to show their facial features clearly. De Deyne was looking for similar features. He observed the boys, studied their physical and mental characteristics, and categorised them. He also believed strongly in their potential. By stimulating the senses, their hidden abilities might be developed further. De Deyne created learning tools to achieve this: educational material to stimulate vision, touch, hearing, smell and taste. The pupils were prepared for a life outside the institution with handicraft workshops and lessons in household tasks. De Deyne believed that every child was capable of development in spite of their disabilities. This conviction can be read from a series of portraits he made of his pupils. The formal pose, with a straight back and in decent clothes, demonstrates this educational optimism. The focus is not on the disability, but on the boys' potential and the learning process.

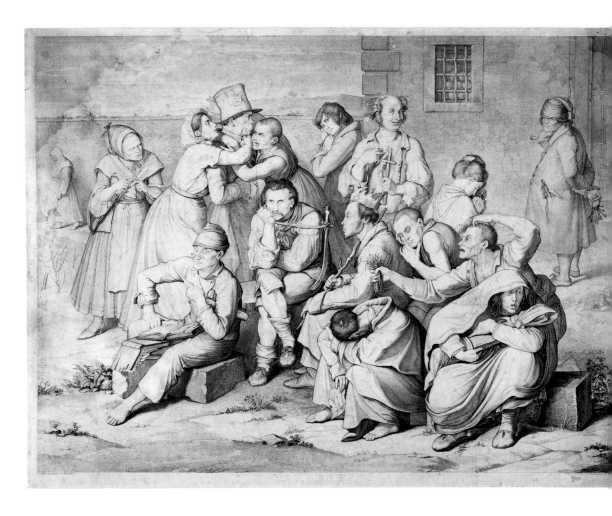

C.H. Merz, after Wilhelm von Kaulbach, *Das Narrenhaus* (The madhouse),
1834, engraving. Dr. Guislain Museum, Ghent

Moved by a visit to a mental hospital in Düsseldorf, German artist Wilhelm von
Kaulbach (1805–1874) encapsulated his impressions in a drawing. The engraving
shows patients in what appears to be the garden of an institution. The attributes
they have with them refer to their illness: the megalomaniac's crown, the crazy
mother with her child made of branches, the religious fanatic with the cross,
the mad genius and his books, and so on. *Das Narrenhaus* became famous at
the time for its artistic qualities and was valued in psychiatry for the scientific
presentation of illness, sick people and symptoms.

Illustration from
C.E. van Koetsveld,
Het idiotisme en de
idioten-school. Een
eerste proeve op een
nieuw veld van genees-
kundige opvoeding
en christelijke
philanthropie
(Idiocy and the
School for Idiots.
A first attempt in
the new field of
medical education
and Christian
philanthropy),
1856, Schoonhoven.

Dr. Guislain Museum, Ghent

Cornelis Eliza van Koetsveld (1807–1893), the founder of the 'School for Idiots' in The Hague, identified three forms of idiocy: 'born mad', 'simple' and 'idiot'. The drawings at the top show discrepancies in the shape of the skull. Van Koetsveld compares the average facial angle of the average European (80–85 degrees) to that of his pupils (68–70 degrees) and that of an orangutan (50 degrees). The illustration below shows 'serious idiocy', with 'a physical build that is so deficient or already degenerated that all hope of recovery must be given up'. In the high chair is a thirty year-old male with severe learning disabilities and whose 'hideous hydrocephaly is not half striking enough to the eye in our picture'.

De Figure van een Monster-Kint, by faute van genoechsame quantiteyt Saets
(A monster child, due to an insufficient quantity of semen), *De Figure van twee monstreuse Kinderen, die onlancks tot Parijs zijn gheboren geweest* (Two monstrous children recently born in Paris), *De Figure van een Monster-Kint, dat sonder Hooft gheboren is* (A monster child born without a head), from: Ambroise Paré, *De chirurgie ende alle opera*, 1592, Dordrecht. Dr. Guislain Museum, Ghent

De Figure wan twee monſtreuſe Kinderen, die onlancks tot Parijs zijn gheboren gheweeſt.

De Figure van een Monſter-Kint, dat ſonder Hooft gheboren is.

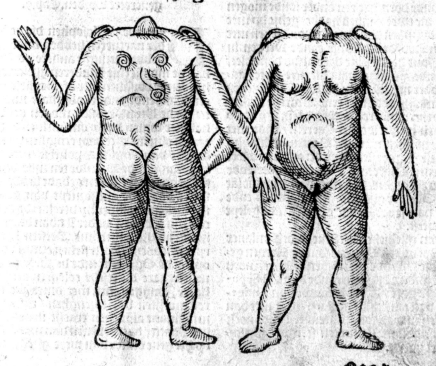

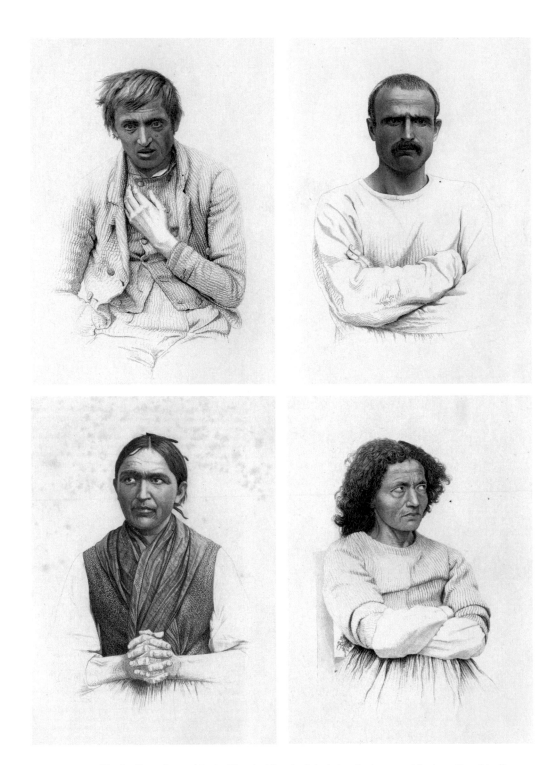

Illustrations from: Maximilian Leidesdorf, *Lehrbuch der psychischen Krankheiten* (Textbook of psychiatric diseases), 1865, Erlangen. Dr. Guislain Museum, Ghent

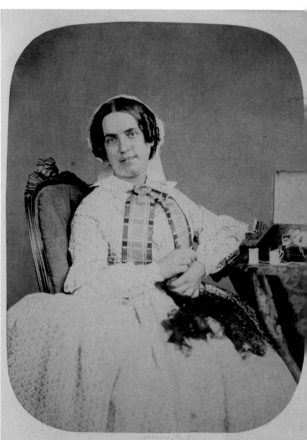

Henry Hering, *Portrait of Edward Oxford*, c. 1859, photograph. Bethlem Museum of the Mind, Kent
Henry Hering, *Portrait of Harriet Jordan*, 1858, photograph. Bethlem Museum of the Mind, Kent

In the mid nineteenth century, British photographer Henry Hering (1814–1893) made
portraits of patients from Bethlem Hospital in London at his photographer's studio
close to the institution. Some patients were photographed twice: shortly after admission
and just before their release. These 'before and after' pictures bear witness to a strong
belief in the effectiveness of the institution. The 'manic, aggressive and confused
behaviour' of the 24 year-old seamstress Harriet Jordan evolved over six months into
'calm, hardworking and exemplary'. The photograph shows a respectable, tidy woman.
The composition and clothing distract attention from the blank look in her eyes.

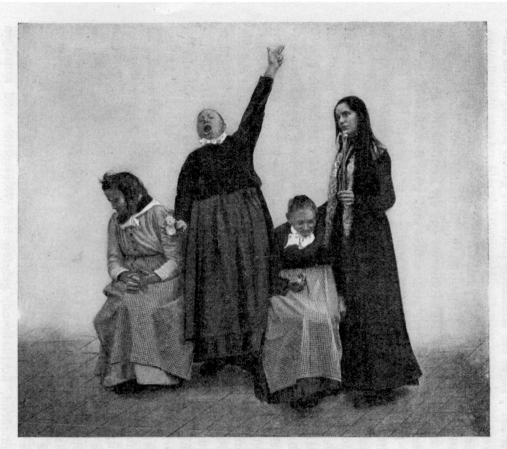

Fig. 211. Manische Kranke.

Fig. 211. Manische Kranke (Manic patients), from Emil Kraepelin, *Psychiatrie. Ein Lehrbuch für Studierende und Ärzte*, 1913, Leipzig. Dr. Guislain Museum, Ghent

German psychiatrist Emil Kraepelin (1856–1926) used the diagnosis 'manic-depressive' for patients with alternating periods of gloom and overconfidence. The women in this group portrait show the illness 'in its various colours, from quiet joy and proud self-assurance to exuberance'.

(next page)
Medical records from the Hospice Guislain, 1920–1923, paper. Dr. Guislain Museum, Ghent

Joseph Guislain (1797–1860) kept substantial medical records in which he noted the details and analysis of the men admitted. A general section contains personal information about the men's address, age and occupation, stating the reason for closing their file: cure, transfer or death. The most extensive section of the records concerns the observation of symptoms during the first three to five days of admission. The further progress of the condition is described on the right-hand page.
Optimism about that progress died with Guislain, and for many long-term residents of the asylum we read the annual comment 'idem ibidem', or 'condition unchanged'.

1. *N° de l'inscription :* 1487

2. **Nom et prénoms :** Dooreman Gert

3. *Date de l'admission :* le 14 juin 1922

4. *Pensionnaire ou indigent :* Pensionnaire

5. *État civil :* Célibataire

6. *Nombre d'enfants :*

7. *Religion :* C. R.

8. *Instruction :* Primaire

9. *Lieu et date de la naissance :* Brugelette, 8 mai 189.

10. *Lieu du domicile :* Brugelette

11. *Profession et position sociale :* S. p.

12. *Diagnostic :* Paranoia

13. *Pronostic :* mauvais

14. *Cause et date de la sortie :* 3 nov. 31

ANTÉCÉDENTS.

1. *Hérédité :* Maladies mentales, nerveuses, cérébrales; suicides, bizarreries, crimes; surdi-mutité, alcoolisme, nervosisme, consanguinité :

2. *Constitution psychique :* Syndromes épisodiques, stigmates psychiques; développement moral et intellectuel; déséquilibration des facultés.

3. *Maladies antérieures :* Convulsions, traumatismes cérébraux, affections nerveuses, cérébrales, zymotiques, spécifiques, diathésiques, hémorroïdes.

4. *Influences nocives et causes occasionnelles :* Alcoolisme ou autre empoisonnement, onanisme, excès vénériens, épuisement, émotions, frayeurs, chagrins, misère, surmenage.

5. *Atteintes antérieures :* Nombre et nature; établissements où il a été traité.

6. *Manière de vivre habituelle et caractère durant l'état de santé.*

7. *Invasion :* Date et phénomènes.

ÉTAT SOMATIQUE.

8. *Signes de dégénérescence physique.*

9. *Constitution :* État de la nutrition.

10. *Tempérament.*

11. *Sensibilité physique :* Anesthésie, hyperesthésie, dysesthésie des organes des sens; douleurs, céphalagie, sensations anormales, crampes, etc.

12. *Motricité :* Innervation faciale, pupillaire; nystagmus, ptosis, strabisme; parole, écriture; tremblements, convulsions, chorée, catalepsie; contracture, ataxie, parésie, paralysie. — État des réflexes.

13. *Circulation :* Cœur, vaso-moteurs.

14. *Respiration.*

15. *Digestion :* Langue, digestion, selles.

16. *Système génito-urinaire.*

17. *Sécrétion et peau :* Sueur, éruption.

18. *Lésions trophiques.*

19. *Sommeil.*

20. *Maintien, gestes, actes, conduite :* Est-il dangereux; refuse-t-il de manger.

21. *Maladies accidentelles ou infirmités à l'admission :* Hernie, affections cutanées, blessures, etc.

ÉTAT MORAL ET INTELLECTUEL.

22. *Dispositions morales.*

23. *Sensibilité morale :* Expansion, dépression.

24. *Sentiments moraux et affectifs.*

25. *Penchants :* Obsession, irrésistibilité, impulsion et perversion des actes; perversion des sens; homicide, suicide, onanisme.

26. *Émotivité :* Inquiétudes, angoisses, frayeurs.

27. *Conscience :* Intacte, troublée, abolie.

28. *Mémoire :* Exaltée, diminuée, abolie.

29. *Perceptions sensorielles :* Perverties, anéanties.

30. *Fonctionnement syllogistique.*

31. *Illusions et hallucinations :* De la vue, de l'ouïe, de l'odorat, du goût, du toucher, de la sensibilité générale.

32. *Idéation :* Normale, régulière, accélérée, loquacité, ralentie, insuffisante; idées délirantes, partielles, systématisées, délire général; incohérence, obsession.

Observations à faire sur la marche de la maladie pendant les cinq premiers jours.

de Brugelette âgé de 32 ans. Il vient de Leuze.

Il dit qu'il se fiche de toutes les poursuites; qu'un homme doit se suffire à lui-même; qu'on peut se correspondre de très loin; qu'on a perfectionné le système, qu'on peut voir la personne à qui on parle etc., il y a certaines incohérences dans son parler. Il croit que je suis né de Hampteau; Il débite beaucoup. Il ne propose sous l'auspice de Pères du Sacré mais les propriétaires ne fournissent plus de leur bras; les idées polymorphes sont incohérentes Qui estimez-vous le plus dans le genre humain? Il dit, je préfère les petites femmes. Me connaissez-vous? C. R. Je n'ai pas de parents ici en Belgique. On le dit d'abord qu'on me nom testament qu'on a volé en qu'on me fiche le camp. Qu'ils s'inquiètent de moi je ne m'inquiète de moi-même.

Examen de l'œil: Les pupilles sont égales. Réflexes rotuliens dispar.

2e & 3e jour Il a déchiré complètement son veston et son gilet la nuit pendant qu'il était au besoin. Il urge - hallucine et urifiant

4e jour idées de grandeur: il est Altesse etc. Personne ne doit s'occuper de ses affaires

Transmis le 20 juin 1922 *une copie des observations ci-dessus au Procureur du Roi de Gand*

5e jour Sur un fond de dégénérescence mentale, il y a des idées paranoïques. malade mentale

Juillet a déclaré tous les effets.
Saute de couche du 9 Cour.
.eff. sarcastique, dit qu'on
.olant par profit 1923
...es femme lesacoup
Mar...de hor de tran
....gr pr du fev 1924
Jar. tranquille 2 Eveus
...mer ... Mai id.
Juillet allongé sur le Can.
9 id. 26 l'amene gof. et
...faire 27 id. 28 id.
...9 id. 30 dement
31 id. Ptransfère à
Grandmont le 3. hov.
3.. je invalidité

R Maer,

Abbildung **97**

Ol. E. ♀ Alter: 66 Jahre

Diagnose:

Chronifizierte Schizophrenie mit schwerstem Defektzustand

Konstitution:

Dysplastisch

Krankheitsbeginn:

Im Alter von 26 Jahren

Verlauf:

Schubweise mit raschem Persönlichkeitsabbau, akustischen Halluzina-
tionen, Gedankenabreißen und affektiver Entleerung.

Jetziges Krankheitsbild:

Extreme Antriebsverarmung ohne affektive Schwingungsfähigkeit.

Gesicht:

Verkürzte Eiform mit hypoplastischem Unterkiefer. Biologisch früh
gealtert. Für das Alter von 66 Jahren ungewöhnlich starke Hautfaltung
mit vorherrschenden Vertikalfalten. Welke, blasse, pergamentfarben
Haut. Die Schläfenwinkel sind verstrichen. Die Augen weit geöffnet,
scheinen aufmerksam zugewendet. An beiden Mundwinkeln aus-
gedehnte Gramfalten.
Das Bild gibt den habituellen Gesichtsausdruck der Kranken wieder.
Bei der Begegnung mutet das äußerst bewegungsarme Ausdrucks-
geschehen als Leere an.

230

Ol. E., from: Gerhard Mall,
*Das Gesicht des seelisch
Kranken* (The faces of the
mentally ill), 1967, Konstanz.
Dr. Guislain Museum, Ghent

In 1967 German psychiatrist Gerhard Mall (1909–1983)
published *Das Gesicht des seelisch Kranken*. More than a
hundred razor-sharp black-and-white portraits were accompanied
by descriptions of the diagnosis, of how the disease progressed
and of the facial expression. The intention was to show what the
doctor sees: things that are usually hidden to the untrained eye.

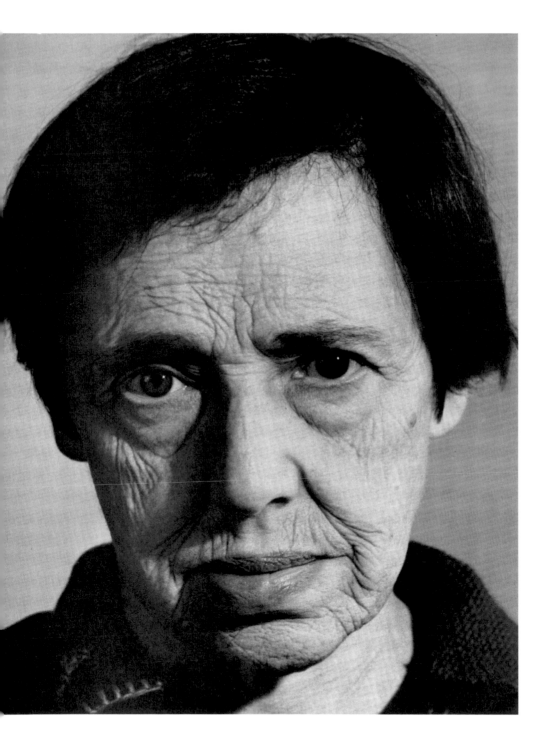

The book is relatively recent, and yet the portraits
echo the age-old tradition of physiognomy.
Faces reveal disease: 'Prematurely aged. Faded,
parchment-coloured skin. Wide open, vigilant eyes.
Deep lines of suffering around the corners of the mouth.
Diagnosis: chronic schizophrenia.'

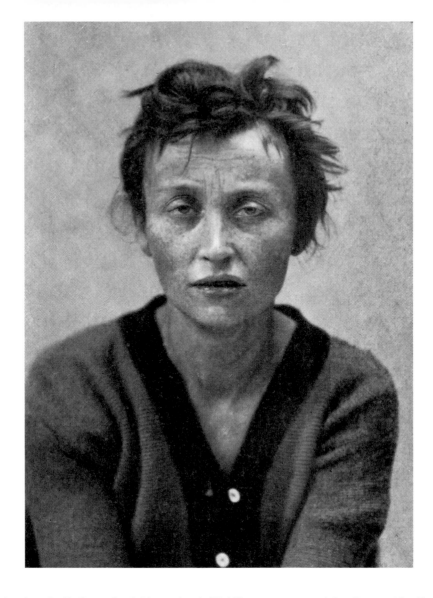

Abb. 115. Schizophrenie. Ratloser Gesichtsausdruck (Ill. 115.
Schizophrenia. Expression of helplessness), from: Oswald Bumke,
Lehrbuch der Geisteskrankheiten, 1929, Munich. Dr. Guislain Museum, Ghent

Advertisement for Fevarin in
the *Tijdschrift voor psychiatrie,*
1990s. Dr. Guislain Museum, Ghent

The way photography has been used throughout the history of
psychiatry often bears echoes of 'visual violence' towards patients.
This is not only because of the physical restraints that are explicitly
present in some photos, but also 'in the sense of a classification:
the individual caught in the power of the institution' (Regener, 2010).
In Oswald Bumke's (1877–1950) *Lehrbuch der Geisteskrankheiten*
(Textbook of mental illnesses) (1929), various harrowing photo-
graphs, such as this one of an anonymous woman, are referred to
dispassionately as '*Ill. 115. Schizophrenie. Ratloser Gesichtsausdruck*'
(Schizophrenia. Expression of helplessness). The caption reduces the
woman to a symptomatic facial expression. Psychiatry's objectivising
gaze contrasts with the personal tragedy that can be read on her face.

Although advertisements for
psychopharmaceuticals in
medical journals are aimed
at doctors, the message is
packaged more in terms of
feelings than scientific
explanation. Advertisements
for antidepressants mainly show
women; those for antipsychotics
usually show men. Depression is
female and psychosis male, the
illustrations seem to be saying.

Dansen kreeg weer zin.

Dankzij Fevarin.

Fluvoxamine
FEVARIN®
duphar Upjohn
Zie bijsluiter elders in dit blad

Met Fevarin zeg je weer ja tegen 't leven.

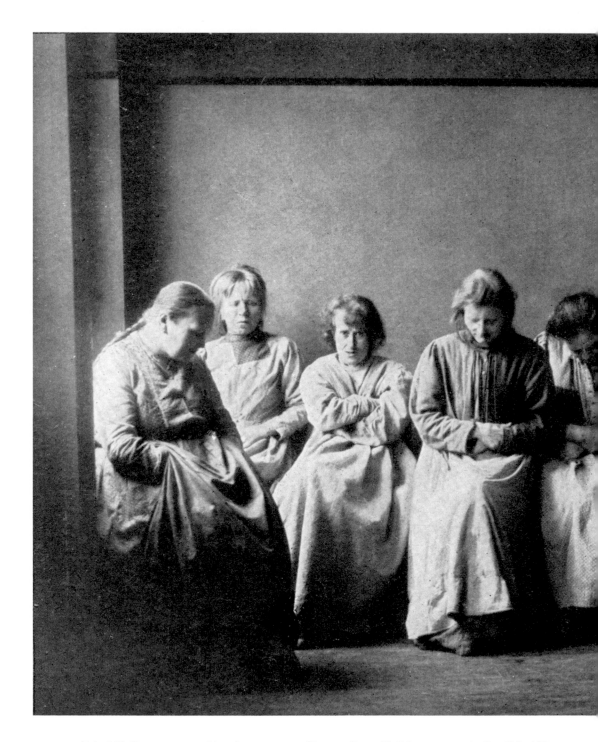

Abb. 145. Gruppe von schizophrenen Endzuständen (Group in end-stage schizophrenia), from: Oswald Bumke, *Lehrbuch der Geisteskrankheiten*, 1929, Munich.

Dr. Guislain Museum, Ghent

The caption with this group portrait — *Abb. 145. Gruppe von schizofrenen Endzuständen* — from the textbook by German psychiatrist Oswald Bumke (1877–1950) demonstrates objectification: he describes his subjects not as women but as 'stages of schizophrenia', and not as patients but

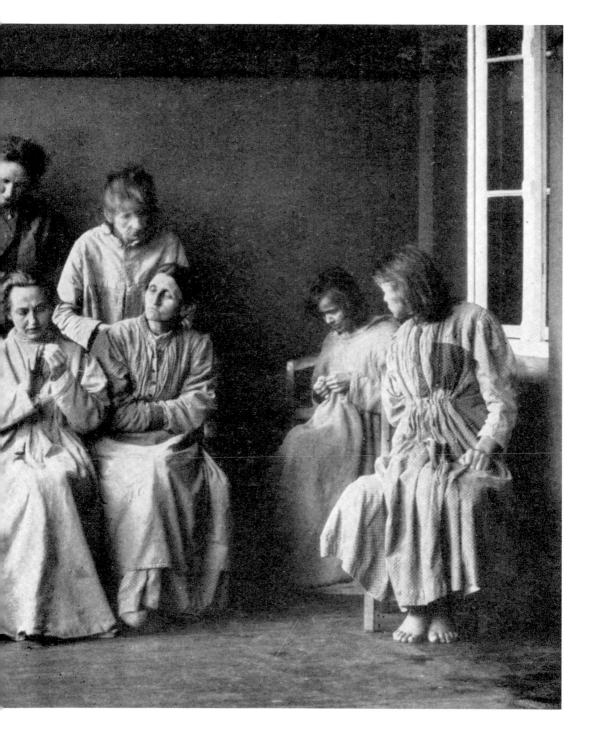

as a disease profile. There are 11 women sitting and standing in a line, centred in the image. The natural light falling into the room casts shadows on their faces and sober clothing. The harmonic composition suggests that it has been staged, testifying to a strong photographic and aesthetic quality.

Ten women are looking away, gazing at the floor or their hands, or have their eyes closed. One woman refuses to avert her gaze, looking straight into the lens. The focus is on the gaze, uneasy rather than scientific or classifying, both for the women in the portrait and the viewer today.

Jan Hendrik van den Berg, Herbarium, 1922–2012,
dried plants and paper. Dr. Guislain Museum, Ghent

Dutch psychiatrist, neurologist and writer Jan Hendrik van den Berg (1914–2012)
became well known for his 'metabletics' or theory of change. To gain insight
into modern existence, Van den Berg assumed that humans and society were
subject to change. The key to the metabletic method is the synchrony of certain
phenomena through history. Van den Berg grouped disparate phenomena that
occur simultaneously and investigated how they were connected. For example,
he linked the increasingly objectivising perspective in the natural sciences in
about 1740 with greater attention to the emotions in poetry. And he saw similarities
between the emergence of the straight line in architecture and nineteenth-century
female fashions. In an idiosyncratic manner, he ordered thinking on medicine,
psychology, mathematics, biology, spirituality and culture to expose the evolution
of human attitudes. How does the world appear to us? What do the 'little things'
say, the anecdotes from history about historical developments and new
mentalities? How did people think in specific periods? And what did they know?
Although established science expressed regular criticism, people were eager to
read Van den Berg's metabletic writings. Phenomenological research of this
kind required extremely broad-based erudition in the sciences and the history
of culture. His exceptional library, inherited by the Dr. Guislain Museum in 2012,
bears witness to this.

Besides his unbridled passion for books, Van den Berg also had a great interest
in plants and insects. In his twenties, he made drawings of his collection of beetle
species with a great eye for detail. He had been working on a remarkable and
particularly carefully composed herbarium since childhood. He continued to
extend, classify and reclassify the collection of plants for 90 years. It demonstrates
Van den Berg's penchant for structure: he collected, named and categorised
to gain insight into our existence.

Cruciferae

...het heele Hauwtje is
duitvormig, zilverachtig,
doorschijnend; en tegen het
licht gehouden schijnt het,
met zijne zaden en hunne
Draadsteeltjes, ons Hebreeuwsch
letters te toonen. Judaspenninge is
de algemeene verspreide naam.
— Veralr: Judasgeld, Judaszilverling,
Médaille de Judas, Medayo de Judas,
Dénié d'Judas
Is Teirlinck, Flora Diabolica, p. 268.

Judaspenning
Lunaria annua
tuin
Woudrichem VI-VII .1991

Jan Hendrik van den Berg, Herbarium, 1922–2012,
dried plants and paper. Dr. Guislain Museum, Ghent

Photo Note	November 15, 1996
Arnhem	Ketelstraat
2.45 - 3.45	

Hans Eijkelboom, *Fotonotitie 15 november 1996,*
Arnhem, undated, photograph. Artist's collection, Amsterdam

Photo Note	December 31, 2004
Amsterdam	Kalverstraat
1.00 - 2.00	

Hans Eijkelboom, *Fotonotitie 31 december 2004, Amsterdam*,
undated, photograph. Artist's collection, Amsterdam

Inspired by August Sanders' *Antlitz der Zeit* (*Face of Our Time*, 1929), Dutch artist and photo-
grapher Hans Eijkelboom began his *Fotonotities* (Photo notes) in 1992. The street portraits show
passers-by who always have one thing in common: a pale fabric jacket, clothes with a leopard
print or skull, a bomber jacket, an anorak, etc. In a busy spot, with the camera against his
chest and the self-timer in his pocket, Eijkelboom seeks out similarities great and small
between individuals in the crowd. Afterwards he groups the photos in grids, stating the date,
location and time. Together they form banal and absurd categories that call the uniqueness of
the individual into question. At the same time, the failure of categorisation is directly implied.

Photo Note	April 11, 1996
Arnhem	Ketelstraat
12.15 - 1.10	

Hans Eijkelboom, *Fotonotitie 11 april 1996, Arnhem,*
undated, photograph. Artist's collection, Amsterdam

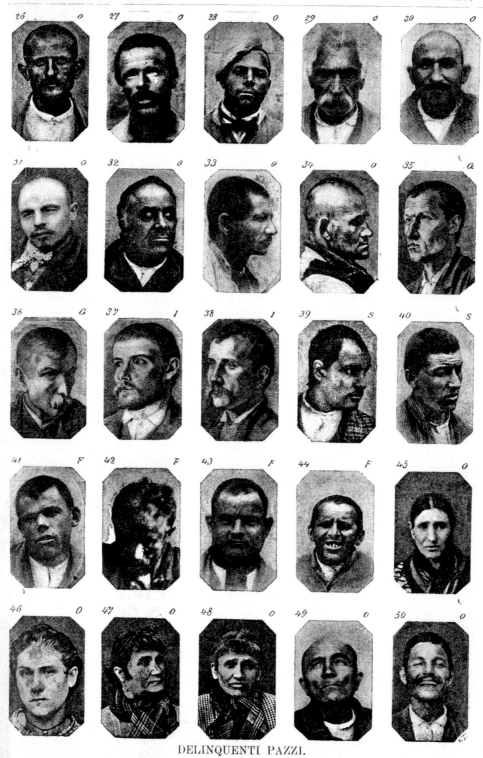

DELINQUENTI PAZZI.

Cesare Lombroso, illustration from: *L'homme Criminel: Atlas*
(The criminal: atlas), 1895, Paris. Dr. Guislain Museum, Ghent

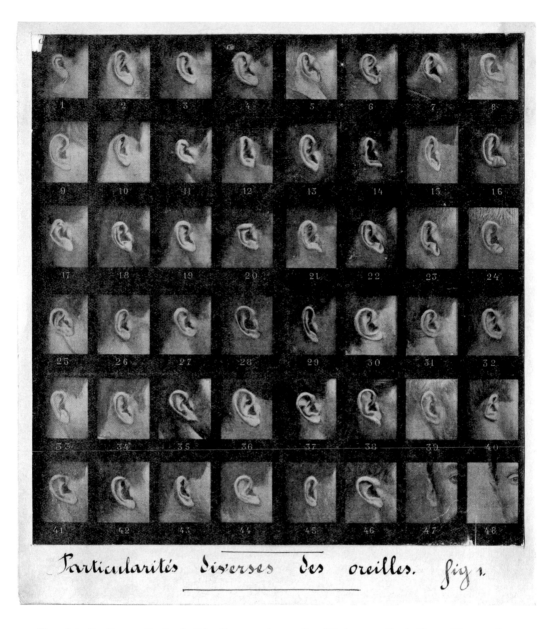

Ebergiste De Deyne, *Particularités diverses des oreilles* (Various particularities of the ears), c. 1930, photograph and paper. Dr. Guislain Museum, Ghent

French criminologist and police officer Alphonse Bertillon (1853–1914) developed an anthropometric classification system to identify suspects. Carefully recorded body measurements and other physical characteristics — such as the colour of the eyes, hair and skin, and the shape of the nose and ears — were collected in files. The method was particularly influential and inspired Ebergiste De Deyne (1887–1943), a Ghent-based educationalist, photographer and the head of the Sint-Jozefinstituut, in his research into types of children with learning difficulties. In analogy with Bertillon's categories, he grouped the children on the basis of their external characteristics, such as the shape of their ears, nose or lips.

Dieter De Lathauwer, *I Loved My Wife — Killing Children Is Good for the Economy*, 2012–2015, photographs. Artist's collection, Ghent

The organised mass murder by the Nazis of their opponents, those who thought differently and the 'impure' — Jews, homosexuals and gipsies — is a well-known dark chapter of history. What is far less well-known is the murder of people with psychiatric issues or physical disabilities in the period prior to the Holocaust. Psychiatrist Erik Thys calls it a large-scale psychogenocide on hundreds of thousands of vulnerable people. Based on so-called ideological and scientific truths, the lines between who was normal and who was abnormal were absolutely rigid. The stigmatisation caused by this categorisation was absorbed into the beliefs of the general public. Propaganda films claimed that these groups were 'unworthy', with nothing to offer society or themselves. From early 1939 onwards, around 5200 unwanted children were the victims of 'child euthanasia'. Parents were sent letters informing them of the death of their 'mentally primitive child' who would never become a 'useful person' and was better off 'released by a gentle death' (Thys, 2015). In Poland, 20,000 psychiatric patients received a 'mercy killing'. And in September 1939, Aktion T4 was authorised in Tiergartenstrasse 4 in Berlin, following which a sophisticated bureaucratic process led to the systematic and carefully orchestrated transportation and extermination of 73,000 patients from German psychiatric institutions to T4 death camps. Family members received standard 'letters of condolence' with an invented cause of death based on medical files. Outside the T4 system, around 200,000 victims died in hospitals of neglect, starvation or poisoning. The subdued photographs of the grounds of Austrian psychiatric hospitals by Dieter De Lathauwer (b. 1978) bear silent witness. The traces of an inhuman history are captured in a bare wall, part of a façade or thick foliage.

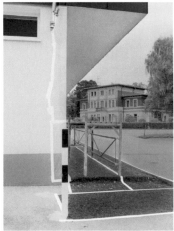

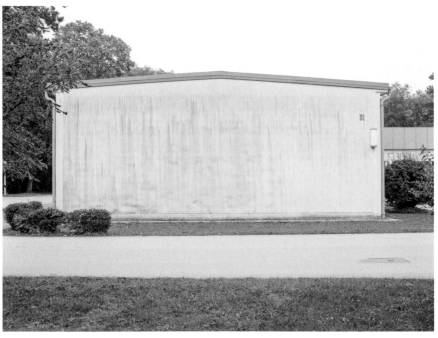

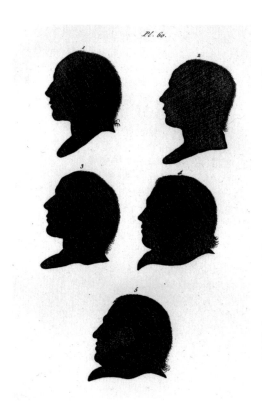

Illustrations from: Johann Caspar Lavater, *L'art de connaître les hommes par la physionomie* (The art of knowing men by their physiognomy), 1806, Paris.

Dr. Guislain Museum, Ghent

Judging people by their external characteristics is something people have always done. An intelligent look in their eyes, a tense mouth, a determined chin — what does the face tell us? According to Swiss theologian and scientist Johann Caspar Lavater (1741–1801), facial expressions were the key to the soul. A straight nose, flat face and healthy appearance constituted the type that united 'all the virtues of prudence in a single person'. A snub nose indicated a musical, poetic and imaginative character. Lavater's insights, in paperback form, were tested by a wide audience. Today physiognomy is considered a pseudoscience, although we still try to read facial expressions and believe in a relationship between the face and character.

Pl. 129.

Illustration from: Oswald Bumke, *Lehrbuch der Geisteskrankheiten*
(Textbook of mental illnesses), 1929, Munich. Dr. Guislain Museum, Ghent

POWER AND POWER LESSNESS

Hand restraints, nineteenth century, leather. Dr. Guislain Museum, Ghent

In 1815 Canon Peter Joseph Triest and his Brothers of Charity freed the male
mental patients at the Castle of Gerard the Devil in Ghent from their shackles.
This was a first step towards a more humane treatment and supervision of
people who had been rejected by society until then. In the Hospice Guislain (1857),
Joseph Guislain (1797–1860) used equipment worthier of human beings, made
of softer materials, such as leather belts to restrain patients, hand restraints
and cage beds padded with cushions. Restraints are still used today, such
as the isolation room and sedative medication.

Arnout De Cleene

TELL THE TRUTH

Power and Language in Psychiatry

Between solitary confinement and assisted living there is a spectrum of power dynamics. The conceptual pair 'power and powerlessness' run through the history of psychiatry up to and including its practice today: from powerlessness in respect of one's thoughts or delusions, compulsive behaviour or offering appropriate help to a loved one, to the relationships between pharmaceutical companies and the scientific agenda, or deciding where the couch and chair go in the psychiatrist's consulting room. There are measures that restrict freedom of movement. There are institutions you can't just enter and leave.

Psychiatric power and powerlessness were and are most visible in the form of confinement, when chains and shackles are used, when patients wear a gown or straitjacket, receive orders, have to be silent, or scream in isolation. But there are also less visible forms of power, such as authoritative theories and current therapies and diagnoses. Power dynamics are intrinsic in the way psychiatry works.

In many respects, the history of psychiatry and the issues it has to deal with today have to do with speaking, with the discourse in which psychiatry functions. What meaning is given to words? To what diagnoses do they lead? Is someone who is quiet calm, or is he or she suffering from aphasia? Do we talk about psychiatric illness or psychic vulnerability? Are those who had 'weak nerves' in the early twentieth century people who are now 'hypersensitive'? How trustworthy is what someone says if he or she has been diagnosed as non compos mentis? How do you deal with a request for euthanasia from someone who suffers from depression? In those sometimes deafening, sometimes whispered words, the tension between power and powerlessness is revealed. Where do we find the traces of those words, fresh or faded, and what significance do we dare give to them?

'MADMEN'

The way in which power, language and psychiatry are inter-related lies at the heart of the psychiatric movement with the generalised and hyperbolical name of 'anti-psychiatry', which flourished in the 1960s and 1970s. The criticism was strong: it was directed at the medical model that was central to classical psychiatry, at overcrowded institutions, at the anonymity of patients and the authority of the psychiatrist. Mediagenic figures such as Ronald Laing, Franco Basaglia and, in Belgium, Steven De Batselier expressed this criticism convincingly in public and at the same time linked it to alternatives. '*Sous les pavés, la plage*': that slogan of the protestors in May 1968, who saw the beach — freedom — under figurative paving stones — the heavily normative surface —, also applied the critical approach to psychiatry. The alternatives were to be found under the worn paving stones in crowded, noisy psychiatric dormitories. Anti-psychiatrists provided a new, conceptual framework to deal with mental illness, like an inner journey, as Laing had suggested. They succeeded in bringing about far-reaching legislative reforms, like the 'Basaglia Act' which closed psychiatric institutions in Italy, and they set up small-scale therapeutic communities, like De Batseliers Passage 144 in Leuven.

The critical, anti-psychiatry movement wrote itself into the history books. Not just because of the substance of the criticism, but also because of the way in which that criticism was expressed. Not in ornamental handwriting from a psychiatrist's fine fountain pen in which patient details had been noted down in dusty dossiers for a century, but with a spray can, and with graffiti slogans that occupied the public space. Suddenly, discussions about ECT (electroconvulsive therapy) and psychotropic drugs were no longer restricted to a select circle of specialists, but were being conducted by the man in the street. The criticism of the old psychiatric institutions was picked up by film and photography. Power acquired the face of Nurse Ratched, the character from Miloš Forman's film adaptation of Ken Kesey's novel *One Flew Over the Cuckoos Nest* (1962), and the interior of the psychiatric institution was revealed by documentary photo series like those of Raymond Depardon and Jerry Cooke.

Language was, furthermore, a central aspect in the critical movement in two ways. Firstly, a new language was developed as an alternative to the authoritarian medical jargon. Not the diagnostic terminology of psychiatrists, but a literary-philosophical

Hanging chair used in prenatal psychodynamics, undated, rattan. Dr. Guislain Museum, Ghent

Leuven-based criminologist and psychologist Steven De Batselier (1932–2007) was well known as a troublemaker. He repeatedly clashed with authority figures. He set up Passage 144, a small-scale residential community for psychiatric patients that sought to offer an alternative to hierarchical, anonymous psychiatric hospitals.

He criticised conventional psychiatry and questioned treatments such as electric shock therapy. In Passage 144, De Batselier created a space for prenatal psychodynamics, where the birth trauma was seen as the basis of psychoses. Residents were rocked in a hanging chair like babies in their mother's womb.

language. Not Emil Kraepelin, but Jean-Paul Sartre was a source of inspiration, and not the chemical formulas of the first antipsychotic drugs, but sonnets (Laing) and *Bildungsromane* (Jan Foudraine's *Not Made of Wood*). Secondly, the critical psychiatrists broke with the then current discourse about the value attached to the patient's opinion. The patient's voice was almost entirely absent in the debate about psychiatry: they were *talked about*, but never *spoke*. In the 1960s and 1970s, increased attention was paid to what patients themselves had to say about their experience. The often critical testimonies were published and read with interest.

A publication such as the *Gekkenkrant* (Madmen's newspaper) in the Netherlands is a well-known example. The DIY newspaper 'for and by psychiatric patients', combined a critical, emancipatory and playful approach, and achieved effective changes. Patients had a platform from which they could speak freely about their situation. The initiative expressed great faith in the power of the word. As the editorial team wrote in retrospect: 'We thought that life in the institutions had to be central. If people had the opportunity to communicate with each other by means of a newspaper, then political and social awareness would follow as a matter of course. (...) The editorial team didn't have to do much more than make a newspaper available' (1978, no. 26).

Breaking the power of the psychiatric discourse doesn't happen by itself, however. The success of the resistance that the protest movement initiated was also its downfall. The belief in the power of the word ensured that the movement increasingly got stranded in a metadiscourse in which it was more about the words themselves than about the reality they described. When the celebrated anti-psychiatrists met in Leuven in 1981 to plan for the future, for example, the congress that was supposed to develop a 'strategy of the small scale' was considered too large, and while patient participation is a crucial element of the philosophy, even that showed its limits when a patient attending the congress decided to intervene and the schedule was so disrupted that he was escorted off the premises. Ultimately, a congress about resistance mutated into resistance against the congress.

This also happened with the *Gekkenkrant*, the 'Madmen's newspaper'. According to the editorial team, the pages were filled with too much discussion about the name of the paper itself: was the term 'Madmen' appropriate or not, did it express resistance or repeat a stigma? Quotation marks were added and *Gekkenkrant*

Gekkenkrant, 1977, year 3, paper.

The *Gekkenkrant* (Madmen's newspaper) (1973–1981) presented itself as a critical newspaper 'for and by crazy people' and functioned as a creative practice with a strong sense of the homemade. The paper became a milestone on the journey towards greater empowerment and participation of patients in the organisation of (institutional) psychiatry. It contained a huge variety of contributions: some heartbreaking, others carnivalesque and yet others experimental, like that of PyQuRus, the *nom de plume* of engineer P. Kuperus. He communicated in a language of his own invention. Dutch critic Jacq Vogelaar wrote about these texts: 'By appropriating or embodying a language — or obscuring it: stealing what once belonged to them or has been denied them — a language emerges (a linguistic world of their own) within language.'

became 'Gekken'krant, but the signposting of irony and parody did not end the discussion. Tension also arose around the various points of view with regard to the campaigns that the newspaper helped to initiate, such as NASA (National Anti-Shock Action) and Valium-Free Friday (*Valium Vrije Vrijdag*). On the one hand, the increased capacity of the psychiatric patient to make him- or herself be heard was an achievement in itself, but on the other hand, there was disappointment that no spontaneous mass movement of resistance had materialized, as the editorial team had hoped it would.

UNDER THE PAVING STONES

It is a constant concern: how should we talk about psychiatry? What words can you use as an alternative for the psychiatric discourse? And how much power do those words have? The questions that were asked during the articulate 1960s are as relevant today as they were then, even if circumstances are very different. 'Under the paving stones, the beach' — but there were new paving stones under that beach.

Michael E. Staub describes in *Madness Is Civilization* (2011) how, after the heyday of anti-psychiatry, psychiatric insights and terminology permeated the social, cultural and political discourse. Subjects involving mental health are the order of the day in popular magazines and newspaper supplements, popular soaps and blockbusters. It has become a 'pop psychology', which has reintroduced norms via individualistic maxims such as 'find yourself' and 'get in touch with your feelings'. This is far from just a contemporary phenomenon: the presence of the words 'autism' or 'depression' in the media today resonates with the popularity of the nineteenth-century romantic 'melancholy' or the twentieth-century modern 'neurasthenia'. Nevertheless, a connection is often made between the remarkable ease with which psychiatric terms are bandied about today and the anti-psychiatric movement. It is ironic that the anti-psychiatric suspicion of 'the ever-expanding tentacles of psychiatry and therapy' (Staub, 2011) would lead to the ubiquity of psychiatric norms today in the form of pop psychology. The broad sociocultural debate aimed at authoritarian psychiatry that the anti-movement brought about has actually made the psychiatric discourse even more powerful.

This throws new light on the question of how we should talk about mental health today. The demand to make psychological

David Horvitz, *Sad, Depressed, People*, 2012, artist book, New Documents, Los Angeles. Courtesy the artist & ChertLüdde, Berlin

In the series *Sad, Depressed, People*, Canadian artist David Horvitz (b. 1982) collects images from online databases that appear when these search terms are entered. What is striking is the recurrent pose with the hands covering the head. On the one hand, the images have a clear connotation. On the other, they are empty signifiers testifying to a certain superficiality because they can be used in various contexts. The work offers a critical perspective on the distribution and commercialisation of images such as those connected to mental health.

David Horvitz, *Sad, Depressed, People*, 2012, artist book,
New Documents, Los Angeles. Courtesy the artist & ChertLüdde, Berlin

vulnerability a subject of conversation was already being loudly made in the 1960s. That demand is still being made very loudly today. The stigma of mental illness is perceived as a negative remnant of a time when little could be openly discussed. It is demonstrated in the inability to talk about psychological problems and to give them a place. Despite this, mental illness is extensively and continually discussed in many places: the subject is ever present. There is a strong contradiction between individual and social shame and taboo on the one hand, and the dominance of the psychiatric and psychological discourse, on the other hand. The inflation of psychiatric insights in popular media seems to be an alternative way of impeding conversation about psychological problems. A lot is said about mental illness, but precisely what can be said is limited by social norms and values. Power expresses itself not in what you are forbidden to say, but in what you are obliged to say.

Although the opinions of French thinker Michel Foucault (1926–1984) on the history of psychiatry as expressed in his *Folie et déraison* (1961) are contested, his work about the connection between power and knowledge in discourse is still relevant. Foucault formulated a critique of the 'classical' history of ideas of psychiatry (sometimes incorrectly described as anti-psychiatric): he attacked the late-eighteenth-century idea that psychiatry was a science and questioned the authority of figures such as Philippe Pinel, Samuel Tuke and Joseph Guislain. They were not the liberating, humanistic benefactors that their statues might suggest. Instead of the chains from which they were thought to have freed patients, there came a new restraint of mad people, where psychiatric power manifested itself much more subtly, in the position of the psychiatrist as a figure of authority, the observation of patients and, above all, the discourse. The spoken word, and psychiatric terminology in particular, began to dominate thought on psychiatric aberration. Physical means of coercion receded, but they were replaced by a mass of rules, words and norms. Madness was called 'irrationality' and then 'psychiatric illness', removing it from what it once was.

Foucault wanted to pay attention to that lost, tragic madness by writing, not the rational history of psychiatry, but the archaeology of the silence. The silence was the unheard voice of the mad(ness) as opposed to the discourse of the psychiatrist, and although that voice grew even quieter through the centuries, there

were still, according to Foucault, occasional eruptions. Not in scientific treatises or historical works, but in wild literary texts and uncomfortable works of art. Foucault found traces of what madness used to be before it was medicalised in visual art, philosophy and literature. In his extreme romanticism, he heard and saw the madness in the poems of Hölderlin and the brushstrokes of Goya. Madness echoed in Artaud's scream and slumbered in Nietzsche's subversive ideas.

That literature has the means to expose the complexity of power in psychiatry and to question it is clear in our country. The fiery pamphlet *Recht op antwoord* (Right of reply) that Roger Van de Velde wrote, the bitter monologue of the psychiatric patient Keefman as recorded by Jan Arends, J.M.H. Berckmans' alter egos who wander through the city, or the manuscripts that the Belgian French-speaking author Sophie Podolski left: they often use a disorientating literary language to reveal what scientific or historical discourses cannot, but they disorientate from within the language itself, because it is precisely in language that a host of norms, rules and opinions are hidden. Dutch author Jacq Vogelaar compiled a collection of 'disturbed' texts, texts which occupy the no man's land between psychiatry and literature, written by anonymous psychiatric patients as well as avant-garde authors. In his introduction, Volgelaar wrote, in imitation of Michel Thévoz who talked of *écrits bruts*: 'Anyone who thinks that they are naive, innocent, unmoulded, spontaneous utterances is confronted by very aware, well considered, subversive texts. Disturbed texts are about attempts to escape from language conventions — a rebellion that is also (...) a rebellion against society; their writer is a spoilsport. — How free of consequences is that writing?'

BRAINS BRAINS BRAINS BRAINS

How we read disorientating, disturbed texts and characters is fundamental. The Dr. Guislain Museum houses some remarkable pieces that bring the subject of power and powerlessness in focus on various levels, like the scratches that a visitor can see here and there in the bricks of the building's external walls. Geometric shapes, years, numbers, tallies ... They are marks that have a documentary but also poetic value. They are documentary in that they function as evidence of the fact that the imposing building, the model of a modern psychiatric institute, served as a place of residence, or passage, for many (often anonymous) lives. The walls

become conveyors of meaning, and that meaning says something different than the therapies and medical theories that the building embodies. But these marks are also poetic, because of their ambiguity and their dependence on the interpretive framework of the person who reads them today. It is impossible to know who made the scratches and what they mean precisely: they might be the scratches of a patient at the end of the nineteenth century who was marking time, but they could just as well have been made by a lovesick pupil who was on a school trip last year. The confrontation with the scratches draws attention to the powerlessness of voices, which could not find their way into the history books, but also to the power of the person who sees and interprets the marks and imposes a meaning on them.

Other remarkable objects in the collection include the patient registers — examples of the administrative machine that psychiatry became in the nineteenth century. Clinical cases and their progress were recorded, often in minute detail. They are often harrowing scenes that are conjured up in detached phrasing. Income and expenditure, the amounts of medication and the duration of confinement have been recorded, including a saddening number of cases where a patient's decades-long residency ends with the sobering note 'dead'. They are fragments of otherwise unobserved lives penned by anonymous writers who could do nothing more than to record what the pre-printed categories and tables allowed them. The blotting paper that can still be found in some of the patient registers and with which the psychiatrists or nurses absorbed the wet ink before they started on the next line and the next patient only reinforces, in mirror image, the effect of the words. Those stained and striped pink and yellow pieces of blotting paper were canvases that soaked up that unused ink, as a metaphor for what wasn't or couldn't be told.

Even more fundamental questions are posed by an apparently banal collection of notes. Small, folded pieces of paper: backs of cigar bands, Rizla cigarette papers and the foil in which chocolate bars were wrapped, Kwatta or Van den Brink's Fleur de Hollande. They were found in the cracks and splits of the wooden beams in one of the dormitories of the Dr. Guislain asylum. Various messages are written in the same handwriting, but the name of the author is absent. Some are dated (the 1960s). They are sometimes legible, sometimes not, and they are often puzzling. The vulnerability of the cryptic and hidden messages is disconcerting:

Blotting paper from medical records of the Guislain hospital,
early 1960s, ink on paper. Dr. Guislain Museum, Ghent

Notes written by a patient, found between wooden beams in the Guislain hospital, 1960s, pencil and ink on paper. Dr. Guislain Museum, Ghent

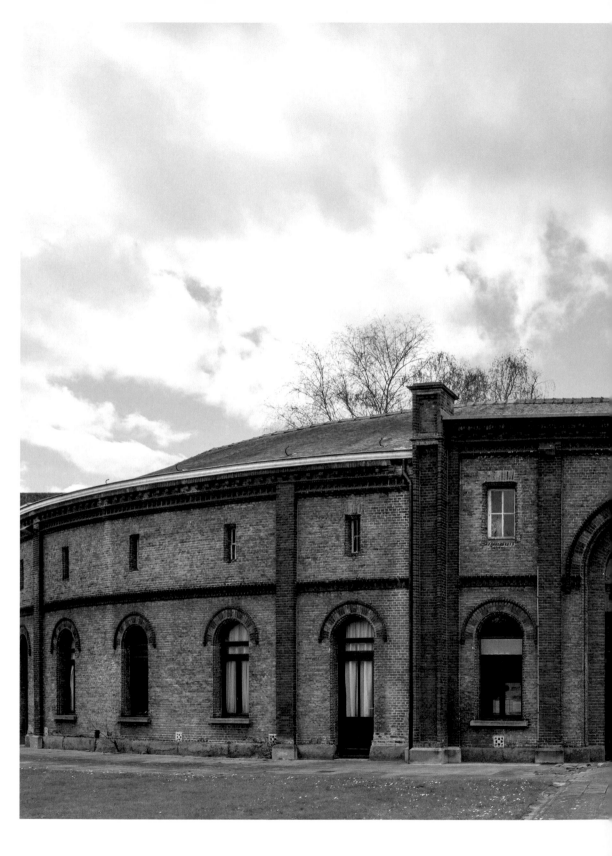

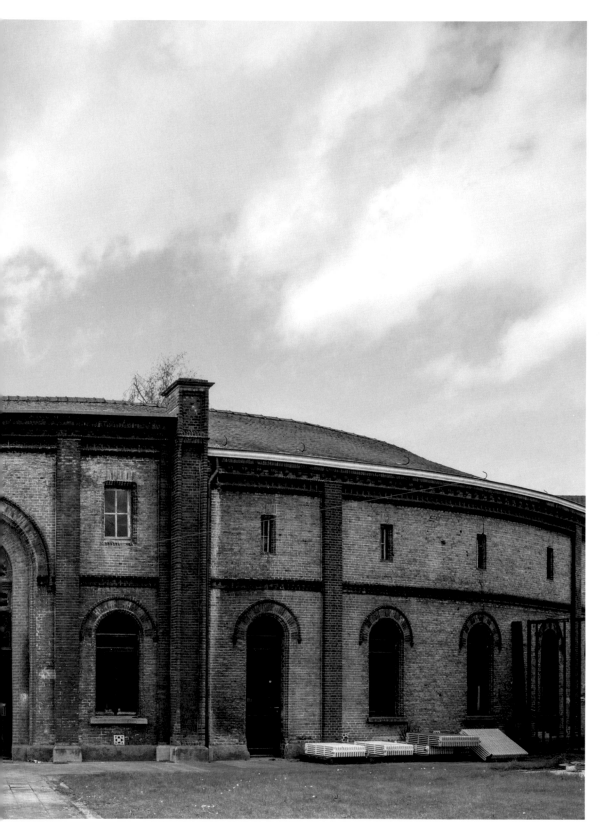

Karin Borghouts, from the series *Museum Dr. Guislain*, 2019, photograph.

De ergste van de toestand des levens (The worst of life)

Eerlijk komt alles uit (The truth will out)

De familie waar (The family in which)
De familie toch (Yet the family)
De familie familie (The family family)
De familie die terug geeft (The family that gives back)

De hersenen hebben coerange (The brain has *coerange* [sic])

Als het nog anders gaat (If it turns out differently)

Hersentjes (Brains)
Hersentjes (Brains)
Hersentjes (Brains)
Hersentjes (Brains)

What these messages mean is anyone's guess: they say both little and much.

In his introduction to an unpublished collection of prison letters, the lesser-known text 'La vie des hommes infâmes', Foucault talks about how that sort of vague, surrendered utterance becomes visible because it comes into contact with the mechanism of power. It is only possible that we can read '*Eerlijk komt alles uit*' (The truth will out) in an exhibition or catalogue because chocolate was part of the rations that a patient received, because someone could keep the paper and had a pencil, that there were dormitories and beams that supported the psychiatric building, that someone stayed there long enough in order to be able to write hundreds of notes and could hide them when no one was looking, that the dormitory became a museum gallery and that it was museum policy to keep the notes, etc. It demands a whole system of written and unwritten rules and psychiatric and museum dynamics to make the words readable.

STRANGE POEMS

The brief notes in registers, the scratches on the walls and the maxims on folded pieces of paper kept in the museum form an idiosyncratic collection of evidence. The Hospice Guislain functions in this way as 'a legend of obscure men, based on the discourse that

they engage in, out of misfortune or rage, with power' (Foucault, 1977). The artefacts do not belong to the museum's historical-scientific collection or its art collection. Nor are they literary works. They are suggestions of lives, evoked by just a few words, 'singular lives that have become, one way or another, strange poems'. These 'strange poems' make clear how gestures are hidden in a few scratches that denote the passage of an often nameless individual. They show how power listens and speaks, but also how it determines speech, in the texture of the blotting paper, in the cracks between the beams and the scratches on the bricks, allowing just a minimal space in which to say something that they hadn't foreseen or do not want to hear. The back of the chocolate wrapper cannot reveal which rules decide what can be said, but it does make tangible that those rules are there nonetheless and that they exercise power. Those rules were present in the period when Guislain erected the walls of the hospice with hope, other rules propped up the discourse of anti-psychiatrists and patients during the tumultuous 1960s, and new rules determine what can be said, read and shown today.

Among the hundreds of folded little notes, one stands out. On the back of the foil of milk chocolate is written 'Tell the truth'. The remark is as noteworthy as the foil on which it is written is not. At first it seems to be an order, an internalised norm, someone telling him- or herself to tell the truth, but the note also reveals another layer. The act of speech that the note describes is precisely that which madness or mental illness is not, according to Cartesian logic. Where the mad person once held a marginal but nonetheless important position in society and was thought to speak truthfully, madness lost that capacity because of its medicalisation and exclusion. Madness is regarded as unreal thought, out of touch with reality, illusion, nonsense — in short, the opposite of truth.

A twentieth-century note from a patient which reads 'Tell the truth', written in repugnance at the power structure that undermines the very foundations of the sentence, is an act of rebellion. It is an urgent and complex demand that is made of society and a fortiori of a museum about psychiatry past and present, namely to continuously look for rules that support speaking out and to expose the interaction between power and powerlessness, which is, in any case, revealed by speaking out. What Foucault calls *parrhesia* — risky, truthful and frank expression — is also a command directed at the viewer, listener or reader and what he or she

wants to read in the surviving, fragile traces: what will he or she dare to say about the scratches? What value do we attach to the words of someone who is mentally ill? What weight is given to the testimony of a nurse? What weight to that of a patient, which is often labelled as unreliable? Who is permitted to say something that can be tested for whether it is true or untrue? How is that right to speak moulded by scientific and ideological motives, by age and gender categories? What determines who can say 'tell the truth'? What determines who can tell the truth?

BIBLIOGRAPHY

Blok, Gemma. *Baas in eigen brein. 'Antipsychiatrie' in Nederland, 1965–1985*. Amsterdam: Nieuwezijds, 2004

Felman, Shoshana. *Madness and Writing. Literature/Philosophy/Psychoanalysis*. Palo Alto: Stanford University Press, 2003

Foucault, Michel. *Folie et déraison. Histoire de la psychiatrie à l'âge classique*. Paris: Plon, 1961

Foucault, Michel. 'La vie des hommes infâmes', in: id. *Dits & écrits, II, 1976–1988*. Paris: Gallimard, 2001 (1977), pp. 237–253

Foucault, Michel. *Fearless Speech*. Los Angeles: Semiotext(e), 2001

Lotringer, Sylvère (ed.). *Schizo-Culture*. Cambridge: MIT Press, 2013 (1978)

Staub, Michael E. *Madness Is Civilization. When the Diagnosis Was Social. 1948–1980*. Chicago: University of Chicago Press, 2011

Thévoz, Michel. *Le langage de la rupture*. Paris: PUF, 1978

Vogelaar, Jacq Firmin (ed.). *Gestoorde teksten/verstoorde teksten* (Raster 24). Amsterdam: De Bezige Bij, 1983

Illustrated letters, undated, paper. Dr. Guislain Museum, Ghent

Herman Derive,
untitled, undated,
blood on paper.
Geel Open Psychiatric Centre

Herman Derive (1899–1957)
was a boarder in Geel.
He made various drawings,
sometimes in his own blood,
that have a mysterious language
of their own. He called them
Des extraîts (sic) *de la Sainte
Ecriture* (extracts from Scripture).
Derive was critical of the Geel
home-based care system, as
Geel doctor Frits Sano noted:
'Herman Derive claims that
hosts are not paid enough for
what they have to give the sick
people who board with them.
He wanders the streets asking
for money. He gives the
people who give him money
a homemade token depicting
the Communist hammer and
sickle' (Boeckx & Vandecruys,
2010).

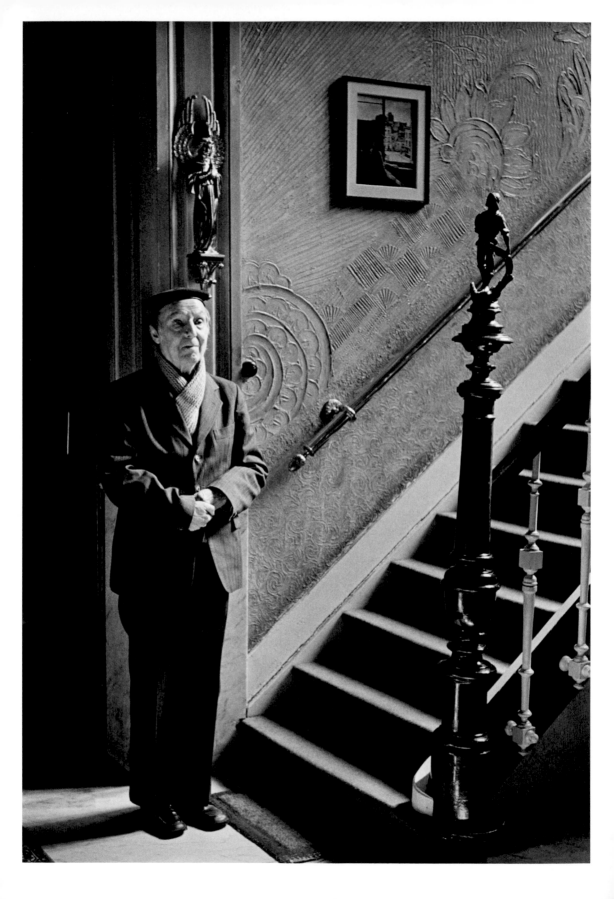

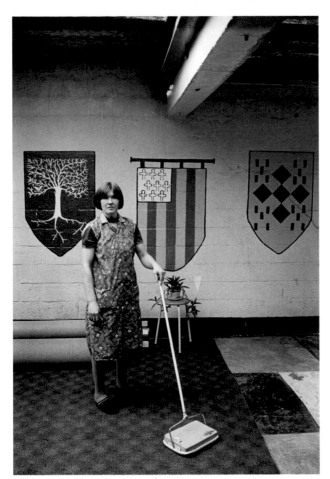

Hugo Minnen, from the series
Een gelaat van Geel (A face from
Geel), 1978–1980, photographs.
AGB Cultuur Geel, Cultural Centre de Werft

Between 1978 and 1980, Hugo
Minnen (b. 1938) photographed
the unique, world-famous family-
based care system in Geel.
Psychiatric patients were housed
in host families, a centuries-old
tradition that formed an alternative,
as it were, to the psychiatric institution.
The current trend that focuses on
'care in the community' seems to
have had a forerunner in the Geel
tradition, although the number of
boarders in Geel has fallen sharply,
and that was already happening at
the time of Minnen's series.
Minnen photographed the boarders
in their domestic settings, often
with attention to poignant details.

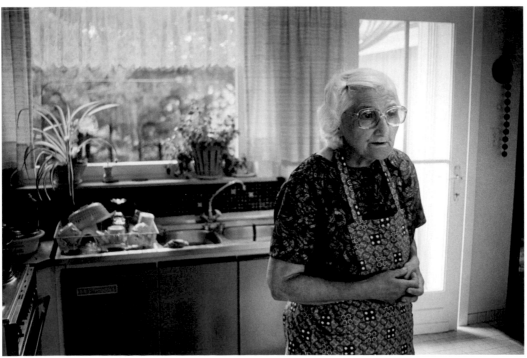

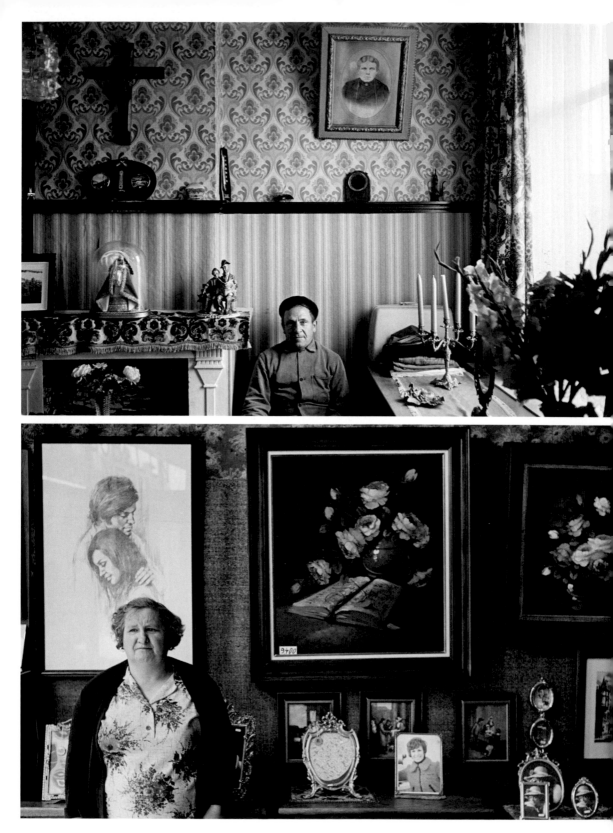

Anonymous, untitled, early twentieth century, pencil on paper.

Doctor and asylum director J.H. Plokker (1907–1976) was a pioneer in the attention he paid to work in the visual arts by psychiatric patients. His book *Geschonden beeld. Beeldende expressie bij schizofrenen* (Damaged picture. Visual expression in the schizophrenic) (1962) discusses four remarkable drawings by an anonymous patient. Plokker detects 'a quasi-profundity that only conceals emptiness'. Besides strange figures and mysterious sayings, the works also depict striking power relationships and figures of authority, such as a doctor and a judge. Opposite an imposing judge is a group of seated figures with conspicuous external features, such as hair in the shape of a claw or a nose drawn as a bird.

11/12/83

Dag, advokaat

Het gaat heelemaal niet GOED in Jeugdzorg
Ik worden dikwijls geslaagen

1. als je niets gedaan heb dan SLAGEN ze u
2. als je niet kunt slapen dan kletsen ze
tot ge in slaap valt
3. als je iets niet lust dan duwe ze je in
je neus en dan moet je het wel eten
4. → als je een brief stuurt dan wagten ze tot er
geen post is DAN, gaan we voor GOED naar
HUIS
Zo, advokaat dat doen ze voor niets!

Zaterdag as er geen schouts is dan zouden we eens
graag naar huis gaan, Dag,

Advokaat

en als het vrijaf is zoals met keerstmis dan zouden
we ook graag naar huis gaan

Letter, 1983, reproduction. Ludo Serrien archive, Werkgroep Bijzondere Jeugdzorg (1972–1985)

In December 1983, a boy wrote a candid letter to a lawyer. He was staying in a children's home and expressed the harsh conditions there: 'if you can't sleep, they hit you till you do', 'if you send a letter they wait until there are no deliveries', 'So, Lawyer, they do it for free!'
In the 1970s and 1980s, scandals led to increasing protests. Belief in the institution crumbled. The Werkgroep Bijzondere Jeugdzorg (Youth-Welfare Working Group), led by Ludo Serrien and Jos Goossens, wrote a horrifying black book: a condemnation of a sick youth-welfare policy. It set off a new debate on aid for young people in institutions, children's rights and the development of Flemish social work.

Pierre Aveline, after Cornelis Visscher,
La folie, 1737, engraving. Collectie Nauta, Rotterdam

This striking engraving was made in the
seventeenth century by French engraver
Pierre Aveline (1656–1722) after a drawing
by Cornelis Visscher (1629–1658).
Both the image and the text are based
on the topos and iconography of the fool.
The image shows a grinning, blonde, andro-
gynous figure, clothed in an animal skin,
holding a cap with feathers and bells in
his left hand and a mask in his right hand,
behind his back. The boy is looking directly
into the eyes of the viewer. The inscription
beneath the engraving reads: '*La folie.
Combien de curieux empressés à me voir —
Pouront* (sic), *en me voyant, se passer de miroir!*'
(Madness. How many curious faces, eager
to see me, will no longer need a mirror once
they see me!).
It is a satirical message: the madman is pointing
out the madness of the viewer. The mad figure,
associated through his clothing with animality,
holds up a figurative mirror to the viewer. That
was the purpose of the fool in the Middle Ages.
On the one hand, as someone of limited mental
capacity, he was at the bottom of the social ladder.
On the other hand, that position was what gave
him the ability to reveal a critical truth about
everyone higher up the ladder. According to
French science philosopher Michel Foucault,
madness is increasingly losing that capacity
as it becomes medicalised. The fact that Aveline
engraved Visscher's original drawing in mirror
image — left becoming right and vice versa —
seems to be a subtle acknowledgement of
the critical function of madness, which he
represented allegorically.

C. de Visscher. del .

Combien de Curieux e

LA FOLIE

s à me voir *Pouront, en me voyant, se passer de miroir ?*

z Huquier vis a vis le Grand Chatelet avec Privilege du Roy.

P. Aveline sculp.

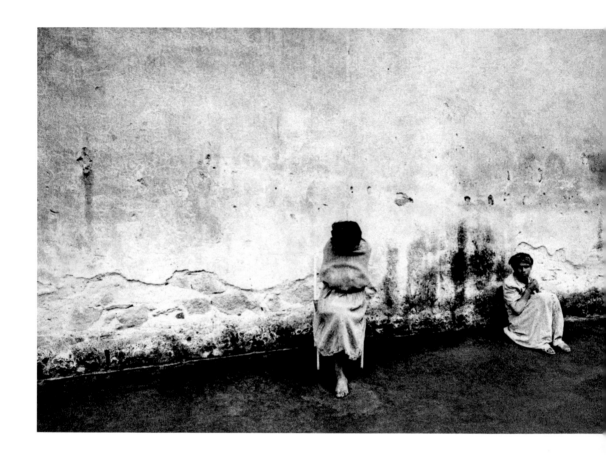

Gianni Berengo Gardin, from the series *Morire di classe*, 1968–1969, photogravure.

Dr. Guislain Museum, Ghent. © Gianni Berengo Gardin / Courtesy Fondazione Forma per la Fotografia, Milano

In the 1960s Franco Basaglia, the director of the Gorizia mental hospital in Italy, began reforming his institution. He removed the fences and walls around the building, introduced meetings with patients, and pleaded in favour of more humane care. He was among the founders of anti-psychiatry, a movement that saw patients not as passive but as active individuals. In 1978 he succeeded in getting Law 180 passed, with the aim of having all the psychiatric hospitals in Italy closed down. It was a process that would take 20 years. A book that made an important contribution to that movement was *Morire di classe* by Carla Cerati (1926–2016) and Gianni Berengo Gardin (b. 1930), whom Basaglia asked to photograph life in Gorizia and other Italian psychiatric hospitals in 1968.

Eric Manigaud, *Klinikum Weilmünster #6* (Weilmünster Clinic #6), 2010, pencil and graphite on paper. Artist's collection, Saint-Etienne. Courtesy Gallery FIFTY ONE. © Adagp, Paris, 2019

French artist Eric Manigaud (b. 1971) is known for his hyperrealistic pencil drawings inspired by existing historical images. The photos from the Weilmünster albums, an early-twentieth-century collection of portraits of patients from the Weilmünster Clinic in Germany, were intended as an inventory of disease profiles. Today we mainly feel a tension between the scientific gaze and the patient's visible suffering. Two hands restrain a young woman. The patient's mouth is fixed and she stares into the distance. The photographed subject is subordinated to the recording gaze of the photographer, but her emotions cannot be eliminated. Fear, anger or despair appear in various portraits. What is emotion or resistance and what is a disease profile?

De begraafplaats. (doorsnede zijaanzicht) D.C.

KAN SOMS NODIG ZIJN VOOR
KUNSTMATIG VOEDEN.

Onder een spanlaken is het zoet slapen.

Alleen zeer agressieve patienten komen hiervoor nog in aanmerking. D.C.

Karel Frans Drenthe, untitled, second half of the twentieth century,
Indian ink on paper. Dr. Guislain Museum, Ghent

The Dr. Guislain Museum collection contains more than a hundred drawings
and collages by Dutch author and artist Karel Frans Drenthe (pseudonym
of Karel 'Karlie' Drosse, 1921–unknown). His work is a ruthless critique of the
power structures in the 'care of the insane' that he experienced as a patient.
It can be seen as an early expression of the anti-psychiatric wave. His
cartoon-like works are bursting with gallows humour, sometimes literally,
as in the cross-section of the psychiatric cemetery with three coffins under
every anonymous gravestone.
Drenthe warned viewers about the possible reactions to his work: 'May I
impress upon you most urgently to remain ABSOLUTELY immune to the
so-called pertinent claims of physicians who declare that the restraints
I have drawn are old-fashioned and medieval. Don't be deceived. Even if
professors get involved. They will collectively attempt to prevent publication,
through thick and thin. The restraints are contemporary and IN GENERAL USE.'
Little is known about Drenthe. A short biography appeared in the sixth edition
of the literary journal *Randstad*, edited by Hugo Claus, Simon Vinkenoog,
Harry Mulisch and Ivo Michiels, presenting him as a singer and natural athlete,
a ju-jitsu and yoga expert, travel guide, stenographer, pianist and author.
Drenthe wrote about the law on the insane, the role of the 'work ethic' ('Anyone
who does not want to work is inevitably considered to be mentally ill') and
electric shock therapy: 'I have seen many terrified patients, dozens of times,
fighting to avoid electrocution. On doctors' orders, they are mercilessly tackled
and dragged away by the nurses, sometimes even tied up, only to be returned
ten minutes later, unconscious, mumbling and groaning on a stretcher.'

Klaas Koppe, from the series about the conference *Strategie van de kleinschaligheid* (Scaling-down strategy) in Leuven, including Steven De Batselier and Ronald Laing, 1981, photographs. © Klaas Koppe

In September 1981, Dutch photographer Klaas Koppe attended the conference *Strategie van de kleinschaligheid* in Leuven. It gathered psychiatrists from around the world with the aim of mapping out the future of the anti-psychiatric movement. Ronald Laing, Kees Trimbos, Félix Guattari, Steven De Batselier, David Cooper, Vincenzo Caretti and many representatives of therapeutic communities and patient associations were present. It was a tumultuous conference. On the one hand, general political stances on psychiatry were discussed. On the other, new forms of therapy were presented. The discussion of prenatal deep-sea-diving therapy — which claimed that consciousness begins before conception — even included sessions in a swimming pool (and psychiatrists in swimming trunks). 'But don't new therapies like this lead to new forms of psychiatric authority?', various attendees wondered. Suddenly one participant dropped his yellow shorts and dived into the pool: 'Splash: the first incident, you'd think. But in fact, no one saw it as a form of protest' (Schrameijer, 1981).

However, the conference itself was the target of protest. Attending patients had their say, whether they were asked or not, and although patient participation was at the heart of anti-psychiatric thinking, intervention was ultimately required. The overly large scale of the conference led to revolt — large groups left the auditorium on several occasions. In hindsight, the conference presented a picture of the final days of a revolutionary movement.
From the 1980s onwards, psychiatry would develop in a different direction. And nothing could change that, not even a figurehead of anti-psychiatry like Ronald Laing, playing 'It's a Long Way to Tipperary' on the piano to calm tempers at the conference.

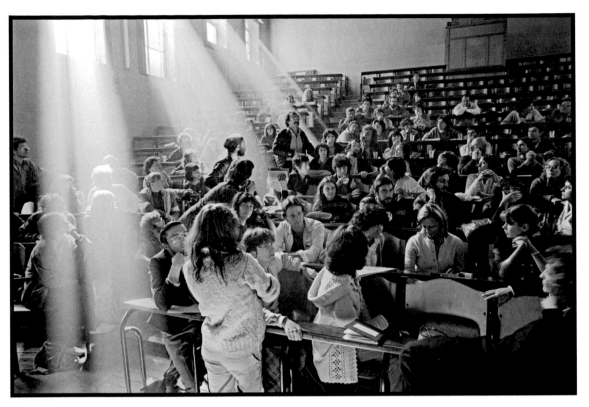

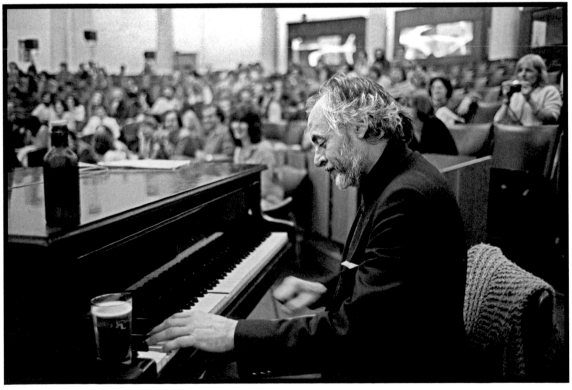

Christian Fogarolli, archival research at the Mental
Health Centre Gorizia (Italy), 2018, photograph.

Italian artist Christian Fogarolli (b. 1983) is developing an intriguing oeuvre
of installations in which various media enter into dialogue with each other.
Psychiatry and madness are central to many of his works. Fogarolli has
made new work for the Dr. Guislain Museum, using the museum archives
as a source of inspiration. His artistic research focuses on the hidden links
between the work of Joseph Guislain (1797–1860) and the thinking of
Italian psychiatrist and reformer Franco Basaglia (1924–1980).

Karin Borghouts, from the series *Museum*
Dr. Guislain, 2019, photograph. Dr. Guislain Museum,
Ghent. © 2019 – Karin Borghouts / SOFAM – Belgium

Wolfgang Hueber, *Du Schwein*, 1988, pencil and paint on canvas.

De Stadshof Collection Foundation. Dr. Guislain Museum, Ghent

Man in straitjacket, 1890s, glass negative. Dr. Guislain Museum, Ghent

German artist Wolfgang Hueber (1950–2008) lived permanently in a psychiatric hospital from 1985 onwards. He made quick sketches of figures and tools, then coloured them in. He used ordinary metal tools that he took apart, melted down and turned into stylised weapons, often pistols or knives. Hueber classified images into three categories: true, really true and lying images. *Du Schwein*, a painting that depicts a doctor trying to hurt a patient, belongs to the category of true images.

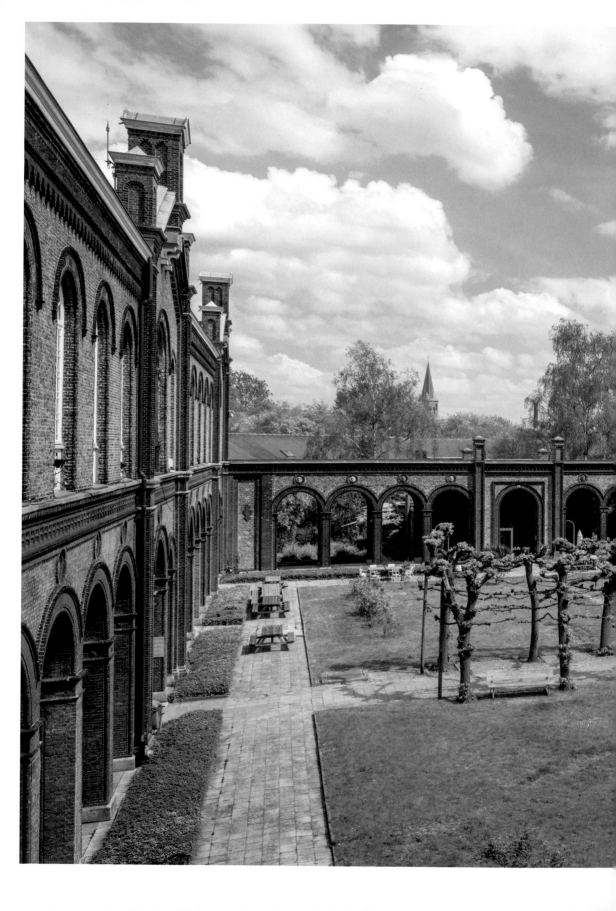

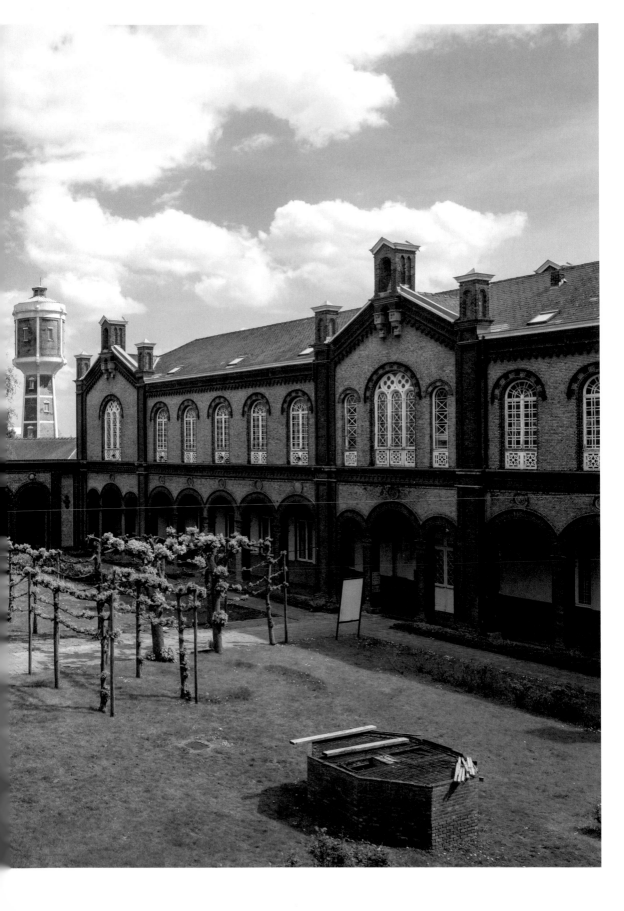

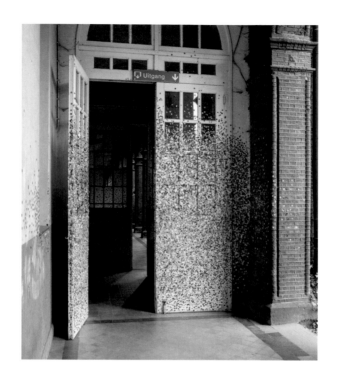

(this and previous pages)
Karin Borghouts, from the series *Museum Dr. Guislain*, 2019, photograph.

Dr. Guislain Museum, Ghent. © 2019 – Karin Borghouts / SOFAM – Belgium

ABOUT THE AUTHORS

PATRICK ALLEGAERT studied philosophy, criminology and educational sciences at KU Leuven. He used to be the artistic director of the Dr. Guislain Museum, where he is now the artistic advisor and policy advisor. He is the president of the Flemish Museum Network and the president of the theatre festival Theater Aan Zee.

ARNOUT DE CLEENE studied cultural sciences and literature at KU Leuven, where he obtained his PhD with a thesis on the relationship between literature and madness. He works as a scientific staff member and policy adviser at the Dr. Guislain Museum. He is also a researcher at the KASK School of Arts.

YOON HEE LAMOT studied art history at Ghent University. She is a scientific staff member at the Dr. Guislain Museum.

BART MARIUS is the artistic director of the Dr. Guislain Museum. He studied clinical psychology and art history at Ghent University. He has worked on many exhibitions and publications over the years.

ANDREW SCULL is the author of many books on the history of psychiatry, including *Madness in Civilization. A Cultural History of Insanity from the Bible to Freud, and from the Madhouse to Modern Medicine*, which has been translated into a dozen languages (London: Thames and Hudson/Princeton: Princeton University Press, 2015).

SARAH VAN BOUCHAUTE studied history at Ghent University. She is a scientific staff member at the Dr. Guislain Museum.

This book has been published
to accompany the exhibition
*Unhinged. On Jitterbugs,
Melancholics and Mad-Doctors*
at the Dr. Guislain Museum in Ghent
from 12 October 2019 onwards.

Foreword: Andrew Scull

Texts:
Patrick Allegaert, Arnout De Cleene,
Yoon Hee Lamot, Bart Marius, Sarah
Van Bouchaute, Eline Van de Voorde

Translations:
Lode Demetter (Ape-Translations.be)

Text and image editing:
Patrick Allegaert, Annemie Cailliau,
Alexander Couckhuyt, Arnout De Cleene,
Yoon Hee Lamot, Bart Marius, Sarah
Van Bouchaute, Eline Van de Voorde

Photography:
Marcel Köppen (pp. 150, 155, 238)
Guido Suykens (pp. 26, 34, 51, 52–53, 69,
88, 89, 90, 91, 97, 131, 135, 137, 140–141,
151, 168, 171, 178, 186–187, 210, 213, 250)

Cover: *Cuirasse protectrice en cauotchouc
portée par un aliéné persécuté*, from:
Nouvelle Iconographie de la Salpêtrière,
volume 8, 1895, Paris. Dr. Guislain Museum, Ghent
Backcover: Paul Regnard, *Attitudes
passionnelles*, photograph of Augustine
Gleizes, from: *Iconographie photographique
de la Salpêtrière*, volume 2, 1877–1878,
Paris. Dr. Guislain Museum, Ghent
Study of the brain by Professor André
Dewulf, twentieth century, brain slices.
Dr. Guislain Museum, Ghent

Design: Dooreman

Copy-editing: Patrick Lennon

Project coordination for Hannibal:
Pascale Goossens

Printing: die Keure, Bruges, Belgium

Binding: Abbringh, Groningen, the Netherlands

Exhibition concept and composition:
Patrick Allegaert, Arnout De Cleene, Yoon Hee
Lamot, Bart Marius, Sarah Van Bouchaute

Exhibition design:
Johan De Wit

Exhibition collaborators:
Patrick Allegaert, Annemie Cailliau, Alexander
Couckhuyt, Arnout De Cleene, Nico Deuninck,
Henk Dewaele, Yoon Hee Lamot, Lieven Leurs,
Bart Marius, Annemie Sneijers, Kristine Timperman,
Sarah Van Bouchaute, Eline Van de Voorde,
Saïdya Vanhooren, Luckas Vervaeke

The staff of the Dr. Guislain Museum:
Isay Aldinov, Fatima Ammi, Linda Arts, Fatiha Asghir,
Rachid Azdoud, Kristof Baetens, Patrick Bertrand,
Wim Blancquaert, Frederik Bourguillioen, Lidwine
De Buck, Rudi De Graaf, Jeannine D'Hondt, Erwina
D'Hoore, Karina De Weirdt, Serkan Eryuce, Wim
Herregodts, Arzu Karaca, Boris Kotiev, Martin Lauwers,
Ilkay Mektepli, Maurice Michiels, Ilse Milants, Kristine
Praet, Marcel Roos, Frank Snoeck, Anne-Marie
Spanoghe, Caroline Speeckaert, Geoffrey Staelens,
Sybille Van den Berghe, Dieter Vanden Bossche,
Geert Van Pol, Hendrik Van Wordragen, Guido
Verschaeren, Judith Verween, Hatice Yagmur

ISBN 978 94 6388 722 9
D/2019/11922/29
NUR 895

© Hannibal Publishing, 2019
www.hannibalpublishing.be
Hannibal Publishing is part of Cannibal Publishing

HANNIBAL

With the support of the Flemish Government

Structural sponsors